IMAGES
of America

MIAMI AND ERIE
CANAL

ON THE COVER: This c. 1900 photograph shows the *Laurel of Lockland* heading north through the Mohawk section of Cincinnati's Over-the-Rhine district. The area north and east of the canal's Plum Street bend was so heavily settled by German immigrants in the mid-19th century that crossing the canal became known as going "uber der Rhein," a reference to the Rhine River in Germany. The name for this area of Cincinnati has been retained to the present day. (Courtesy of the Frank Wilmes collection.)

IMAGES
of America

MIAMI AND ERIE CANAL

Bill Oeters and Nancy Gulick

ARCADIA
PUBLISHING

Published by Arcadia Publishing
Charleston, South Carolina

Library of Congress Control Number: 2014944109

For all general information, please contact Arcadia Publishing:
Telephone 843-853-2070
Fax 843-853-0044
E-mail sales@arcadiapublishing.com
For customer service and orders:
Toll-Free 1-888-313-2665

Visit us on the Internet at www.arcadiapublishing.com

This is for all the "Canawlers" who have gone before us and who left us with a passion for exploring and saving our canals. Also, this is for our families, who have indulged us in this obsession. Thank you.

CONTENTS

ACKNOWLEDGMENTS

The authors would like to thank and acknowledge the following individuals and organizations for their help in providing both photographs and information: the Canal Society of Ohio, in particular Boone Triplett, David Neuhardt, Michael Morthorst, Neal Brady, and Scott Bieszczad; Roger Miller and the Midpointe Library of Middletown; Kathy Creighton and the Butler County Historical Society; Jim Oda and the staff of the Piqua Public Library; Chris Hart and the Roscoe Village Foundation; Suzanne Sizer and the Middletown Historical Society; and the late Bob Mueller.

INTRODUCTION

The idea of canals in the United States began almost as soon as the nation itself was conceived. George Washington and his compatriots considered it necessary to open up the interior of this new republic to settlement and the rapid development of its vital resources. Thomas Jefferson's secretary of the treasury, Albert Gallatin, published a report in 1808 that was astounding in its scope, proposing roads, harbors, and canals, including the National Road, the Erie Canal, and canals leading into the Ohio Territory. Federal financing was not forthcoming for any of the proposed projects; instead, New York was forced to finance its Erie Canal by selling bonds, and Ohio faced the same dilemma.

By March 1, 1803, Congress passed an act creating the state of Ohio, and, by the very next month, the Ohio General Assembly met in Chillicothe to consider, among other items of business, the potentially profitable interior of the state and how to provide access for settlement and transfer of goods into and out of the state, as well as within its borders. It took until 1820 for the General Assembly to call again for similar surveys. Ohio entrepreneurs were urging the surveyors working on the Erie Canal to come to Ohio to survey and help construct canals to cross the state. Unknown and un-surveyed terrain notwithstanding, the General Assembly had already concluded that Ohio needed two canals: one to connect Cleveland to Portsmouth on the Ohio River and one to connect Cincinnati to Dayton. Later development of this second canal would extend it to Toledo on Lake Erie, thus connecting Lake Erie with the Ohio River at two points and traversing the entire interior of the state, north to south. These canals presented a continuous water route from any location along the canal to Lake Erie. From there, boats could enter the Erie Canal, which led to the Hudson River, and, thence, from New York seaports to Europe. It was a heady prospect indeed for the young state.

This plan languished for lack of funding until 1822, when a Canal Commission was formed consisting of Alfred Kelley, a wealthy Cleveland lawyer; Thomas Worthington, an ex-governor; Ethan Allen Brown, a US senator; Isaac Minor; Benjamin Tappan; Ebenezer Buckingham; and Jeremiah Morrow, who was later replaced by Micajah Williams when Morrow became governor. Somewhat later, the commission was expanded to include John Johnston of Piqua. A glowing report of this commission led to state funding of $6,000 to hire an engineer to determine canal routes in Ohio. Commissioner Kelley went on a head-hunting expedition to New York and wooed James Geddes away from the Erie Canal to come assess the five different canal routes proposed by the General Assembly. Geddes and his assistants spent several unprofitable months in the field. After filing his report Geddes quit his post, saying that Ohio was far too treacherous and pestilential for him. Luckily for Ohio's canals, it fell to the untiring efforts of Commissioners Kelley and Williams to save the project. Samuel Forrer, who had worked with Geddes as an assistant engineer, wound up spending a 50-year career on the Ohio canals, acting as commissioner at

different times on both canals. Samuel Forrer, his brother John Forrer, Bryon Kilbourn, William Price, and David Bates made up the engineering team, with Price and Bates coming directly from their work on the Erie Canal. Initially, Bates served as principal engineer.

On February 4, 1825, the Ohio General Assembly passed the Canal Act, authorizing the construction of a canal from Cleveland on Lake Erie south to the Ohio River, and a second canal, the Miami, from Cincinnati on the Ohio River north to Dayton, with planned extensions to Lake Erie at a later date. By originating each canal in a strategic city, the state could guarantee the start-up success of each canal, which would lead to votes of approval from the legislature and assure funding for continued canal construction. The law also gave the Board of Canal Commissioners the power of eminent domain for land required for canal rights-of-way, towpaths, and reservoirs, as well as the power to seize timber or stone required for construction. Due process was established through arbitration of fair market value offered for land or materials. With financing not forthcoming from the federal government, Ohio created a separate, three-man Board of Canal Fund Commissioners charged with obtaining loans, selling bonds, and managing canal funds. Due in some part to the proven financial success of the Erie Canal, Ohio found eager purchasers for bonds in New York and Europe. Construction on both Ohio canals could proceed immediately.

One

THE MIAMI CANAL
CINCINNATI TO DAYTON

On July 21, 1825, ground was broken south of Middletown, on the Daniel Doty farm, for the Miami Canal. Ohio governor Jeremiah Morrow was present, as well as New York's governor, DeWitt Clinton. Costs were figured at $12,000 per mile, or an estimated total cost of $673,000. Months later, 1,000 laborers were hard at work on the canal, destined to reach Cincinnati and Dayton. Wages for common laborers began at $5 per month plus board, including a daily ration of whiskey. Blacksmiths earned $11 a month, carpenters earned $21, and a man with a team earned $40. The completed Miami Canal, fed by dams and feeders from the Mad and Miami Rivers, ran for 66 miles, with 24 locks and 10 aqueducts.

On November 28, 1827, two short years later, the first boats arrived in Middletown from Cincinnati to celebrate the opening of the first section of the Miami Canal. By January 1828, the first boats arrived from Cincinnati in Dayton on the completed Miami Canal. Although whiskey, flour, and pork were popular shipping items, wheat and corn were also staples of the shipping industry to Cincinnati. The residents of the interior could finally receive finished goods from Cincinnati, which had not previously been available locally. By 1830, the two fledgling canals on opposite sides of the state were bringing the state revenues of $100,000. The commercial promise of canal building was being fulfilled, as well as the development of the state itself. The canals were crowded with traffic; boats packed with freight floated alongside boats packed with immigrants coming to settle farther and farther inland, pushing the line of settlement faster and with more ease than at any time in history. During the 1831 shipping season, 7,065 passengers arrived in Dayton from Cincinnati. Canal-side towns and industries prospered and expanded in each succeeding year, offering solid evidence to any doubters that canals could indeed ensure growth and prosperity for Ohio.

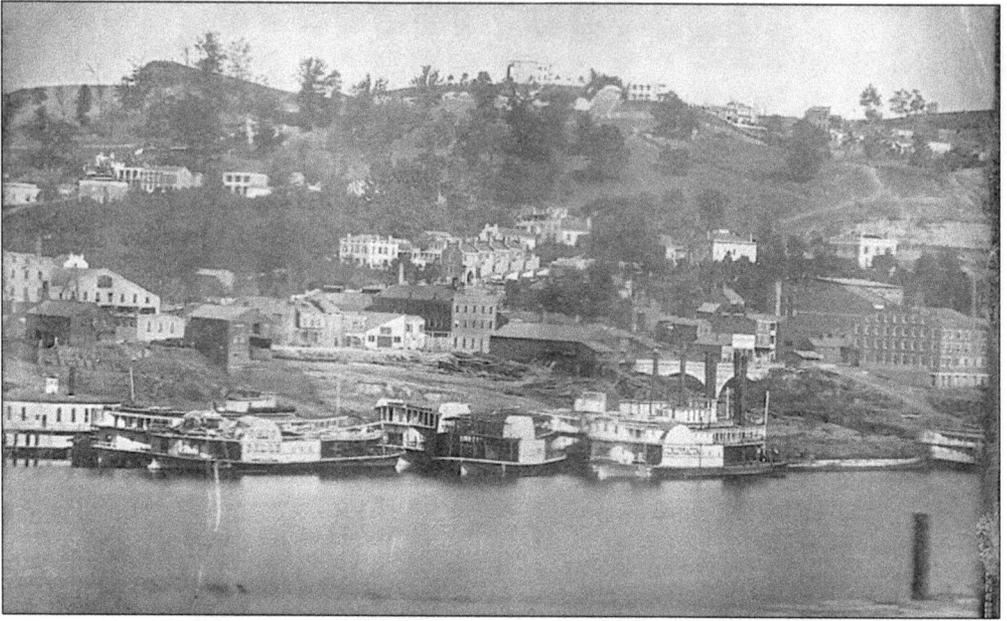

The bridge in the right foreground crosses the Miami and Erie Canal at its terminus with the Ohio River. Ten stone locks, completed in 1834, ascended 110 feet in elevation to Lockport basin in downtown Cincinnati. These 10 locks were rarely used by boaters, who opted to offload their freight at the basin rather than spend the time and tolls necessary in locking down to the river. (Courtesy of the Canal Society of Ohio.)

Bicentennial Commons Park, at Cincinnati's riverfront, commemorates Cincinnati's founding in 1788. The brick structure shown here is an artist's concept of the canal lock that would have sat at this very spot until the staircase of 10 locks was abandoned by the state in March 1863. After 1863, navigation on the canal would terminate at the Lockport basin. (Courtesy of Boone Triplett.)

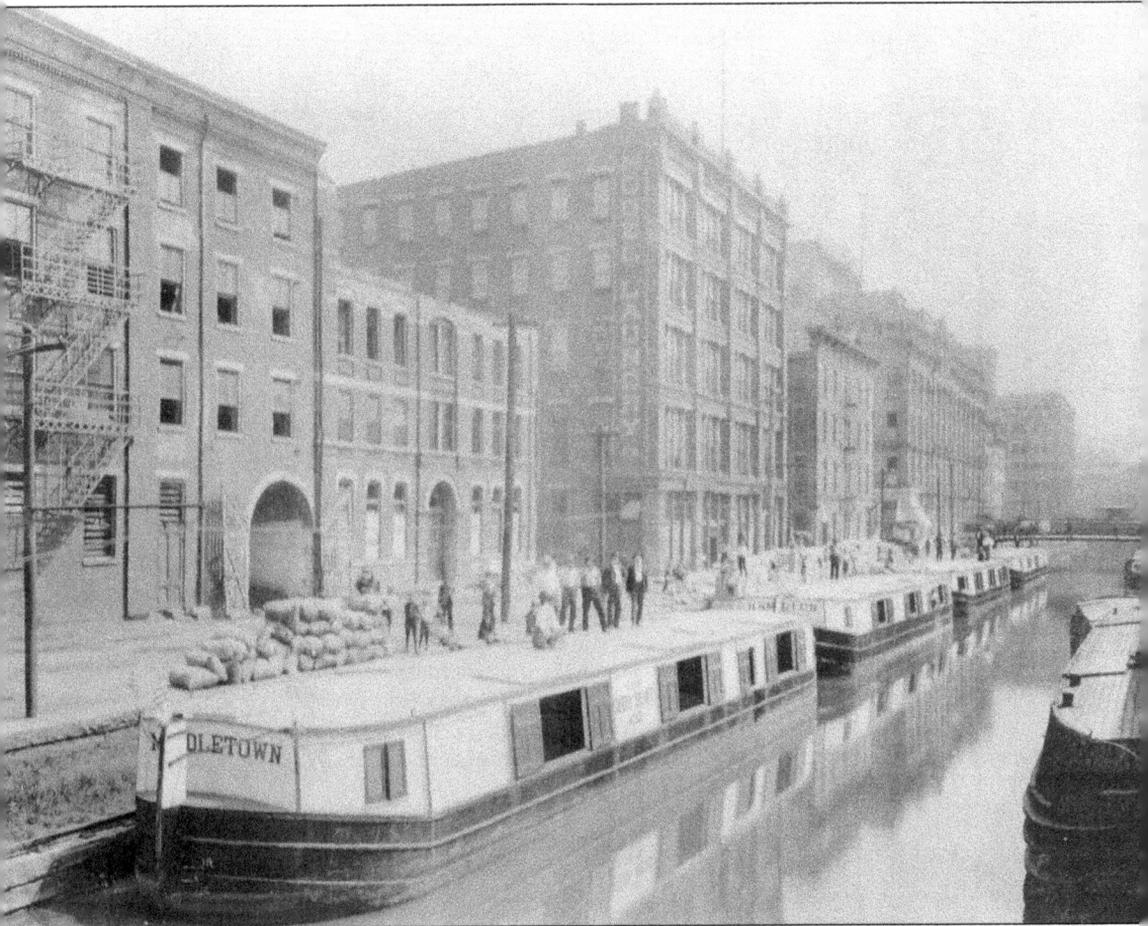

The Ohio Boat Company was owned and operated by the Fox Paper Company. This c. 1905 photograph shows a portion of the company's fleet docked in Cincinnati, near the canal's southern terminus. The boats were steel-hulled and were powered by locally manufactured Carlisle & Finch inboard gasoline engines. The Ohio Boat Company fleet made daily trips between Cincinnati, Hamilton, Middletown, and Dayton. Fox initially operated two boats, the *Ajax* and the *Monitor*, which shuttled product between Hamilton and Middletown. Later boats added to their fleet were named after canal towns along their expanded route: Dayton, West Carrollton, Miamisburg, Hamilton, Middletown, and Lockland. Fox Paper was one of the last commercial boat operators on the Miami and Erie Canal. (Courtesy of David Neuhardt.)

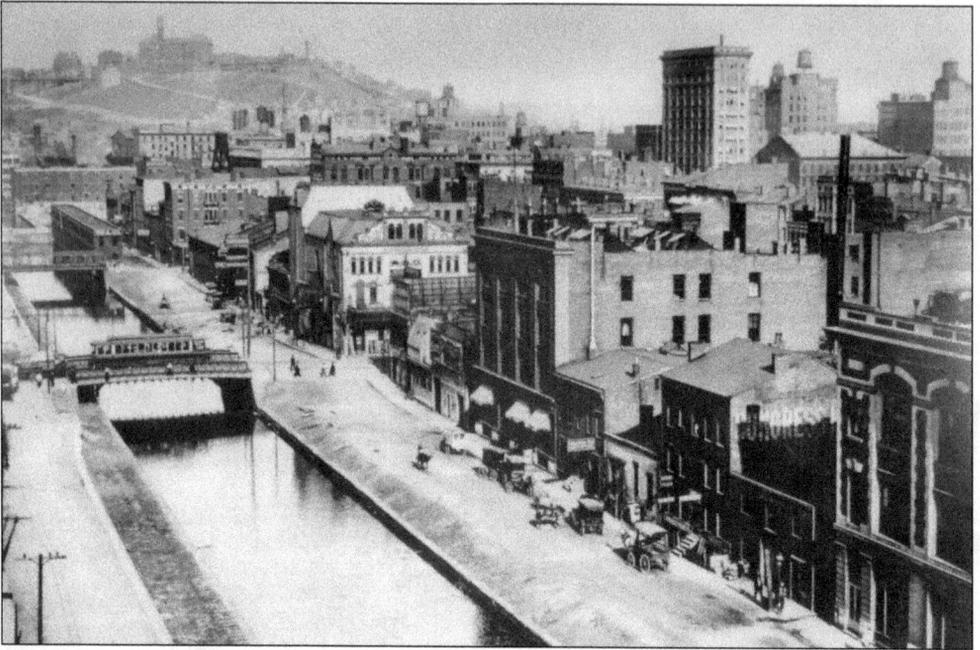

The Miami and Erie Canal runs parallel with Main Street in this c. 1910 photograph. A streetcar is shown crossing the Vine Street Bridge. Streetcars began operation in Cincinnati in 1888. At their peak, there were over 250 miles of track servicing the city and its nearby suburbs. Operation ceased in 1951. Holy Cross Monastery crowns Mount Adams in the distance. (Courtesy of the Frank Wilmes collection.)

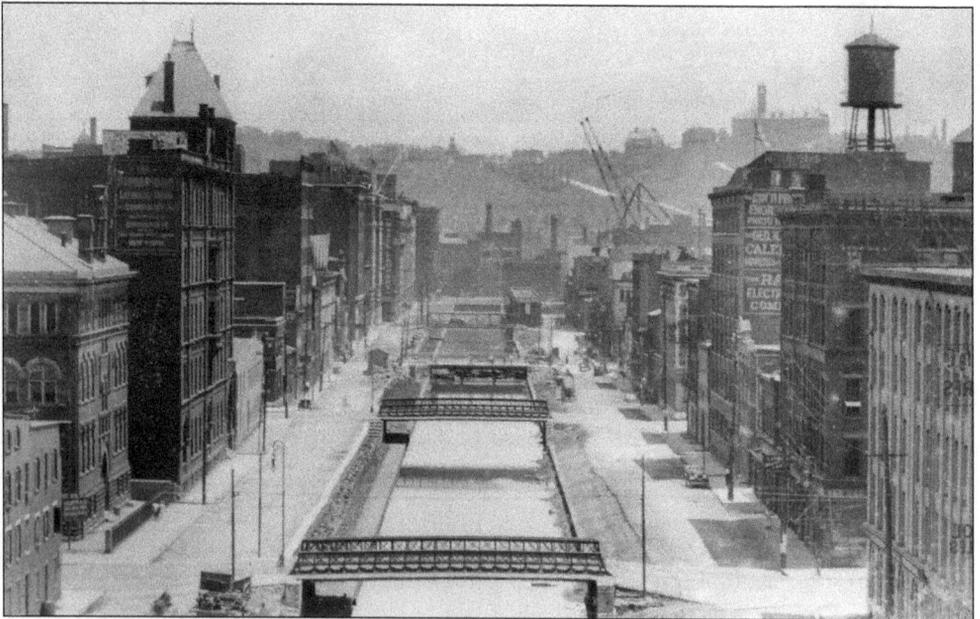

This 1915 photograph shows the Miami and Erie Canal flanked by Canal Street (present-day Central Parkway). The three-story Rashig School is to the near left. Cranes are shown building the Hamilton County Courthouse in the background. The tall building advertises the Cincinnati Process Engraving Company and the Rapid Electrotype Company. (Courtesy of the Frank Wilmes collection.)

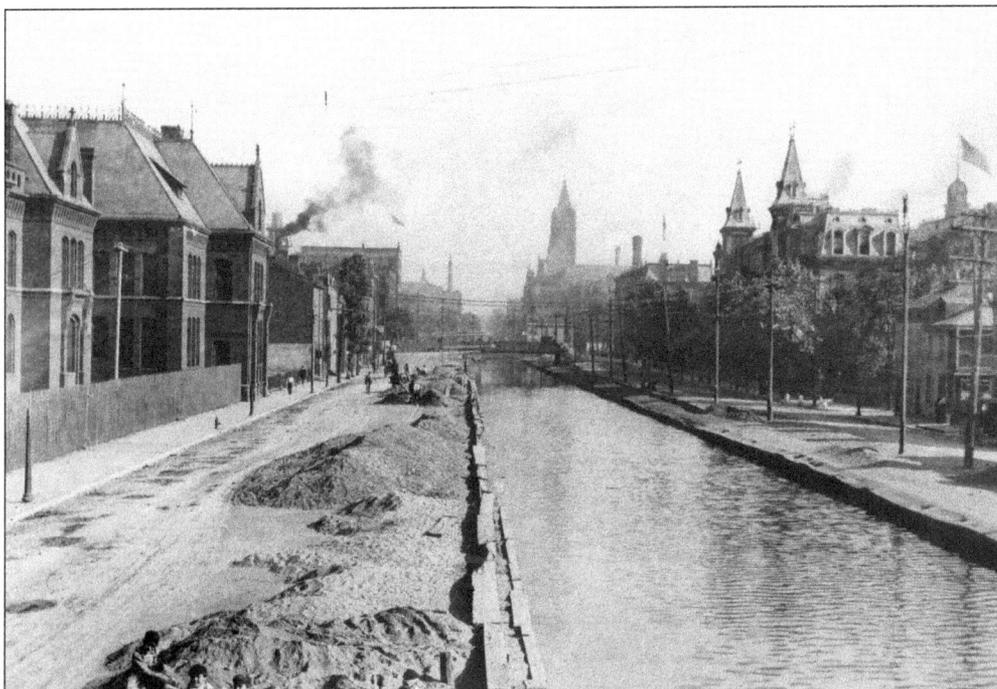

Looking south from the Fourteenth Street Bridge, the Cincinnati Music Hall is on the left in this 1900 photograph. The twin-towered Cincinnati Commercial Hospital/Insane Asylum is on the right, and the Cincinnati City Hall is the tall spire structure in the background. (Courtesy of the Frank Wilmes collection.)

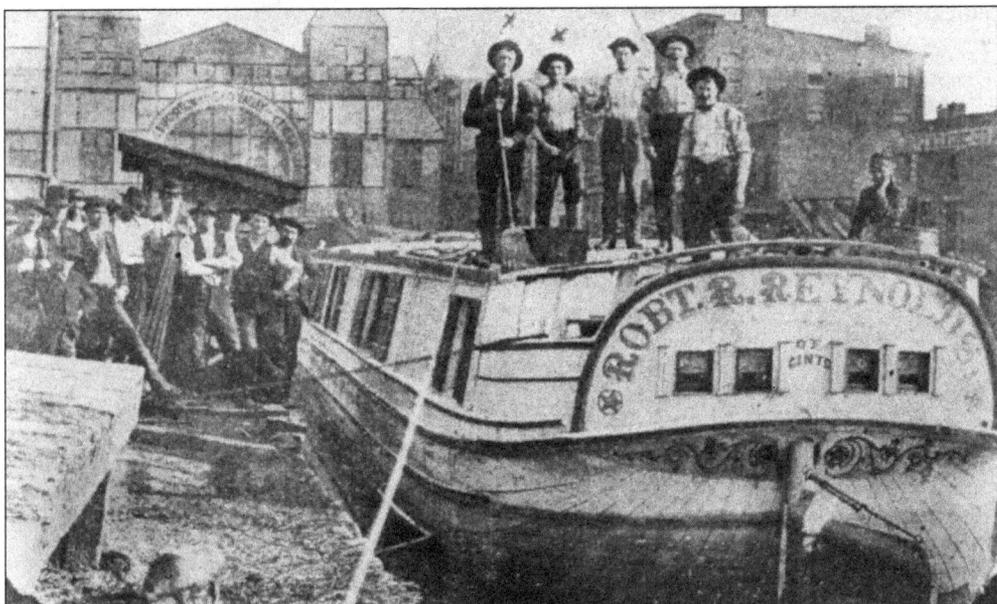

The *Robert R. Reynolds* was a Cincinnati-registered ice hauler. It is berthed outside of Machinery Hall in this 1888 image. Machinery Hall was built that year for the Cincinnati Centennial Exposition. Built over the canal, the hall was three city blocks long and 150 feet wide where it adjoined with the Music Hall. (Courtesy of the Canal Society of Ohio.)

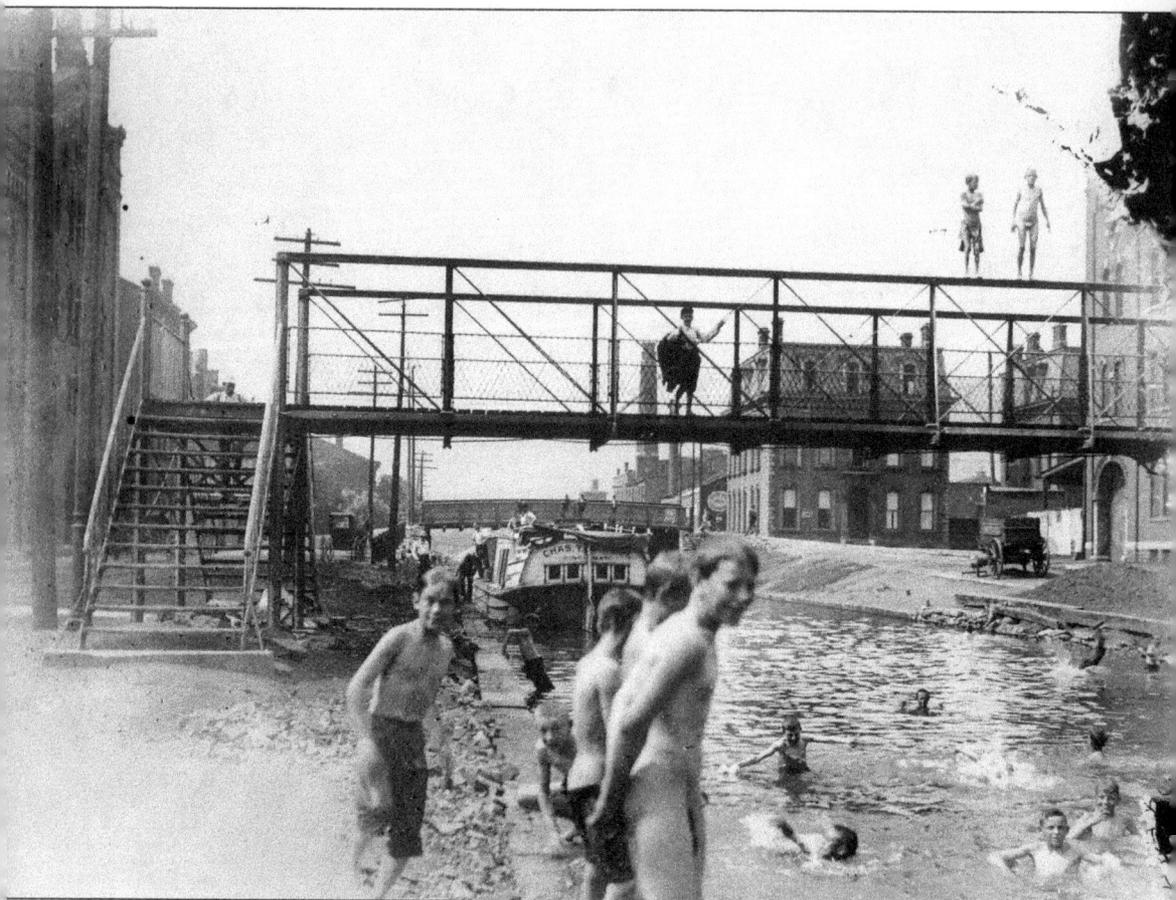

These skinny-dippers are shown at the Wade Street Bridge "swimming hole" in Cincinnati's Over-the-Rhine district. Swimming in the canal was illegal, and police often had to chase children away. The pollutants in canal water were appalling and posed a serious health risk. Rotting animal carcasses floating along the waterway were not an uncommon sight. Nevertheless, these children retained fond memories of the canal into adulthood. When the canal in Cincinnati was paved over in the mid-1920s, the Canal Swimmers Society was founded by a *Times-Star* newspaper columnist. Anyone who had swum the canal was eligible for membership. Former president and later Supreme Court chief justice William Howard Taft became an early and prominent member of the society. (Courtesy of the Frank Wilmes collection.)

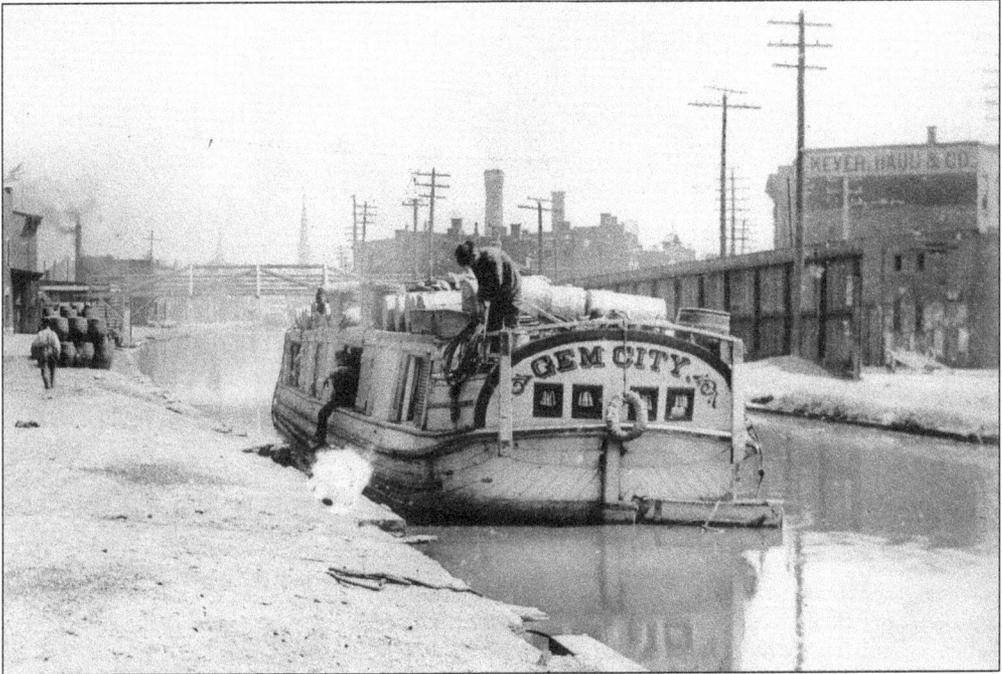

The steam-powered *Gem City* was registered in Dayton in 1883. Boat owners hoped to remain competitive by replacing workers and animals with steam engines. These boats usually exceeded the canal's strict four-mile-per-hour speed limit, resulting in damaging wave action on the banks. The boat is shown north of the Mohawk Bridge in the c. 1900 photograph above. This bridge was replaced by an iron lift bridge in 1909. The photograph below shows another freighter heading south at the same spot. Keyer, Haug & Co. operated a planing mill and furniture business in this area. (Both, courtesy of the Frank Wilmes collection.)

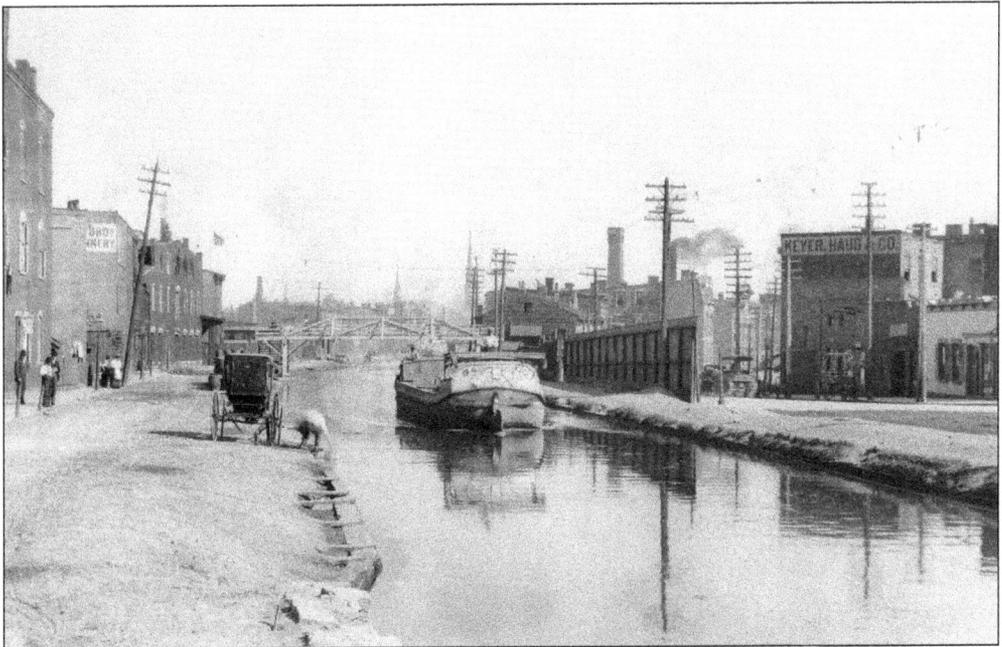

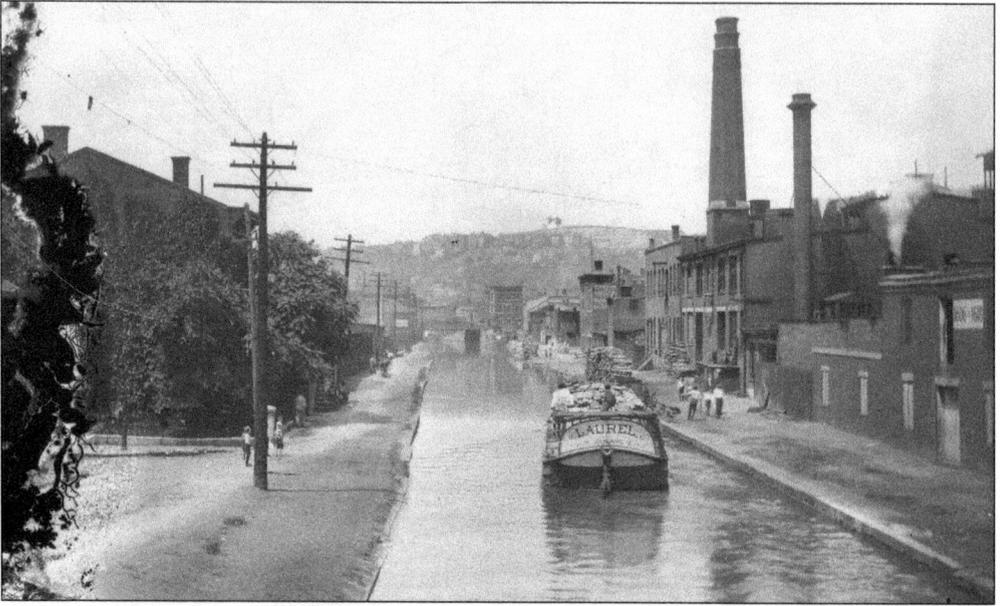

These are several images of boats in the Mohawk area of Cincinnati. Above, the *Laurel of Lockland* is headed north after having off-loaded its freight. Both photographs appear to have been taken from the Mohawk Street Bridge. The Findlay Street Bridge is in the background. The Mohawk neighborhood was home to numerous pork packinghouses, tanneries, and several breweries. Pork processing was big business in Cincinnati throughout the 19th and 20th centuries. The Queen City even earned the not-so-flattering nickname of "Porkopolis." Many a visitor to the city would be amazed or possibly appalled by the sight of hogs being driven down the streets on their way to the slaughterhouses. (Both, courtesy of the Frank Wilmes collection.)

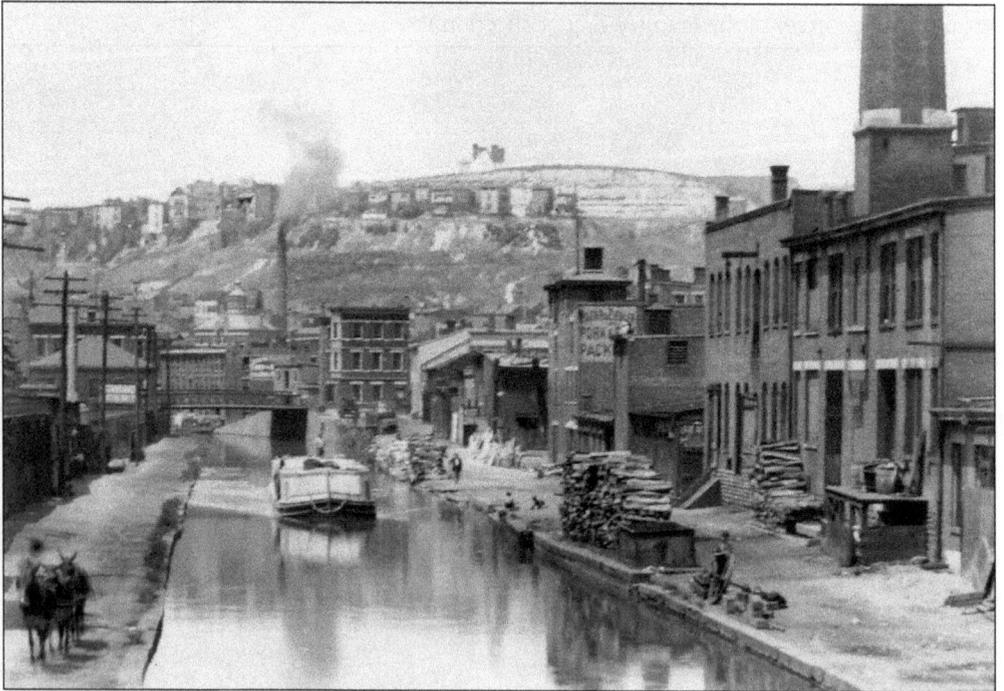

The canal took a bend just past the Mohawk Bridge. The Fairview incline is shown above in the distance. Cincinnati had five inclines to allow access from the city to the communities built atop its surrounding hills. These inclines ranged from 650 feet to 1,000 feet in length and pulled their cars up an elevation of close to 300 feet. All of the inclines, with the exception of Fairview, had pleasure palaces built at their summits. These establishments offered up a great view of the city below, as well as theater, concerts, bowling, carnivals, dining, and alcoholic beverages, depending on which one was visited. The photograph at right shows the notable roundhouse located near the base of the Fairview incline. (Both, courtesy of the Frank Wilmes collection.)

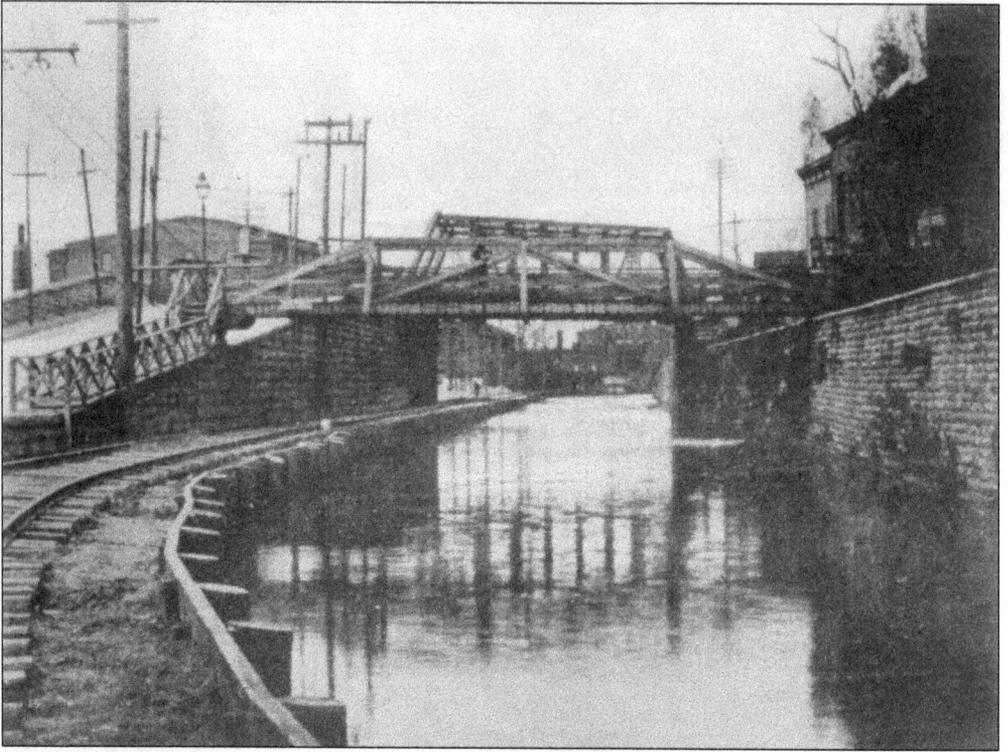

The Miami and Erie Canal Transportation Company obtained a state charter in 1900 to run 68 miles of track between Cincinnati and Dayton. The plan was to have up to 10 freight boats towed by a single electric engine, thereby eliminating labor and animal care expenses. This modernization scheme failed in less than two years, and the only thing eliminated were its investors' bank accounts. The photograph above shows the tracks for the ill-fated electric mule passing tightly beneath a hump, or high bridge, in the Brighton neighborhood. The image below displays one of the 55,000-pound towing engines. (Both, courtesy of the Canal Society of Ohio.)

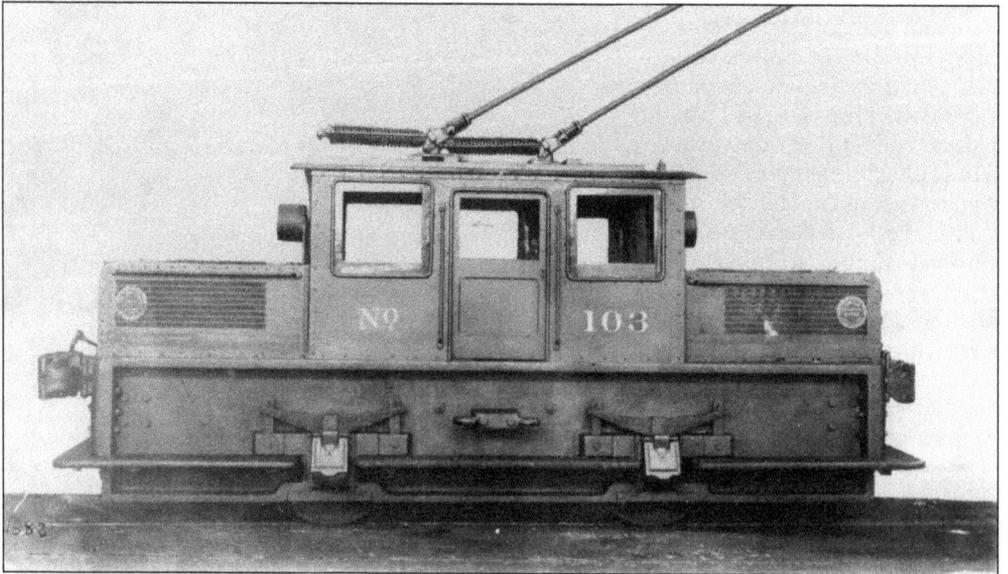

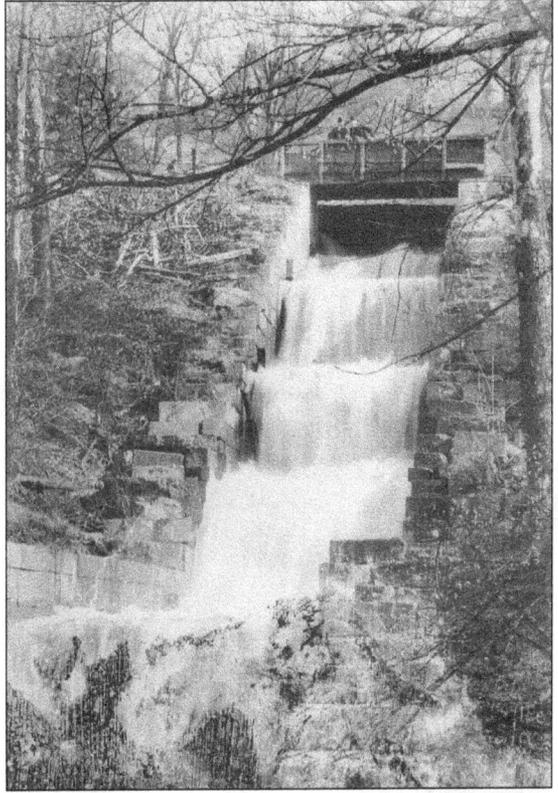

Waste weirs were necessary in the shedding of excess water. The Clifton waste weir (right) was located on a stretch of canal that was cut into a hillside above Mill Creek. Small streams flowed into the canal, and this weir protected the canal banks from damaging high water levels. Two men stand on the towpath bridge, below the Scarlet Oaks Hospital. The photograph below shows a very pastoral view of the canal in this same Clifton area. There were several wide basins along this stretch that doubled as ice ponds in the winter season. (Both, courtesy of the Frank Wilmes collection.)

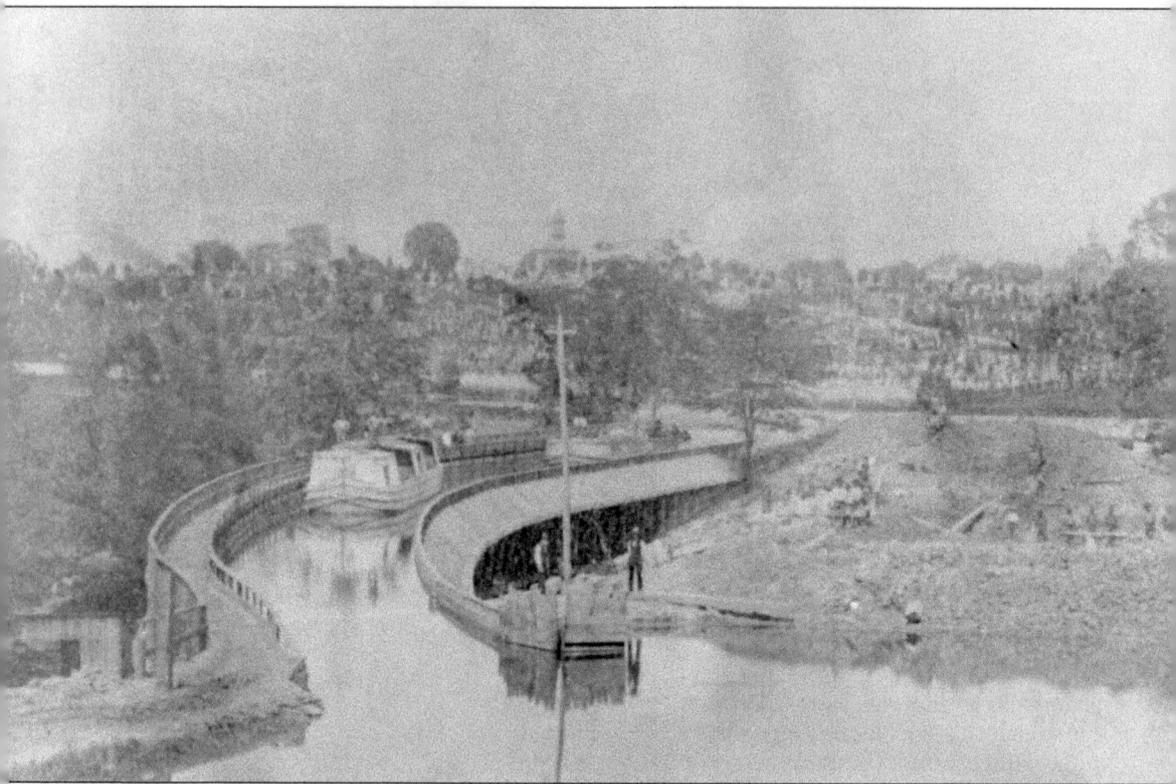

When the Miami and Erie Canal was carved through the Mill Creek valley bluffs of Hamilton County in the late 1820s, the engineers used fill from their excavations to bridge a ravine. By the 1870s, several small hamlets sprung up on the east side of the canal in this area. The nearest bridge over the canal was four miles distant, so the City of Cincinnati paid for the construction of a road tunnel beneath the canal in 1877. The Mitchell Avenue tunnel failed in 1883. A contemporary news account hyperbolically compared its collapse and the resulting water damage to the Johnstown flood. This 1883 photograph shows a unique S-shaped temporary aqueduct put in place while the road tunnel and causeway were rebuilt. The St. John Catholic Cemetery is shown on the hillside in the background. The replacement culvert was itself replaced with a steel-framed aqueduct that remained in place until the canal's abandonment in 1920. (Courtesy of Bob Mueller.)

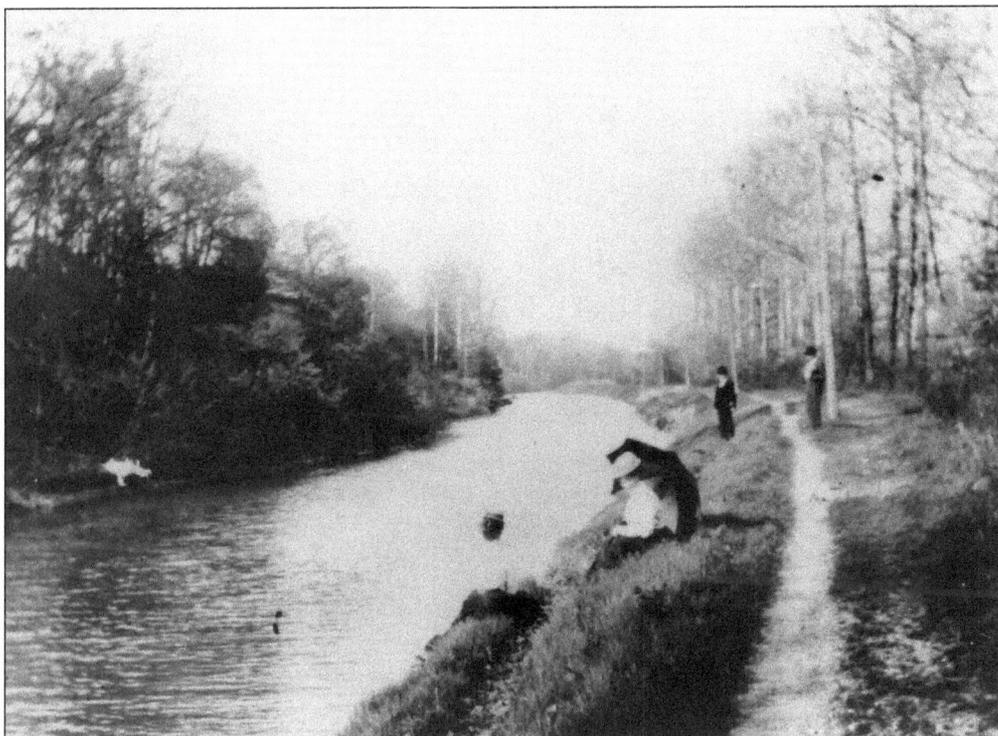

These images show a section just north of the Mitchell Avenue Aqueduct, where the canal was carved into a hillside as it approached the village of Saint Bernard. The photograph above shows this stretch of canal to be quite scenic and a nice place to take an afternoon stroll. The photograph below of this same area dates to approximately 1905 and shows the towing mule team stumbling along tracks laid by the "Electric Mule" company. The state mandated that the rail ties be made level with soil or gravel. This order was ignored, however, and the mules and their handlers needed to tread carefully to avoid injury. (Both, courtesy of the Canal Society of Ohio.)

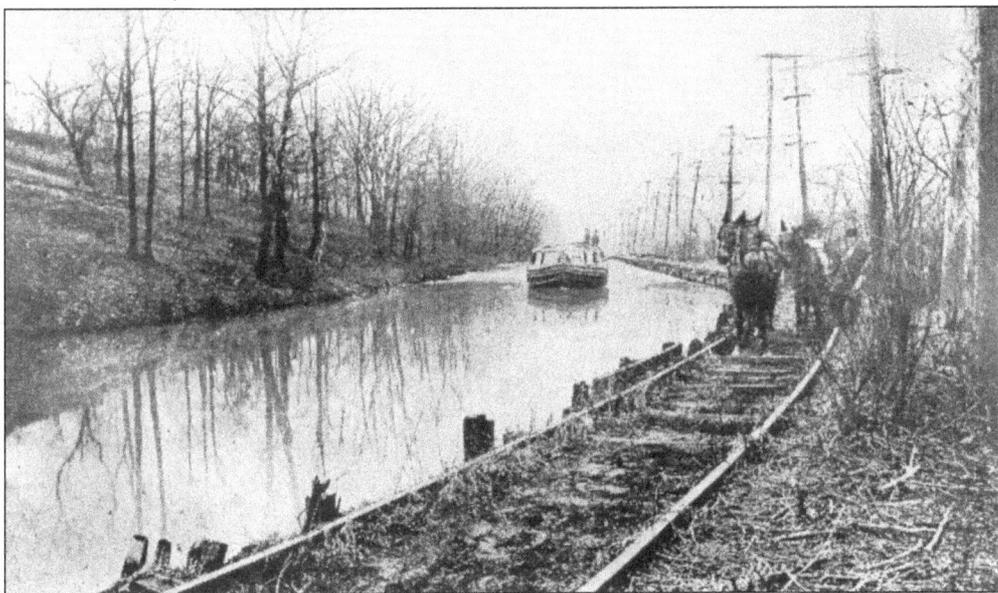

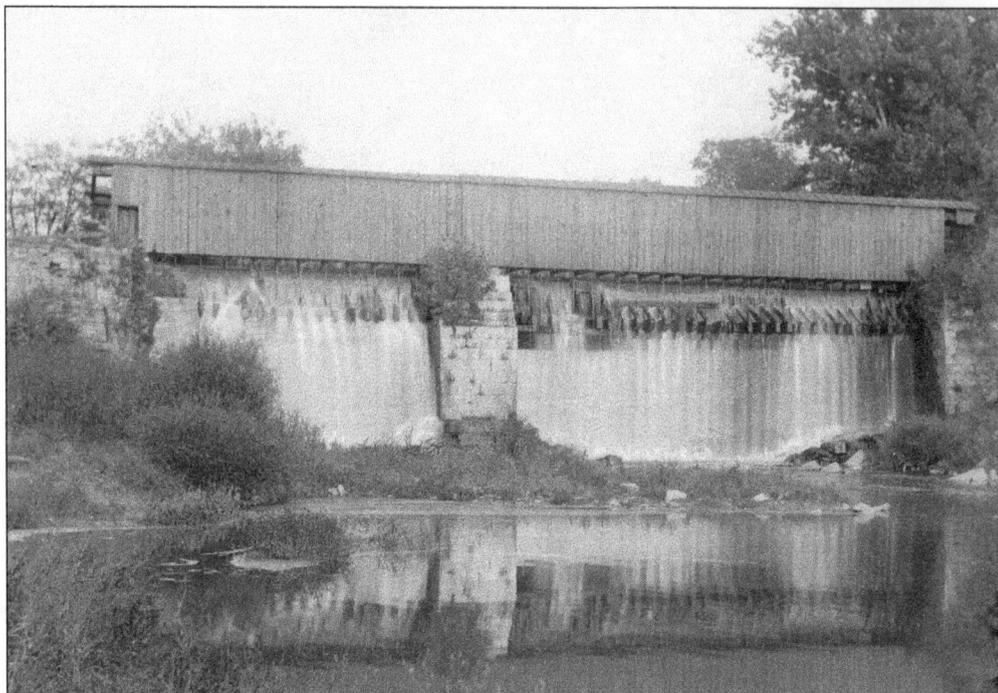

The canal crossed over Mill Creek on a 111-foot, covered, wooden-troughed aqueduct between the towns of Carthage and Hartwell. Hartwell's basin was located just north of the aqueduct. The large Hartwell basin was the temporary northern terminus of the Miami Canal from 1827 to 1828. The aqueduct was replaced with an open-troughed steel aqueduct and mule trestle in the early 20th century, as shown in the photograph below, dated 1916. Note the pile of stone blocks cast aside from an earlier renovation. (Above, courtesy of the Frank Wilmes collection; below, courtesy of the Canal Society of Ohio.)

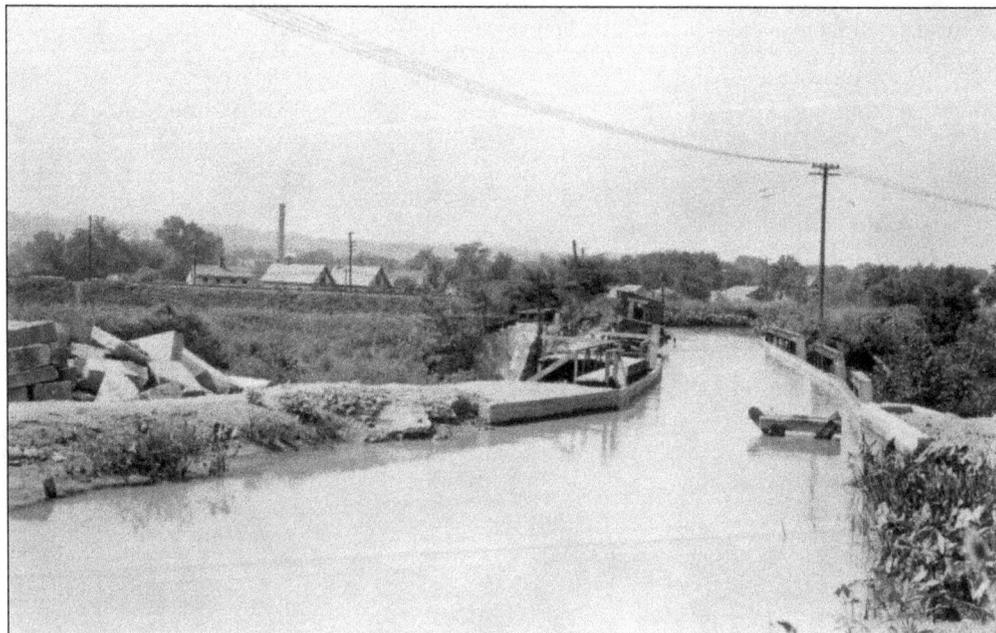

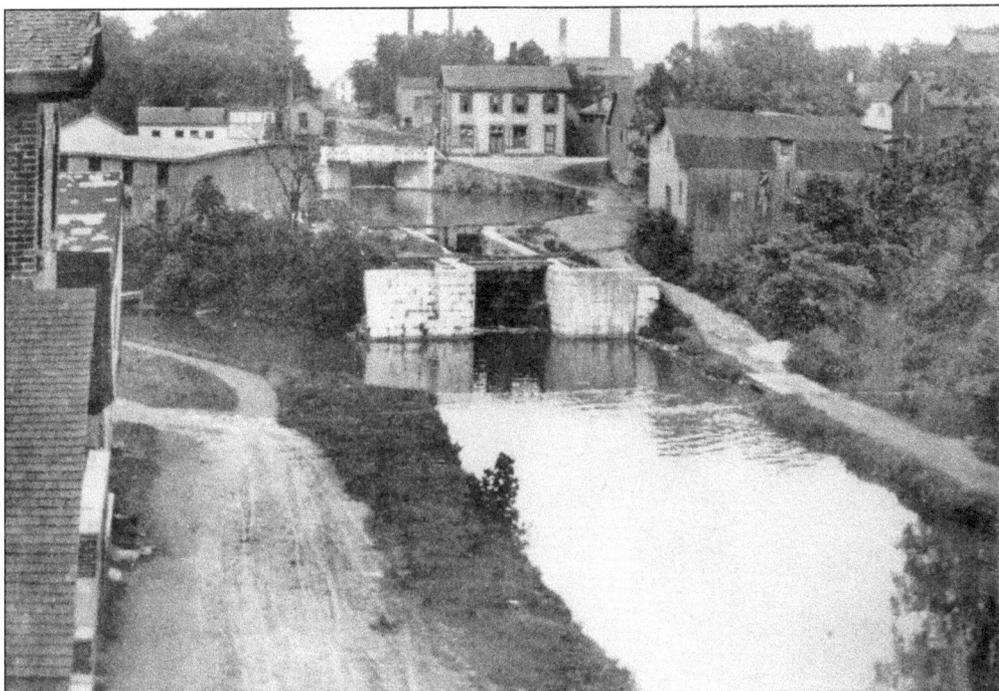

Above is a 1900 view of Locks 42s and 41s in Lockland. Lockland was platted in 1828 by Nicholas Longworth and Lewis Howell. A plentiful supply of cheap waterpower was supplied by millraces at four locks within the town's limits. In its late-19th-century heyday, this 48-foot fall of canal water powered at least four paper mills, several lumber mills, a starch works, and a roofing material manufacturer through a convoluted system of aboveground and subterranean millraces. Lock 40s is shown below. The lock tender for Lockland resided in the house to the right of the lock. (Both, courtesy of the Canal Society of Ohio.)

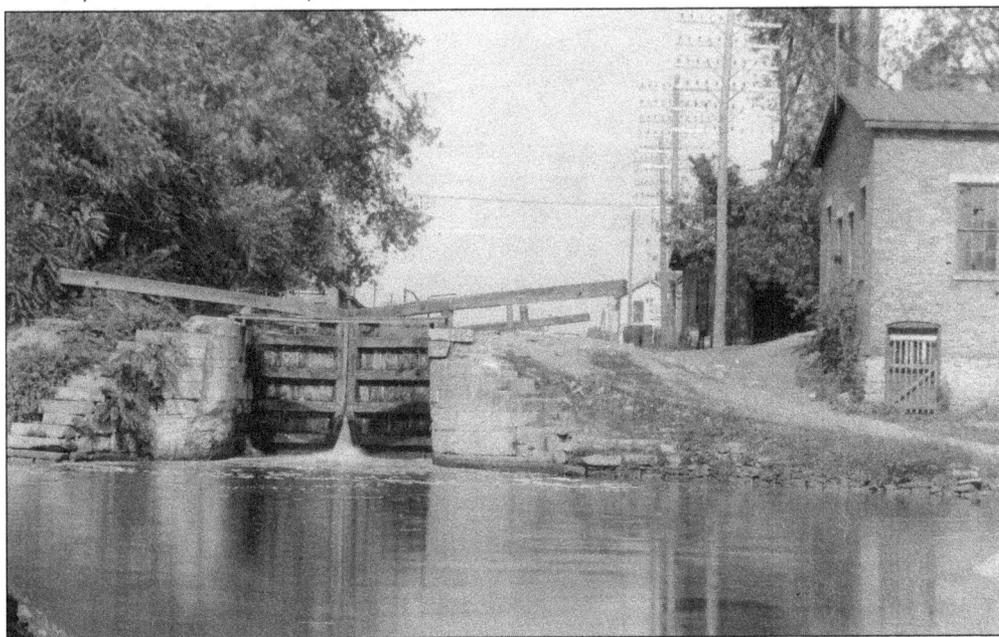

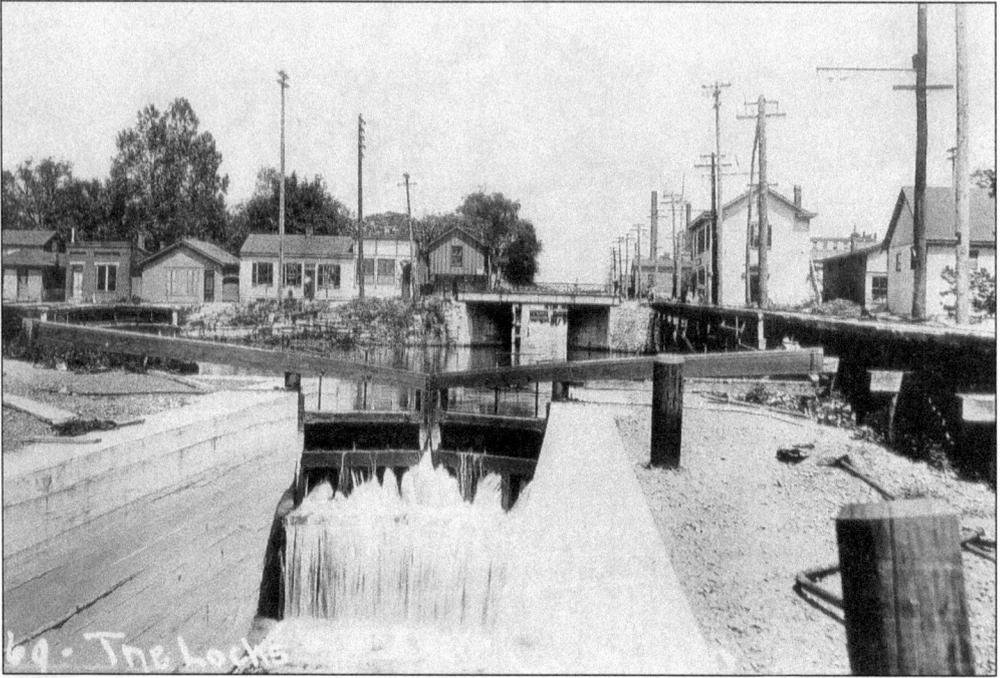

The photograph above shows Locks 43s and 42s. The "s" suffix indicates that these were the 42nd and 43rd locks south of the canal's summit in Shelby County. Locks north of the summit had an "n" after their number. Note the "electric mule" rail trestle that paralleled the canal to the right. The image below shows Lock 41s at the Lockland basin in the late 1880s. Note the small wooden bridge over a mill tailrace at lower right. (Above, courtesy of David Neuhardt; below, courtesy of the Midpointe Library of Middletown.)

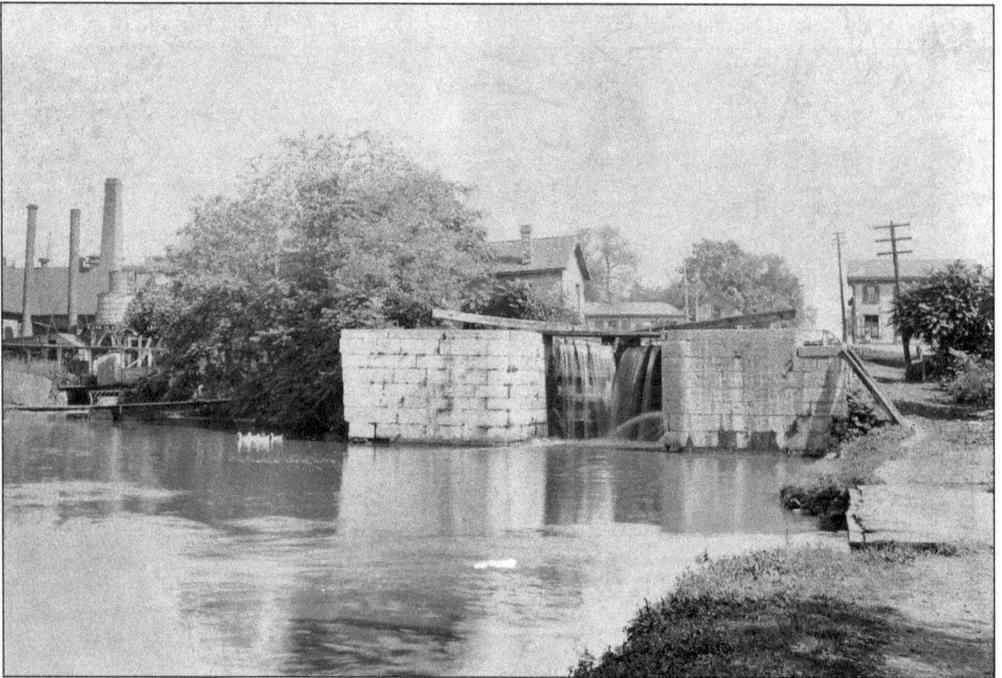

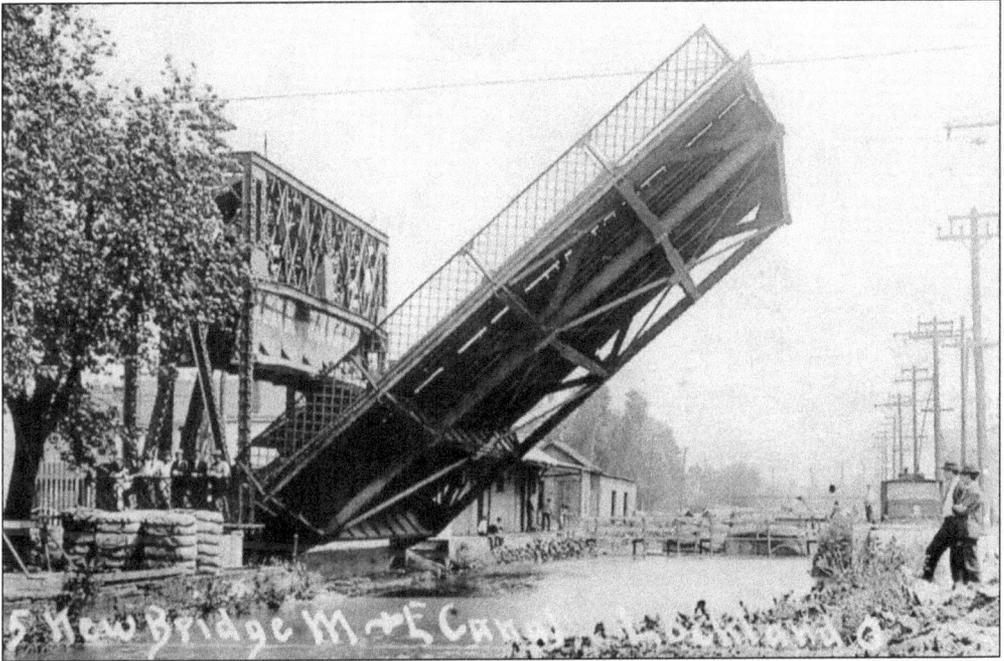

Several bridges were needed to cross the canal in Lockland. This image shows the "new" Benson Street lift bridge. This was an uncommon style of bridge over a canal. Most bridges were of the high/hump or swing styles in the canal's earlier years. The more expensive hoist-and-draw bridges were installed in urban areas during the canal's twilight years. (Courtesy of David Neuhardt.)

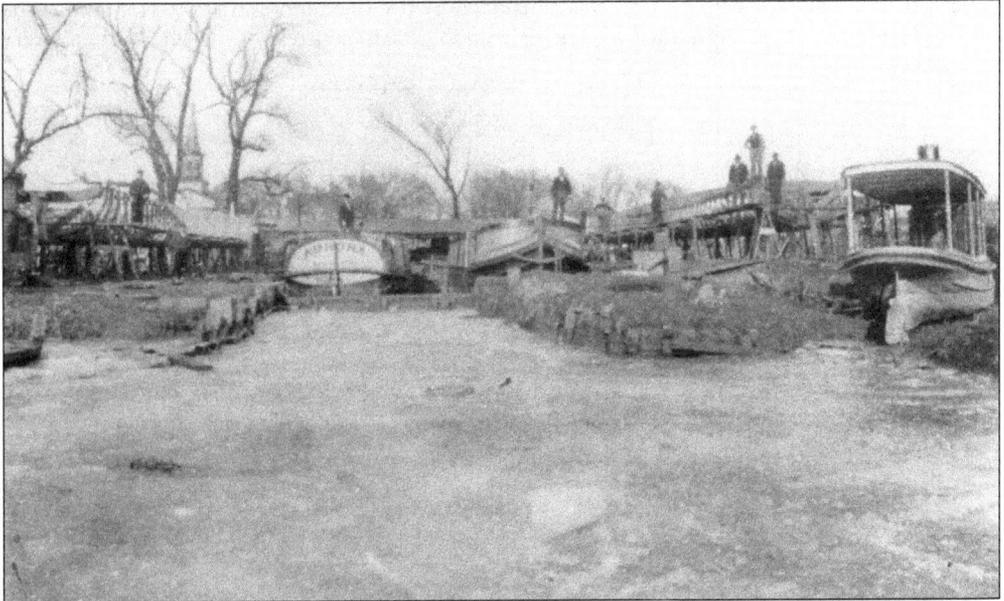

Lockland's dry dock, seen here around 1900, was one of the busiest on the canal. The *Aurora* would have been steered into the dry dock chamber, after which the water would have been drained, leaving the craft to rest on a wooden cradle. Canal boats, like automobiles, required periodic maintenance. The hull of the *Aurora* likely needed re-caulking or replacement of decayed sections. (Courtesy of the Canal Society of Ohio.)

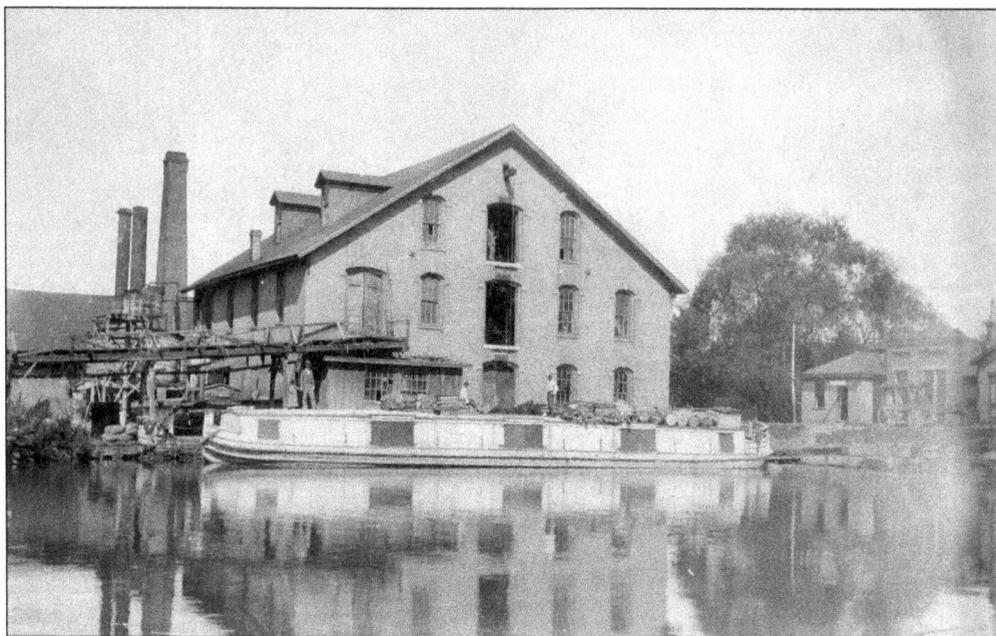

Lockland's first canal-powered gristmill was built by C.W. Friend shortly after the opening of the Miami Canal. Friend soon partnered with George B. Fox, and the mill was converted to the production of paper in 1835. The firm was later incorporated as the Fox Paper Company in 1894. The image above shows the mill building before it burned down in 1873. The image below shows the replacement mill. This mill had a stated capacity of 5,000 pounds of "book-grade" paper per day. The replacement mill was consumed by fire once more in 1909. Fox rebuilt the mill and remained in business until its closing in 1988. (Both, courtesy of the Midpointe Library of Middletown.)

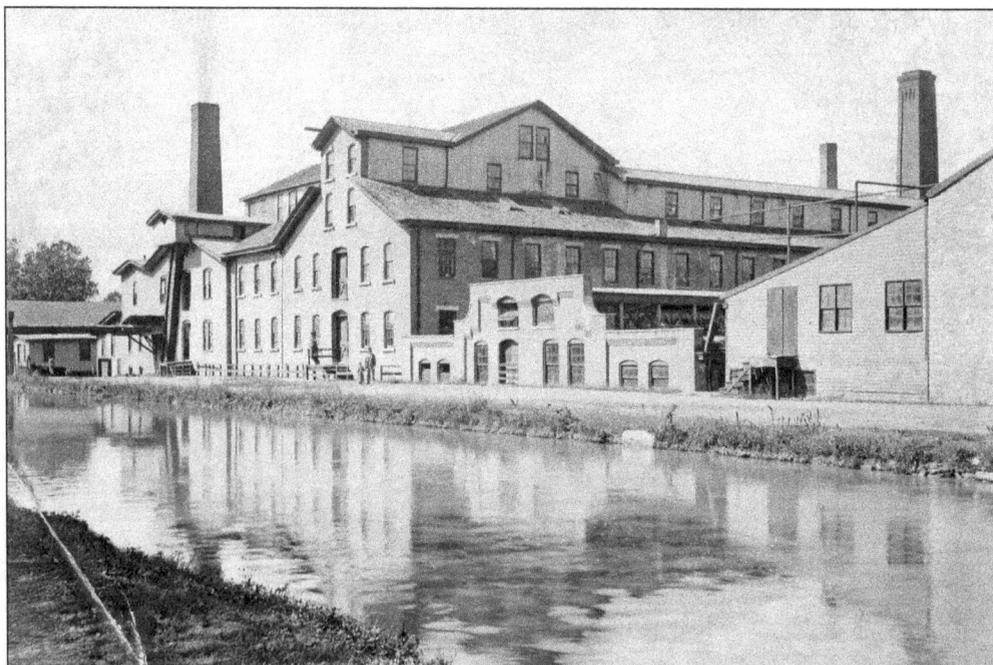

The hump/high Glendale–Milford Road Bridge crossed the canal two miles north of Lockland. The Oak Road Bridge can be seen in the far distance. Hump bridges were favored on the less-traveled crossings of the canal due to their lower cost. A wagon would need to build up a "head of steam" to get over the hump. This would have been more difficult, as well as dangerous, in the more congested urban sections of the canal. Confederate general John Hunt Morgan's highly publicized 1863 incursion through Indiana and Ohio crossed the canal at this point as Morgan headed east towards his ultimate capture at West Point, Ohio, in July of that year. While Morgan's raiding party did no significant damage on the Miami and Erie Canal, it did wreak havoc at crossings of both the Ohio and Erie Canal and the Hocking Canal. (Courtesy of the Frank Wilmes collection.)

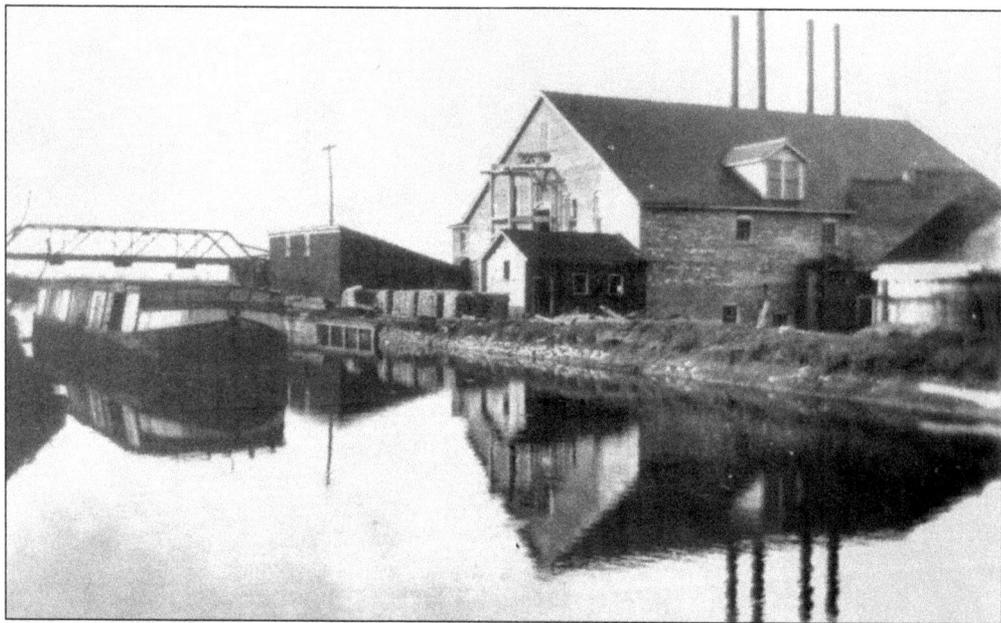

The Fox Paper Company's Crescentville mill straddled the border between Hamilton and Butler Counties. The Crescent Mill, as it was known, was built in 1869. It was powered by the fall of water at Lock 39s. Roofing and wrapping materials were the primary items produced at this mill. In 1875, it had a capacity of 6,000 pounds per day. The mill shown in the c. 1890 photograph above burned down in the mid-1890s. It was rebuilt and upgraded to electric and steam power. Its manufacturing capacity rose to 40,000 pounds per day by 1905 as a result of the update in technology. The Crescent Mill continued in operation into the late 1920s, when it once again succumbed to flames and was not rebuilt. The photograph below was taken in 1890. The land between the child and the mill in the background is now occupied by Interstate 75. (Above, courtesy of Darrin Upps; below, courtesy of the Butler County Historical Society.)

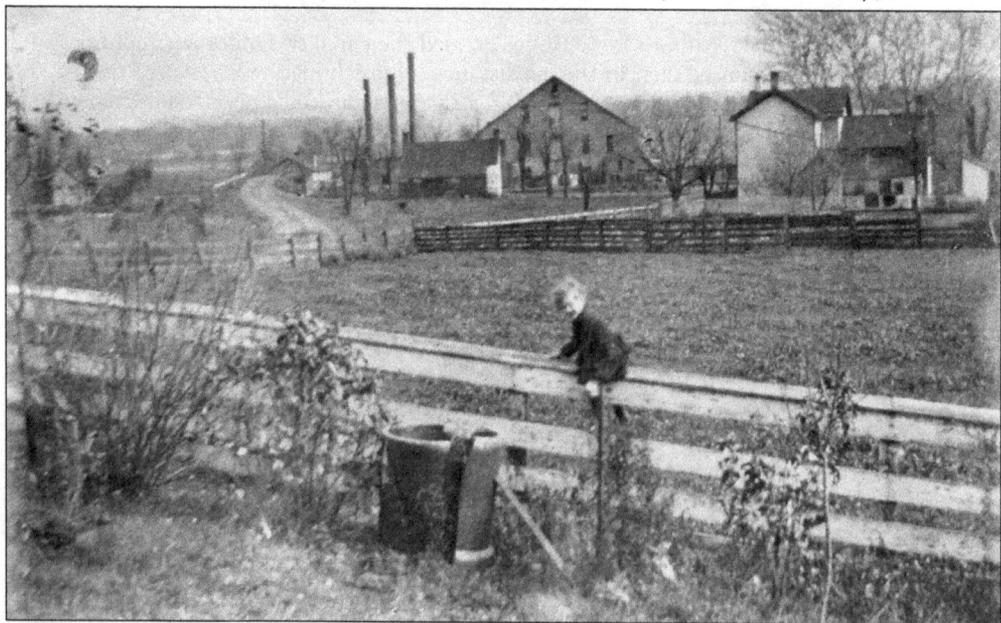

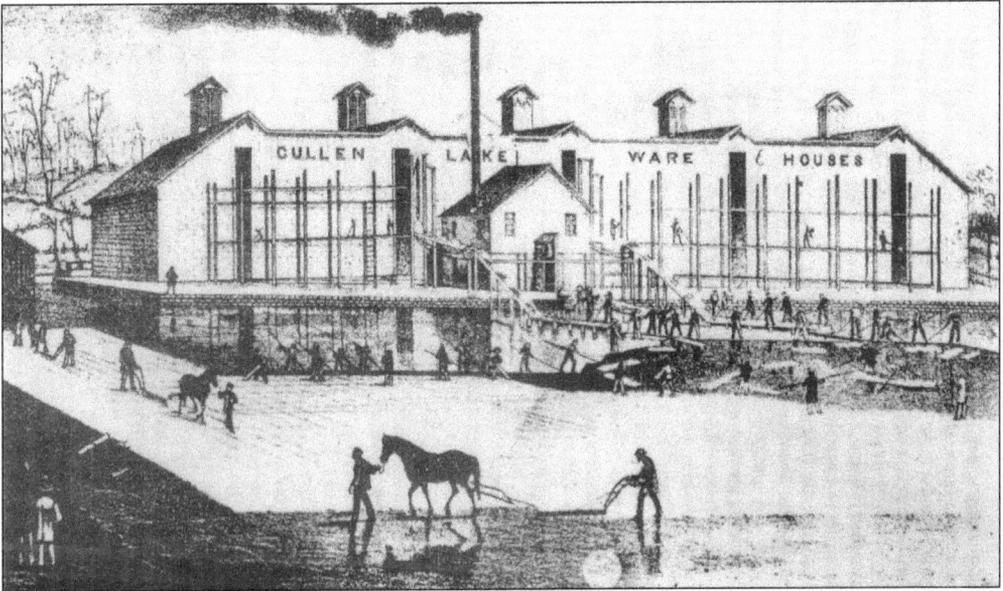

The harvesting and transport of ice to market was one of the chief sources of revenue on the canal in the latter part of the 19th century. The Cullen Ice Company was one of the larger operations in Butler County. The Cullen ice storage barn had a footprint of roughly 200 feet by 280 feet and held up to 20,000 tons of ice. The State Board of Public Works allowed the drawing off of water for these ponds at no cost and subsidized the building of ice freighters in a futile effort to keep toll-paying customers on the waterway in the late 1890s. With the introduction of artificial refrigeration in the early 20th century, the Cullen Pond acreage was converted into a private hunting preserve. The photograph below shows an ice freighter ready to take in a load of ice beneath a drop-down bridge. Freight would be lowered through a trapdoor in the bridge floor. Note the ice barn and pond in the background. (Above, courtesy of Midpoint Library of Middletown; below, courtesy of the Frank Wilmes collection.)

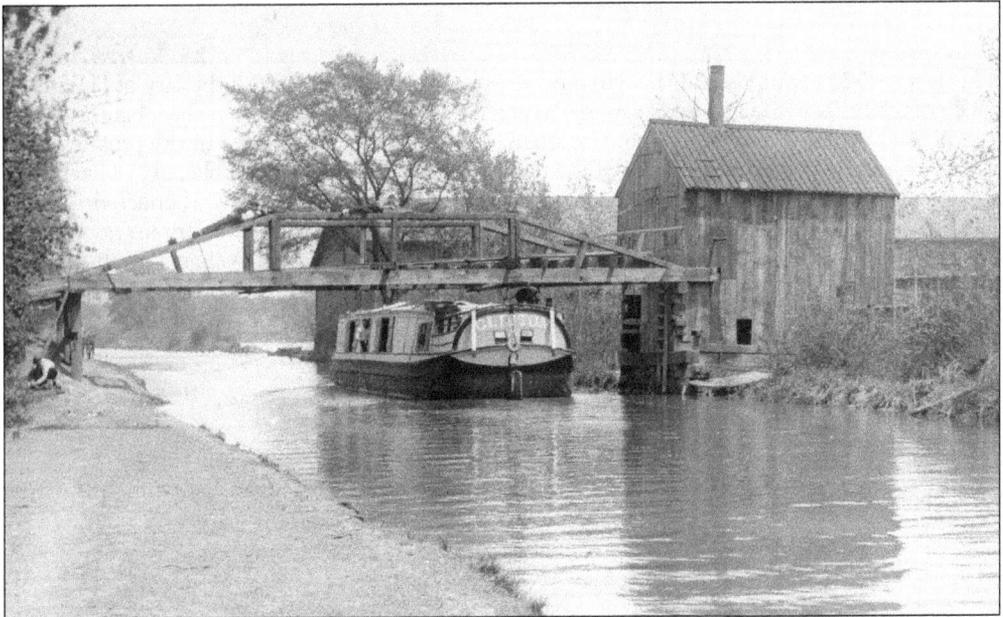

This is a c. 1920 aerial view of the canal on its southeastern approach to the city of Hamilton. Much of the cultivated acreage adjacent to the canal was owned by Cincinnati's beer barons. Barley and hops grown on these lands would be shipped south by canal and used in the production of beer. After the harvest season, some of the fields were flooded and did double duty as ice ponds. When the 18th Amendment prohibiting the sale of alcoholic beverages was enacted in 1919, Cincinnati had 26 operating breweries. Not surprisingly given its heavily German population, the vote in Hamilton County was four-to-one against the amendment. When Prohibition was repealed in 1933, only a handful of these breweries resumed business. (Courtesy of the Canal Society of Ohio.)

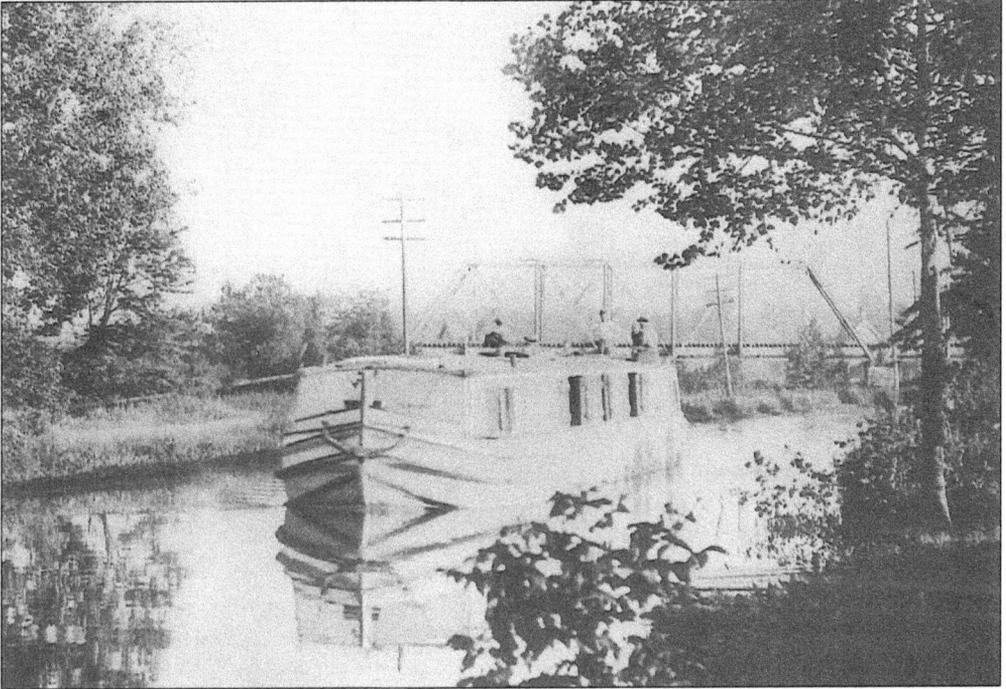

The photograph above shows a canal freighter passing the Pennsylvania Railroad trestle near Hamilton. Established well before the arrival of the Miami & Erie Canal, Hamilton was founded as Fort Hamilton in 1791 by Israel Ludlow. The town already had a population of over 600 when the canal came through its eastern outskirts in the late 1820s. The photograph below shows the Smith Brothers ice pond and barn. Smith Brothers was located north of High Street in Hamilton. A canal ice freighter is docked next to the barn and likely taking on a load of ice. (Both, courtesy of the Butler County Historical Society.)

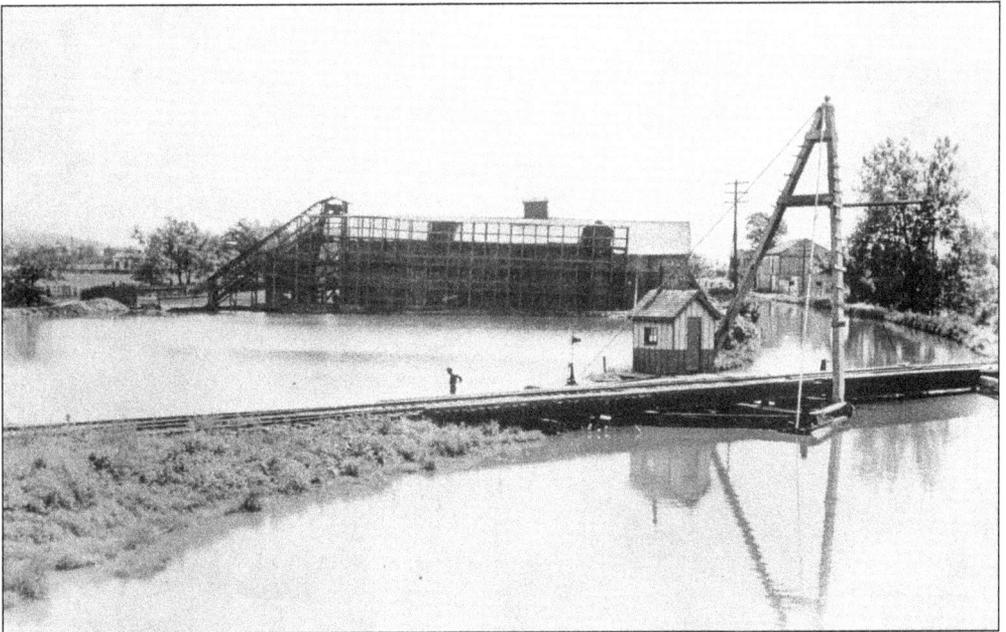

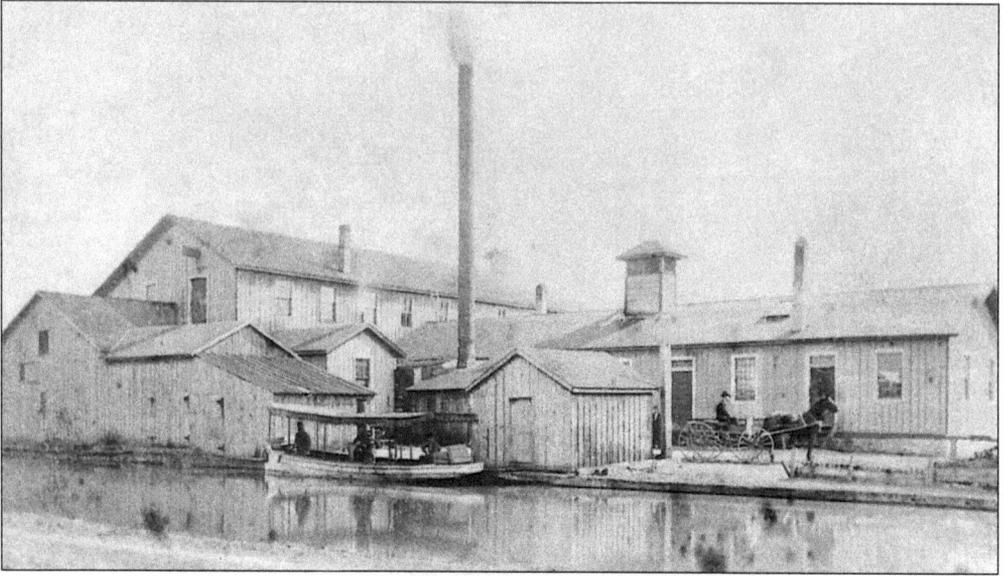

Hamilton was home to several milling operations established adjacent to the canal, including the W.B. Browne & Company Corn Mill at Lock 37s and the Louis Snider & Sons Paper Mill (above) at Lock 36s. Snider, a German immigrant, established the mill in 1868. Its primary product was newsprint. The undated photograph below shows Lock 36s before its concrete refurbishment in 1909. The Snider Mill property was later occupied by an assembly plant for the Republic Auto Company from 1911 to 1914. Republic then built a new facility nearby, but the company failed sometime prior to 1920. (Both, courtesy of the Butler County Historical Society.)

Upon exiting Hamilton, the canal closely paralleled both the Hamilton Hydraulic Canal and the Great Miami River for several miles. The Hydraulic was fed by waters impounded by a wooden-cribbed dam on the Great Miami and powered many of the industrial plants in Hamilton. This photograph shows another of the stone regulating weirs north of Hamilton. This stone construction protected the banks of the Miami and Erie Canal through the shedding of superfluous waters that poured into the canal from hillside streams into the adjacent river. Once the canal passed the Hydraulic Canal's dam, it closely followed the river, often within a few dozen feet, until reaching the outskirts of Middletown. Runoff from the adjacent hills filled the canal with soil and gravel that necessitated expensive dredging. (Courtesy of the Butler County Historical Society.)

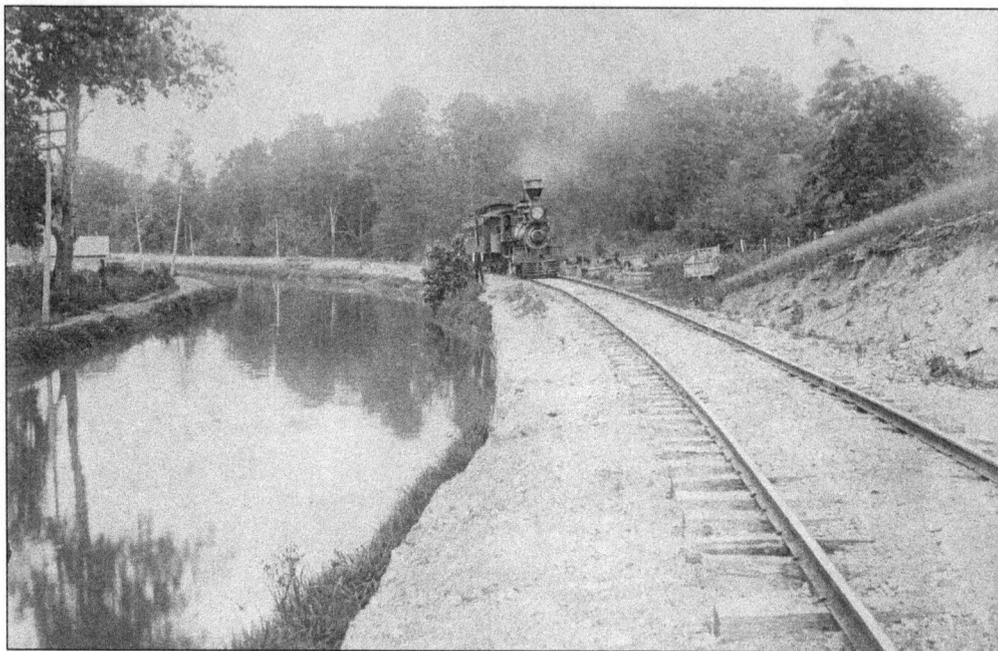

The photograph above shows a train near the Woodsdale resort. Woodsdale Island was the self-proclaimed "playground of Southwest Ohio" and offered food, drink, and dancing to all who made the trip there. Woodsdale was served by the canal and by the Louisville, Cincinnati & Dayton Railroad. The photograph below shows the rail station and pedestrian bridge at the park's entrance in 1912. Many local companies in Hamilton and Middletown would hire canal boats to transport their staff to "the Island." The moniker came from the resort being bracketed by the Great Miami River on one side and the Miami and Erie Canal on the other. Flooding in 1898 damaged the venue, and the great flood of 1913 finished it off. Subsequent flooding over the years has erased any trace of this once-popular recreational destination. (Both, courtesy of the Midpointe Library of Middletown.)

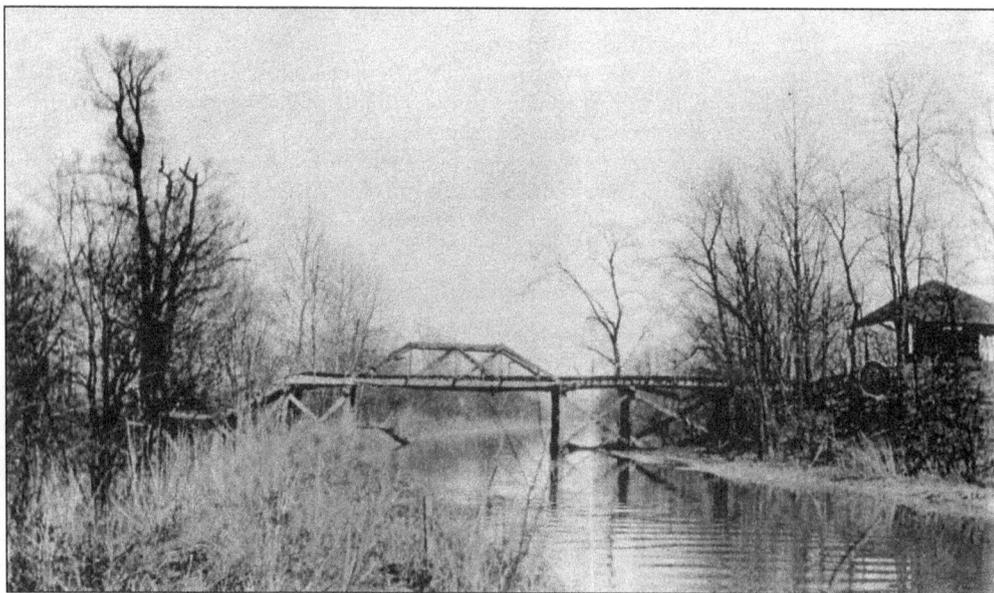

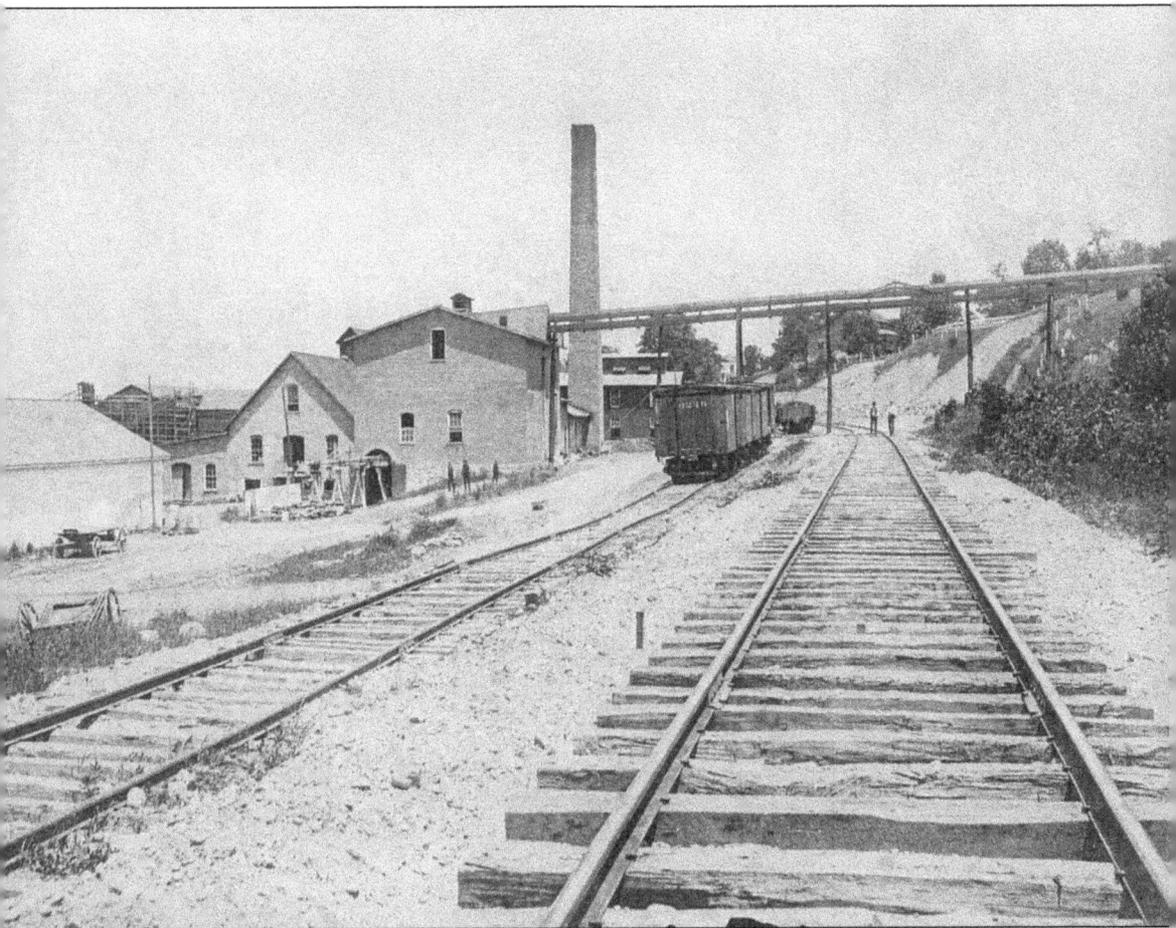

The head of water at Lock 35s powered the mill at Rockdale. This mill was originally built in the late 1860s by the Tangeman & Davis Paper Company. Tangeman also operated a mill in Lockland. The Rockdale plant produced strawboard (cardboard produced from straw fiber). Ownership of the mill passed to the Union Strawboard Company in 1887, then to Friend & Forgy, and later to the American Strawboard Company. The Lockland-based Fox Paper Company acquired the property in 1904. This photograph was taken in 1905 and shows that the mill was serviced by rail in addition to the Fox corporate fleet of gasoline-powered freight boats. Ownership of the mill passed to the Sall Mountain Corporation in 1913. Sall Mountain's primary product was fire-retardant asbestos wallboard. The asbestos plant burned down in 1942. The FBI investigated the fire and ruled out Axis espionage. The plant later resumed paper production and operated under several more owners before ceasing operations at the site in the late 1990s. (Courtesy of the Midpointe Library of Middletown.)

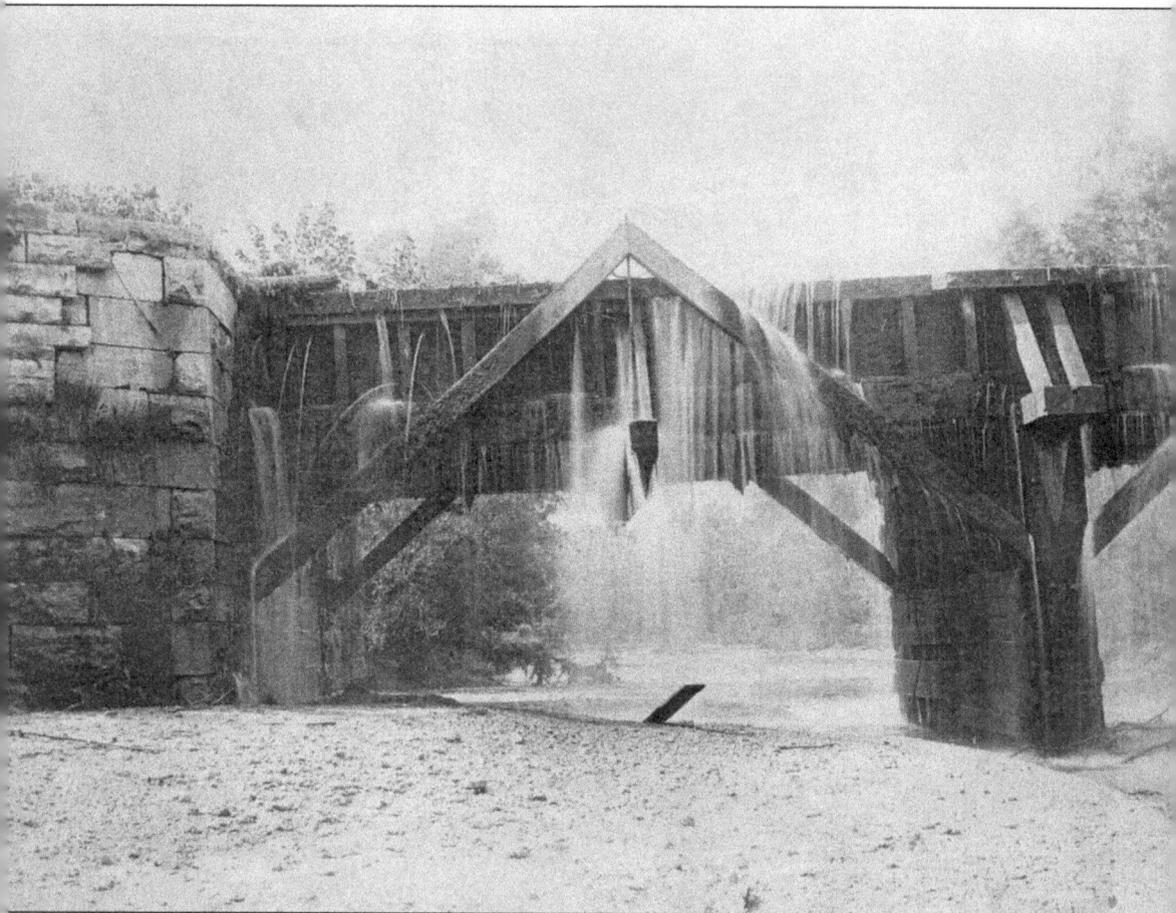

Still closely following the path of the Great Miami River, the canal crossed Gregory Creek on the 60-foot, wooden-troughed, single-span LeSourdsville Aqueduct. A small community of no more than 30 houses sprang up on the eastern side of the canal and a nearby basin. The A.H. Knorrs Ice Company pond and insulated storage barns were located on the west side of the canal. Knorr filled their pond from the river rather than from the canal and conducted business there from 1855 until the late 1890s. The advent of artificial refrigeration eventually rendered the ice pond obsolete. In 1922, Lesourdsville Lake Park opened at the site of the dormant ice pond. The park, much like that at Woodsdale Island, catered to the family and business outing market. The park's name changed to Americana in 1977, and it struggled against larger, modern competition until closing in 2002. (Courtesy of the Midpointe Library of Middletown.)

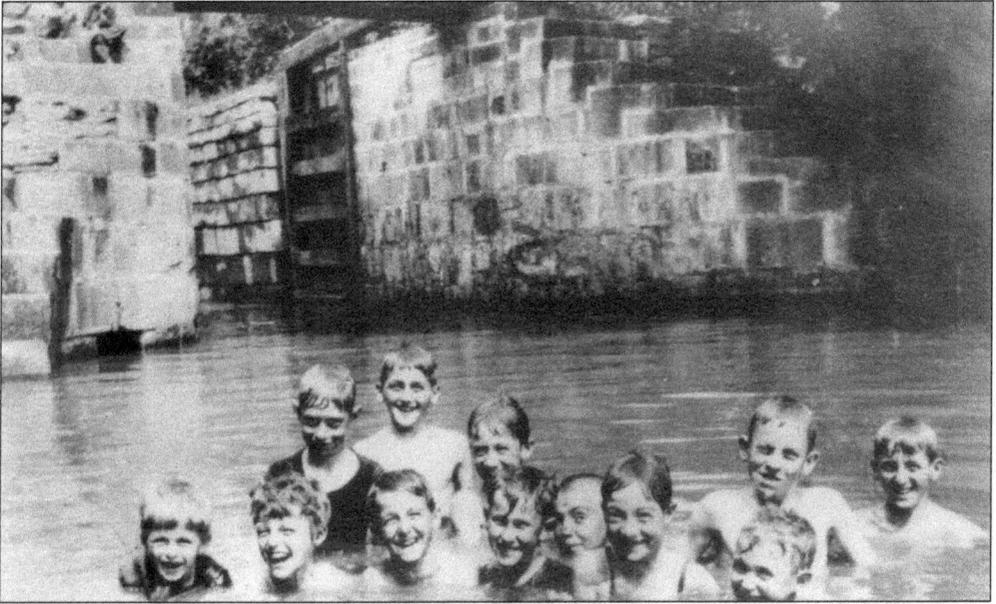

Swimming in the canal was a popular pastime with kids up and down the route. The photograph above shows a school of young swimmers at the Excello Lock, south of Middletown. Excello Lock 34s was the first lock built on the canal line after its authorization by the state legislature in 1825. All Ohio locks were mandated to be a minimum of 15 feet wide and 90 feet in length. The head of water generated at this lock powered the nearby Harding-Jones Paper Mill from 1865 until the canal's functional demise in 1913. The photograph below shows Lock 34s after its 1906 concrete resurfacing. (Both, courtesy of the Midpointe Library of Middletown.)

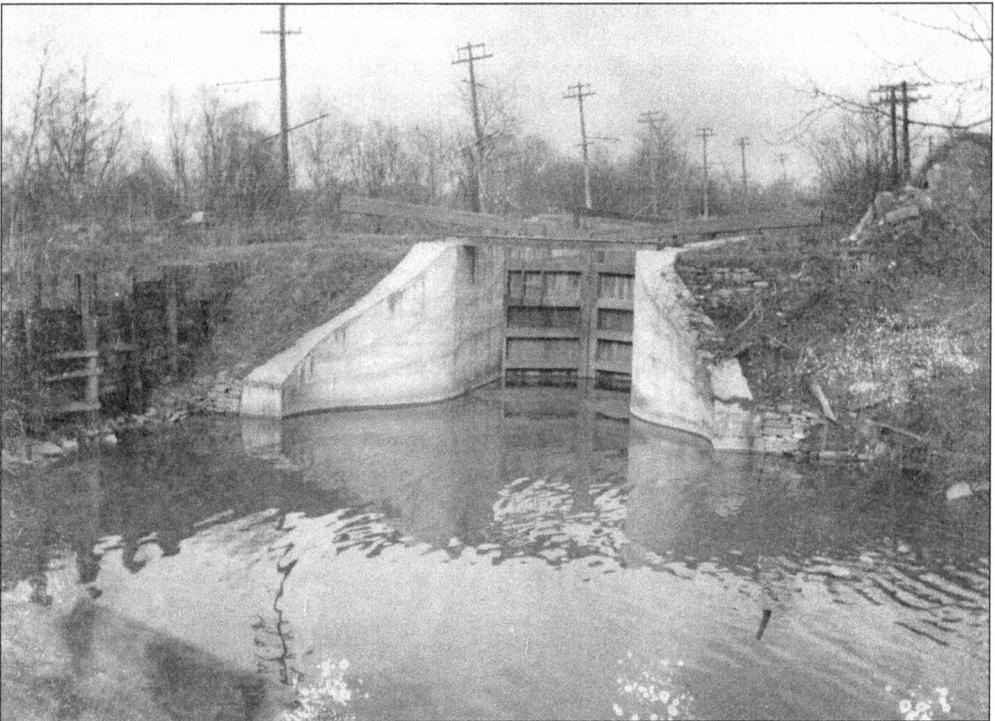

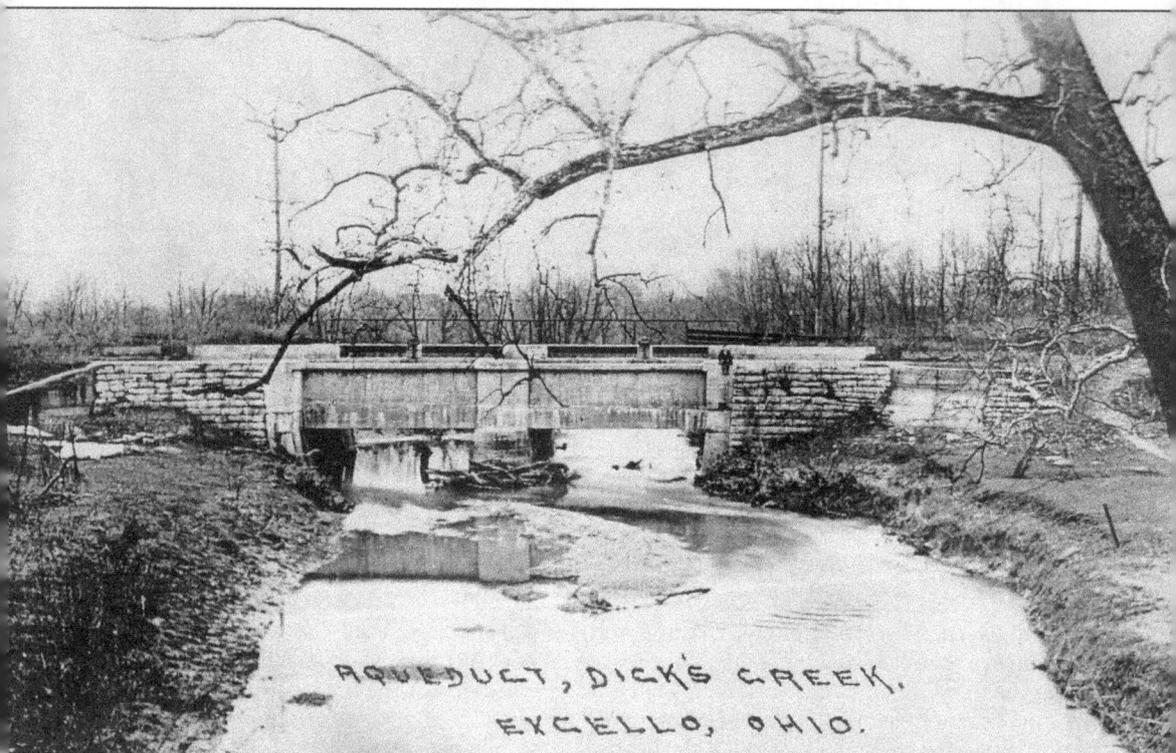

AQUEDUCT, DICK'S CREEK.
EXCELLO, OHIO.

The Dick's Creek Aqueduct, also known as the Amanda Aqueduct, passed the canal into the small, unincorporated community of Amanda. The aqueduct was originally built as a two-span, 92-foot, wooden-troughed structure. The state authorized a 1907 expenditure of $7,500 to convert the trough from wood to a leak-proof concrete. The original Miami Canal had a specified minimum width of 40 feet, which allowed for boats to pass each other. Locks and aqueducts were far narrower, only allowing for the passage of one boat at a time. A boat's passage at high speed in the narrow confines of the aqueduct trough displaced a great deal of water into the creek below. Water losses such as these, as well as normal evaporation, required constant replenishment from feeders in order to maintain the minimum depth in the canal. (Courtesy of the Midpointe Library of Middletown.)

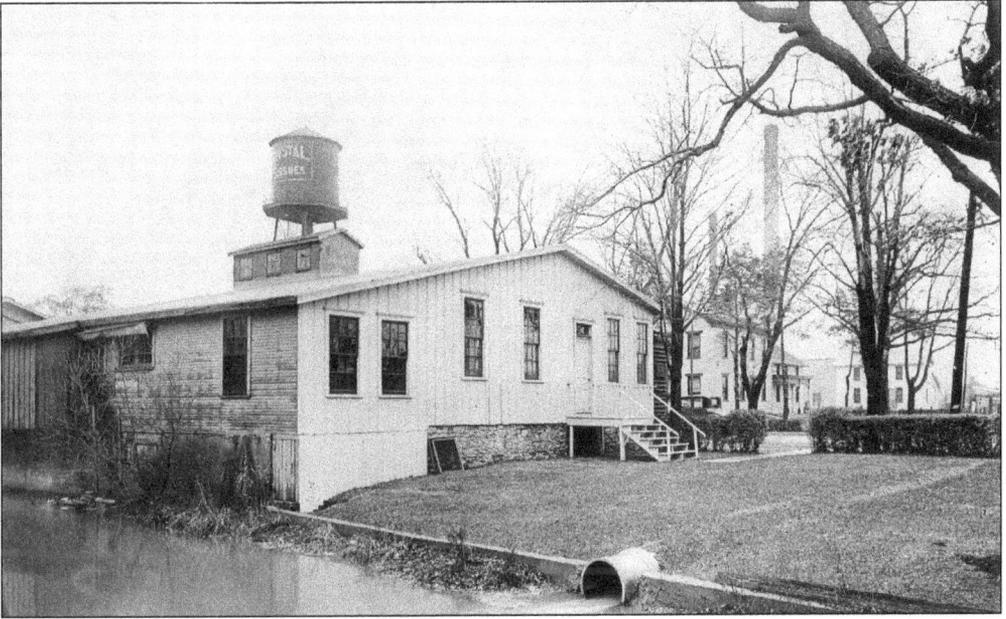

The Miami Valley earned the nickname of "Paper Valley." The Crystal Tissue Mill was one of at least seven Middletown paper mills on the Miami and Erie Canal or the adjacent Middletown Hydraulic Canal. By 1880, the Middletown paper mills employed over 440 workers and produced 12 million pounds of paper products per year. Crystal Tissue (above) utilized water at Lock 33s and remained in business until 2003. The photograph below shows the eastern chamber wall of Lock 33s and the lock tender's house. Local students surveyed the home prior to its 1964 demolition, and their notes served as the blueprint for the Middletown Canal Museum, constructed to pay homage to Middletown's canal history in 1982. (Both, courtesy of the Midpointe Library of Middletown.)

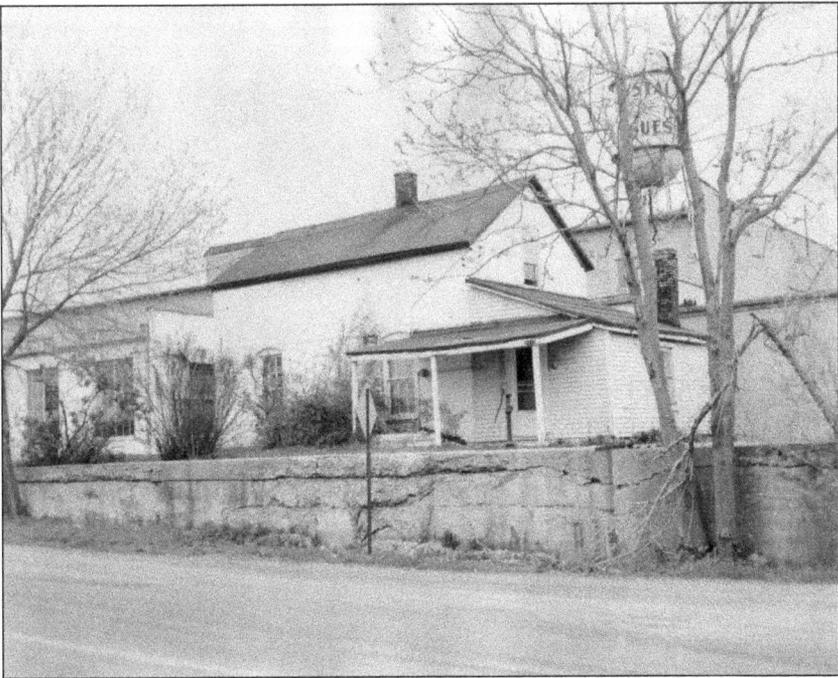

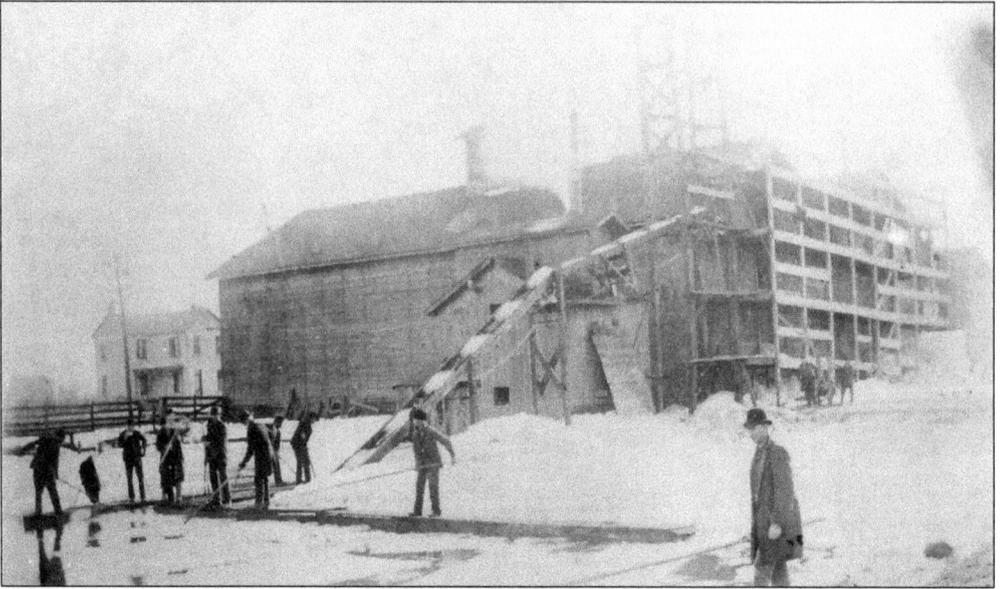

The Sebald ice pond was one of several ponds on the southern outskirts of Middletown. The image above shows the Sebald Brewery's ice pond and storage barn as ice is being harvested in the winter of 1890. Note the steam-powered conveyor system hoisting the ice blocks into the barn, where it would be stored until needed for lagering the beer in the warmer seasons. Ice pond operations terminated in 1897 when Sebald purchased ice-making machinery. Brewing operations ended in 1919 with Prohibition. The photograph below shows another group of skinny-dipping kids enjoying a swim in the canal, proving that Cincinnati had no monopoly on creating a Canal Swimmers Society. (Both, courtesy of the Midpointe Library of Middletown.)

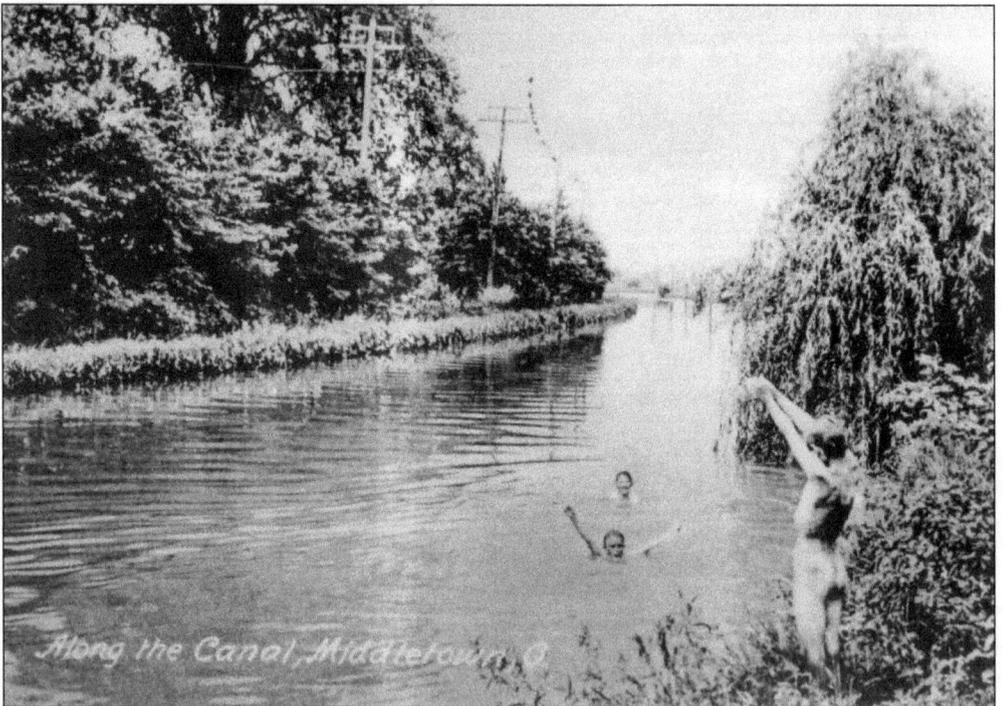

Lock 32s was the third lock constructed on the Miami Canal. It was also known as Middletown Lock, Doty's, and the Thomas Mill Lock (the paper mill powered by the fall of water generated at the lock). The 1900 photograph at right shows Andrew Barnickle, the lock's last tender, sitting on the gate beam to the right, and Norman Nichols on the left. Batchelor Thomas & Company built its mill adjacent to the lock in 1868 and produced flour sacks and strawboard. The photograph below shows Doty's Grove. It was a very idyllic section of the canal, as well as the site of the canal's ground-breaking in 1825. (Both, courtesy of the Midpointe Library of Middletown.)

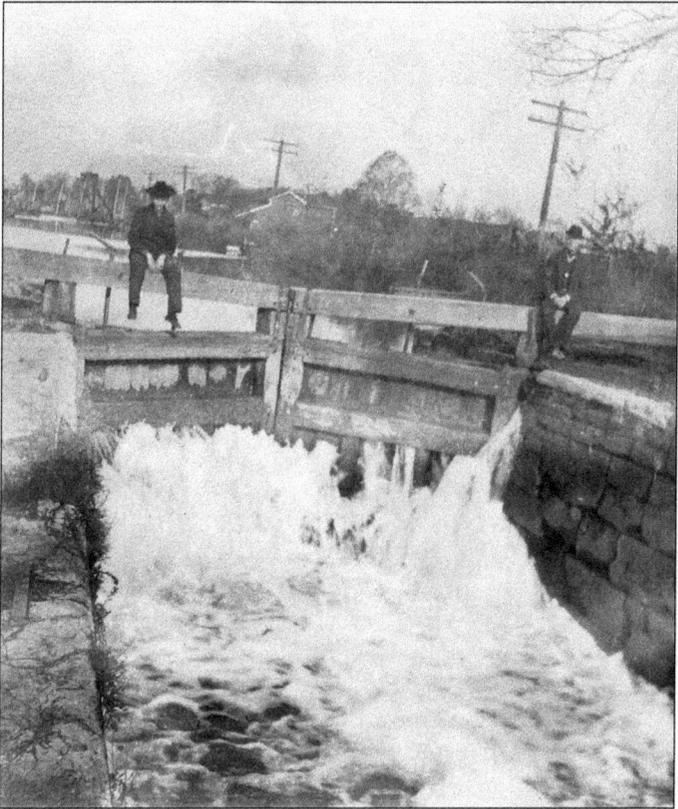

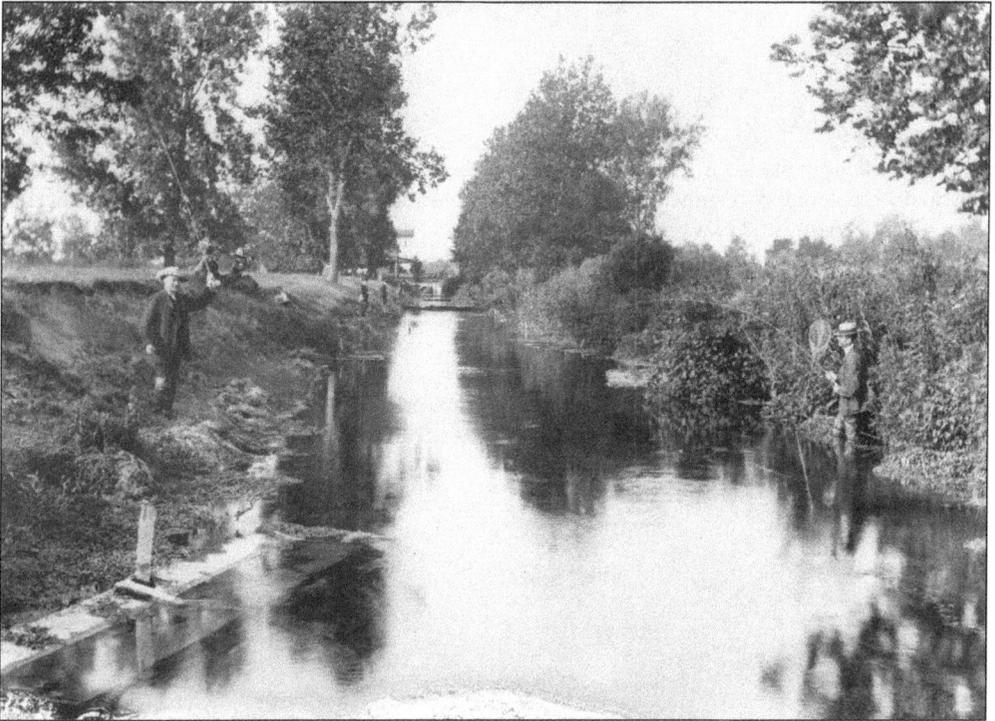

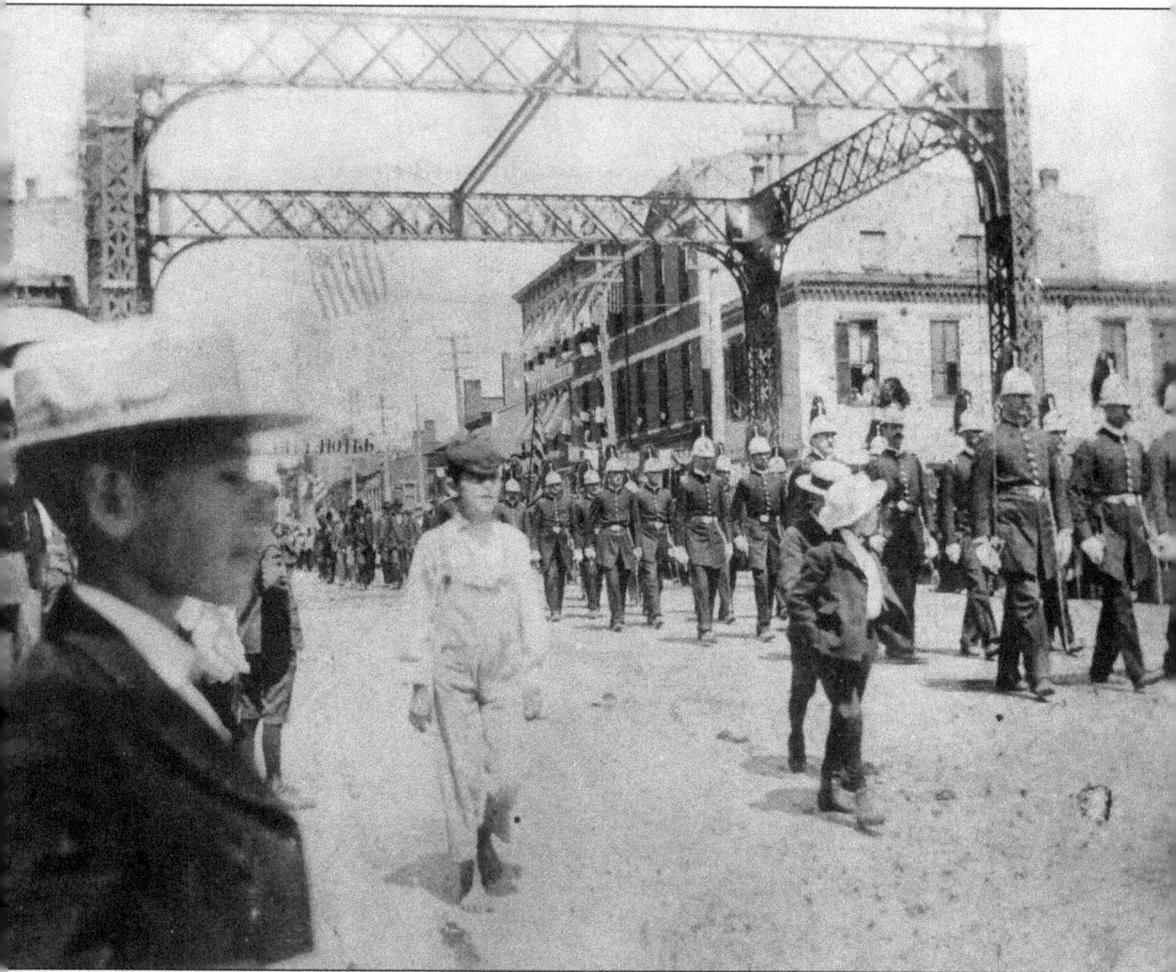

The USS *Maine* exploded in Havana harbor on February 15, 1898. After a cursory investigation, the Spanish colonial government was held responsible and war was declared in mid-April of that year. The US Army and Navy scored a succession of victories on land and sea that resulted in a halt to hostilities on August 12, 1898. Middletown veterans returned from the Spanish-American War and celebrated victory with a parade on September 16, 1898. The soldiers seen here marching across the Third Street canal hoist bridge were joined by 5,000 of their fellow citizens on that day. The war officially ended with the signing of the Treaty of Paris on December 10, 1898. Cuba attained independence, and the United States acquired the Spanish colonies of Puerto Rico, the Philippines, and the pacific island of Guam. The junction with the short-lived Warren County Canal was located south of the bridge. (Courtesy of the Midpointe Library of Middletown.)

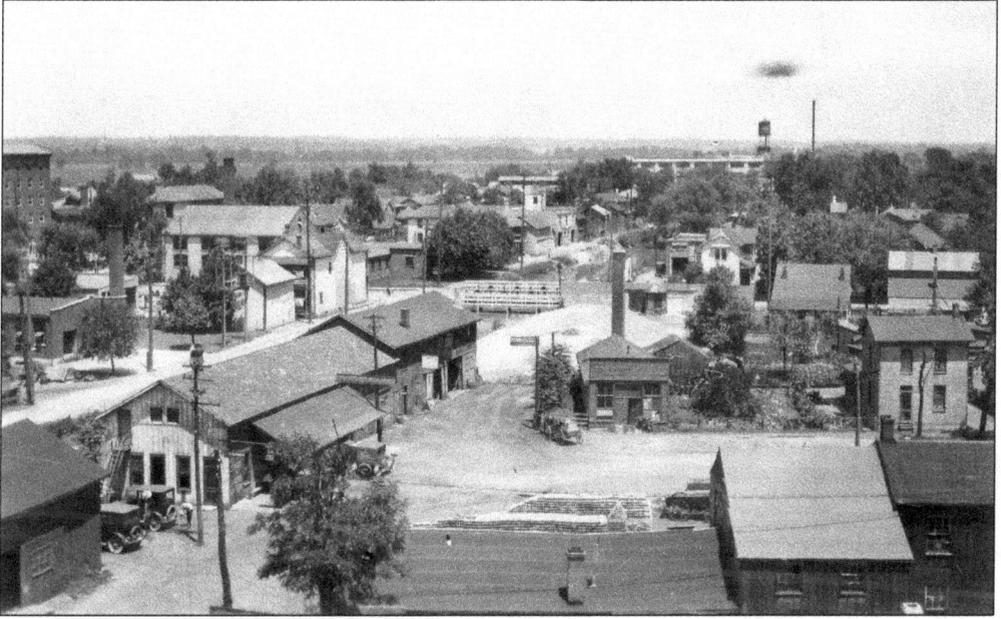

This photograph was taken from the Reed-Klopp Building and provides a bird's-eye view of Middletown in the early 20th century. The recently opened Manchester Hotel is to the left of the Manchester Avenue (formerly Second Street) Bridge over the canal. The large building in the background is the Advance Bag Company. (Courtesy of the Midpointe Library of Middletown.)

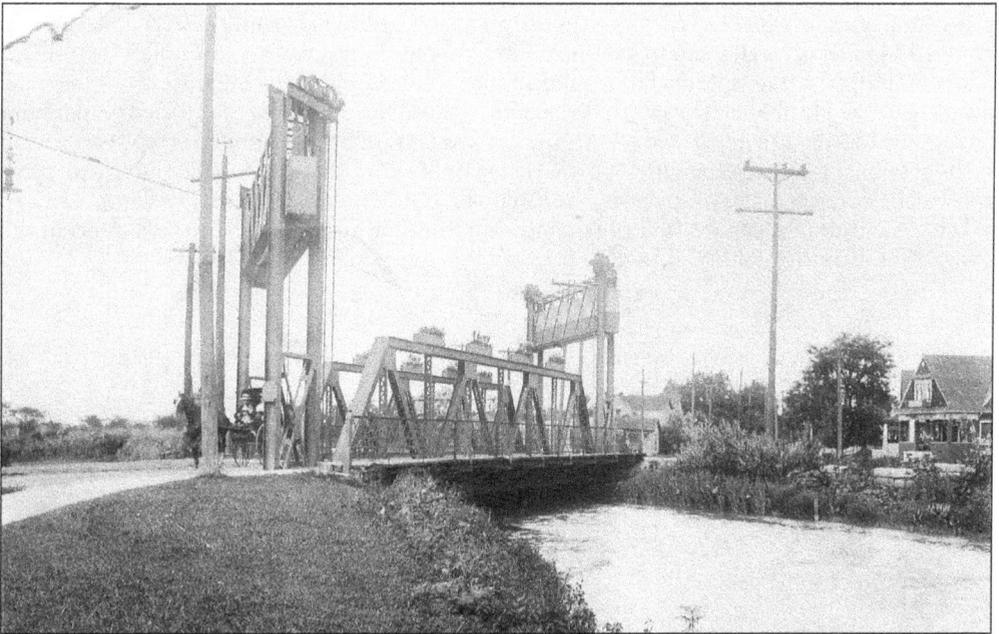

The Tytus Street hoist bridge, shown here in 1900, crossed the canal at a point where the canal routed within only a few hundred feet of the Middletown Hydraulic. This structure replaced one of the unpopular hump-backed high bridges that proved to be difficult for horse-drawn vehicles to cross. (Courtesy of the Midpointe Library of Middletown.)

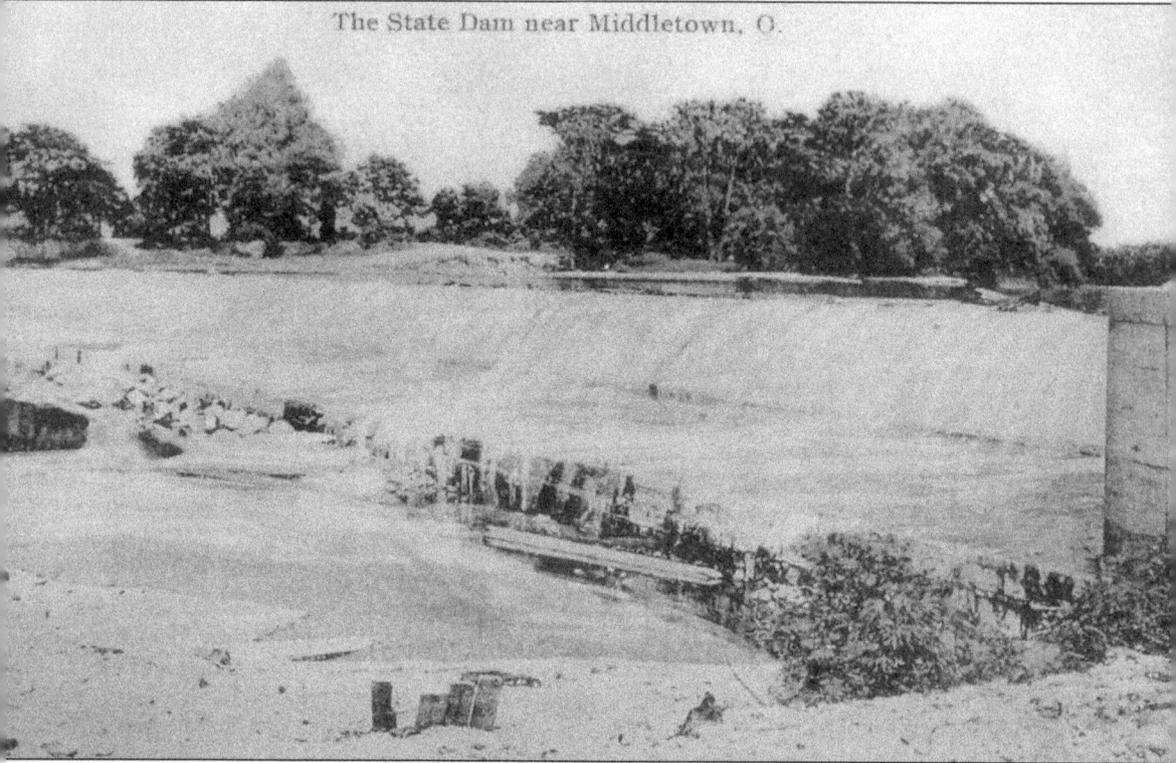

The State Dam near Middletown, O.

Waters impounded at Middletown's state dam on the Miami River were fed into the Miami and Erie Canal north of Middletown, as well as the privately operated Hydraulic Canal. These waters powered 44 miles of canal south to its Cincinnati terminus. By agreement, only waters superfluous to maintaining the state-specified minimum 48-inch water depth on the Miami and Erie could be diverted to the Hydraulic. The original wooden-cribbed dam proved to be difficult to maintain and seemed to require expensive repairs almost annually. This structure was replaced with a more permanent concrete one in 1908. At a cost of $61,000, the dam was the most expensive construction project undertaken during the canal's 1906–1910 modernization. The dam continued to serve the hydraulic canal with little maintenance until it was breeched by floodwaters in the early 1980s. (Courtesy of David Neuhardt.)

The Miami and Erie Canal clipped across the extreme northwestern corner of Warren County for about four miles. The city of Franklin was centered within this stretch. A basin in the middle of town was the focal point for canal activity within the village. This photograph shows the bypass tumble for Lock 27s, located north of town. An interurban rail trestle crosses its abutments. (Courtesy of David Neuhardt.)

Miamisburg derives its name from the native Miami Indians who once ruled this river valley. Miamisburg was founded in 1818 on the banks of the Great Miami River. Tobacco warehouses and cigar manufacturing became central to the local economy. This photograph shows the Central Avenue hoist bridge crossing the canal into Miamisburg's bustling business district. (Courtesy of David Neuhardt.)

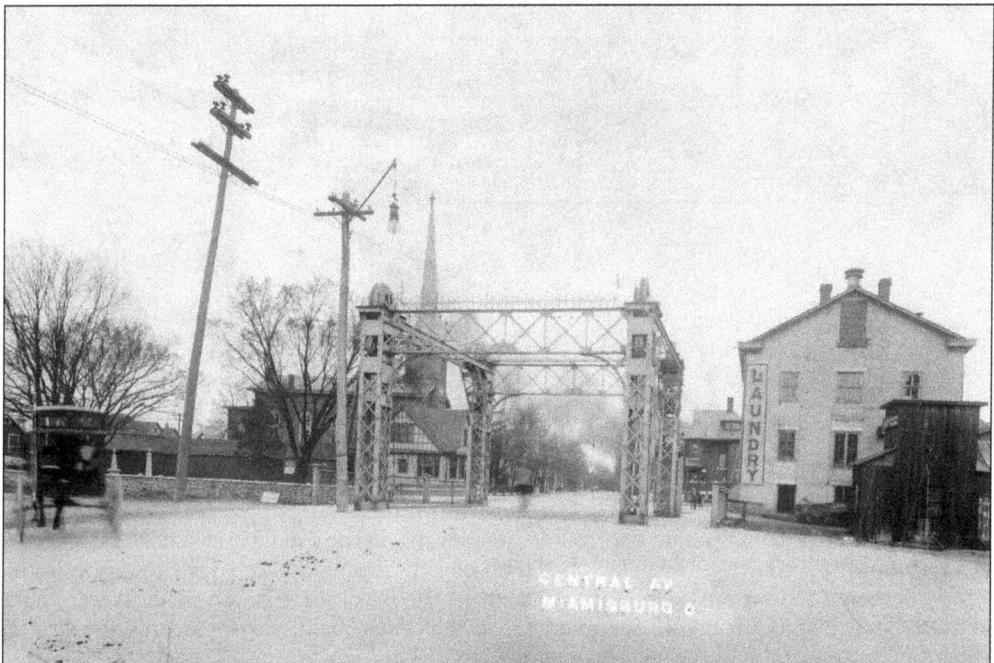

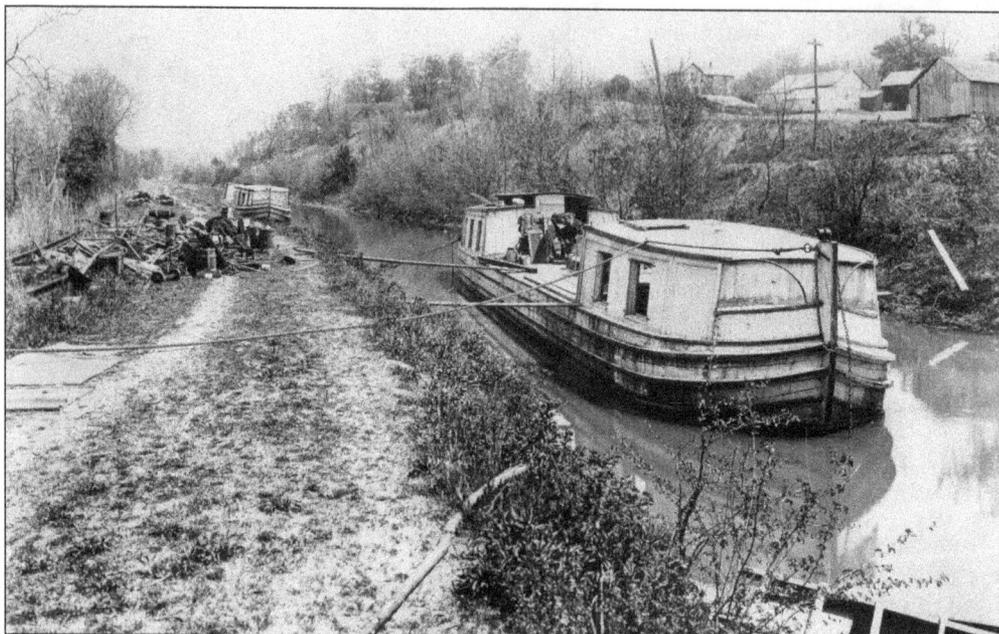

This photograph shows several canal freighters docked along the banks of the canal between Miamisburg and West Carrollton. It would appear that this stretch of canal was a favored spot for the canawlers to rest and dispose of their accumulated rubbish. (Courtesy of the Canal Society of Ohio.)

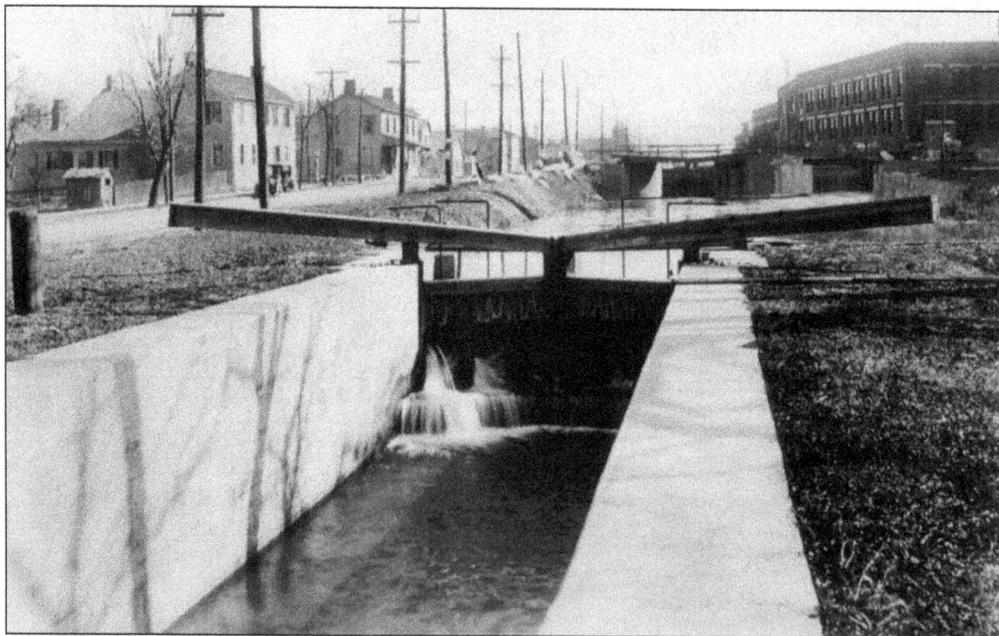

West Carrollton, originally named Carrollton, was platted on the canal beside Locks 25s and 24s, as shown in this 1907 image. Each lock had a lift of eight feet and powered the town's industry. A distillery and a flour mill were built adjacent to the locks in 1835. These mills were later converted for the production of paper products such as strawboard, envelopes, and fine writing papers. (Courtesy of the Roscoe Village Foundation.)

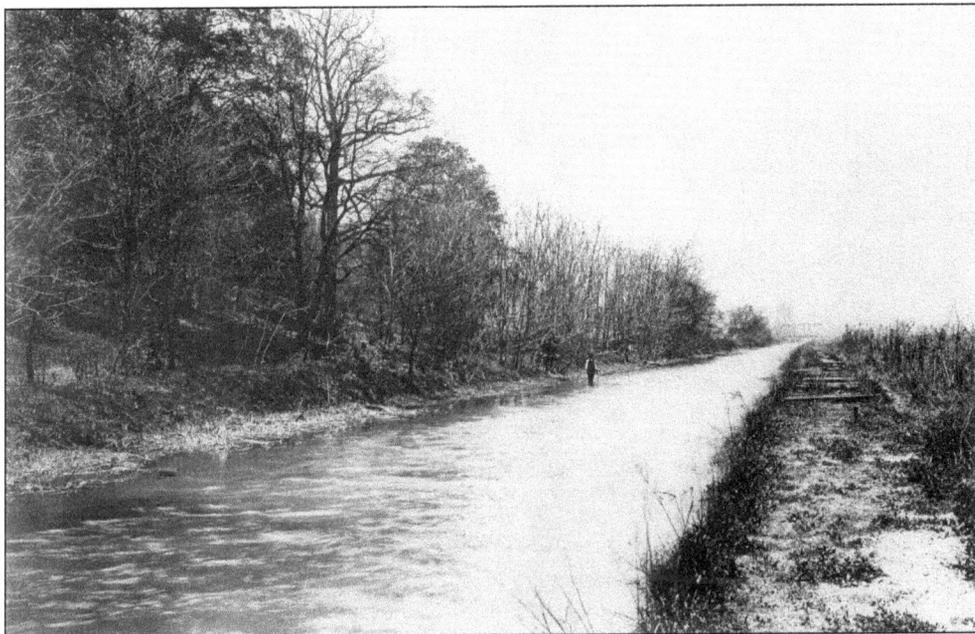

When this photograph was taken in 1904, the canal's route into Dayton was far more peaceful than it is today. This scene was a short distance from the Calvary Cemetery. The Catholic cemetery was founded in 1872 in response to a need for more plots when downtown Dayton's St. Henry's Church Cemetery had reached capacity due to epidemics and Civil War casualties. (Courtesy of the Canal Society of Ohio.)

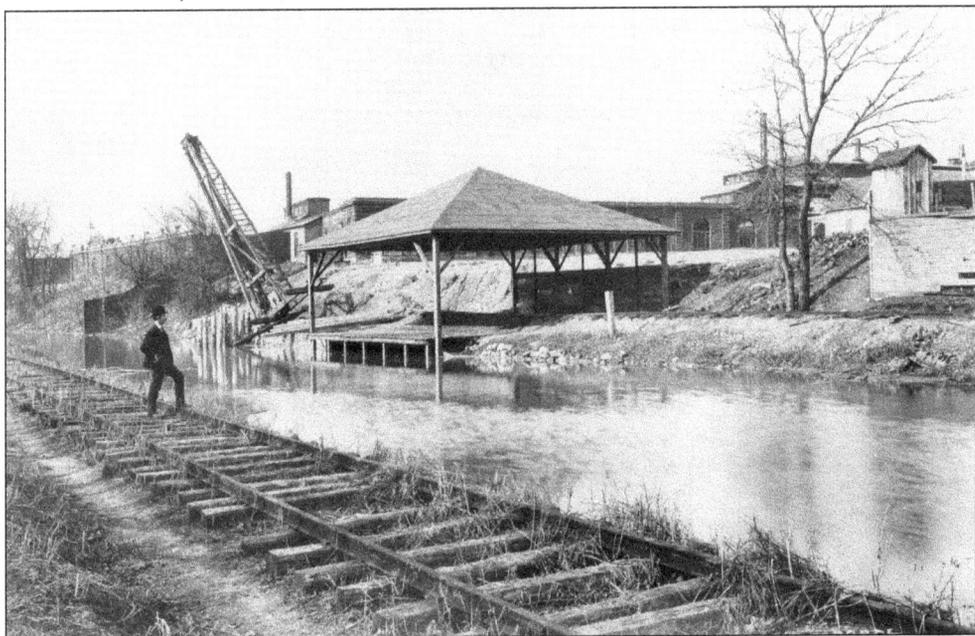

This is another 1904 photograph of the canal south of downtown Dayton. A covered loading dock behind the National Cash Register Company is at center. The gentleman on the left is standing on the tracks laid for the ill-fated "Electric Mule." It is considered unlikely that these rails were ever utilized in the towing of freighters in Dayton. (Courtesy of the Canal Society of Ohio.)

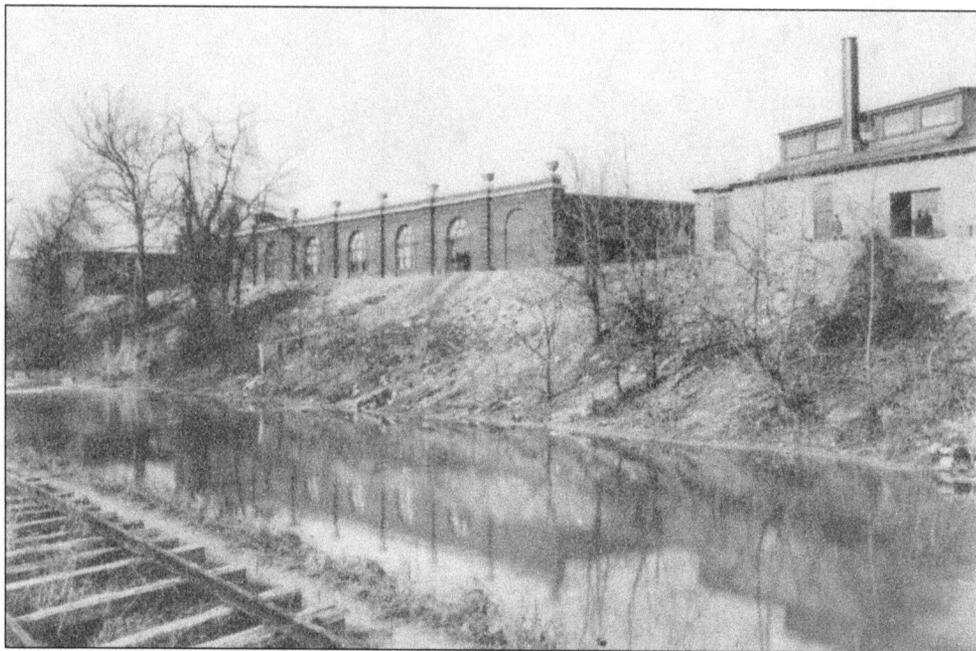

The National Cash Register Company was one of Dayton's largest and most recognized companies from its founding in 1884 until it chose to relocate to Georgia in 2009. NCR, as it was known, created the first mechanical cash register and also patented many other "firsts" now commonly used in modern-day commercial transactions. The photograph above shows the firm and the never-used tracks of the "electric mule" in 1904. The photograph below shows the freighter *St. Louis of Dayton* plying the waters of the canal near Dayton. The *St. Louis of Dayton* is possibly the most photographed boat on the Miami and Erie Canal. (Both, courtesy of the Canal Society of Ohio.)

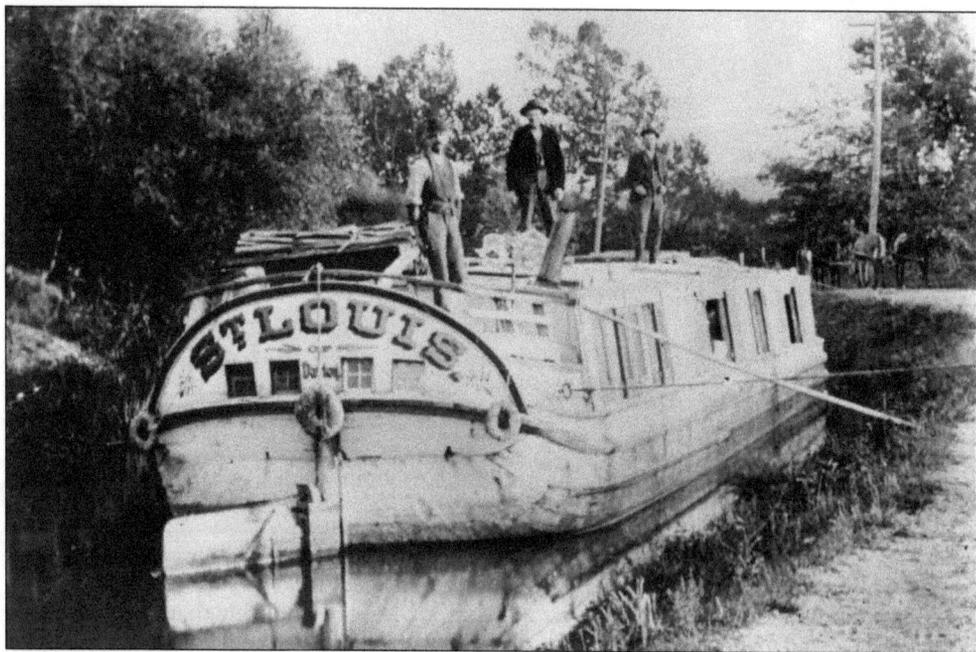

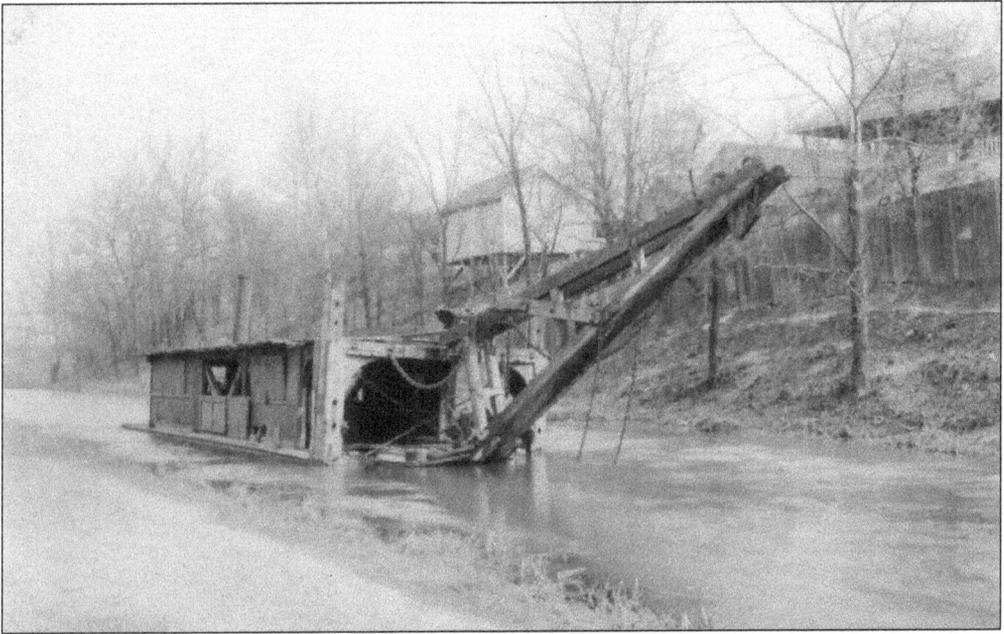

A sunken dredge blocks the canal behind the Montgomery County Fairgrounds in the waning days of the inland waterway in 1911. The waterway was largely dormant in Dayton at the time this photograph was taken. (Courtesy of the Canal Society of Ohio.)

There is a tall tale of a canal freighter in the Delphos area that sprung a serious leak. The bilge pump was employed, but it was unable to keep up. The leak then mysteriously stopped, and the boat crept its way to dry dock for repair. It was found that a catfish had been sucked into the breeched hull and plugged the gap. The sunken vessel shown behind the fairgrounds in this 1911 image did not benefit from such fortuitous circumstances. (Courtesy of the Canal Society of Ohio.)

Numerous bridges crossed the canal in Dayton. The 1911 photograph above shows the high, iron Apple Street Bridge spanning the waterway above the stone abutments of a guard gate. The Ohio Boat Company's gasoline-powered freighter *Dayton* is shown docked by the bridge. The *Dayton* had been stranded in Dayton due to the condition of the canal. Morrison's dry dock is shown to the right of the *Dayton*. The image below shows the iron Jefferson Street swing bridge crossing the canal in downtown Dayton. (Both, courtesy of the Canal Society of Ohio.)

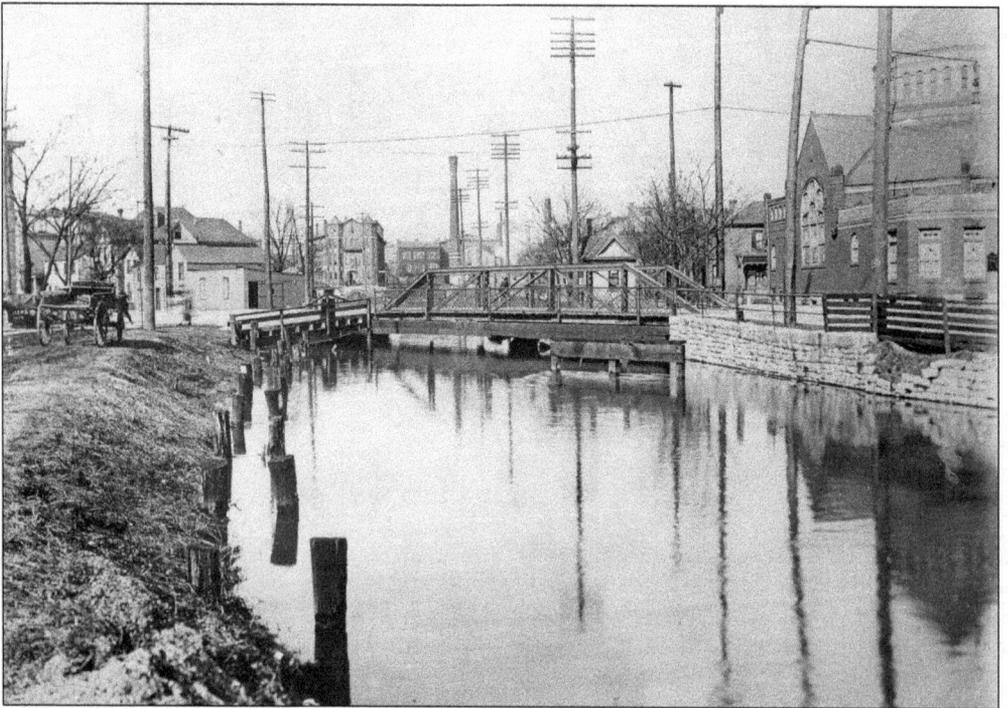

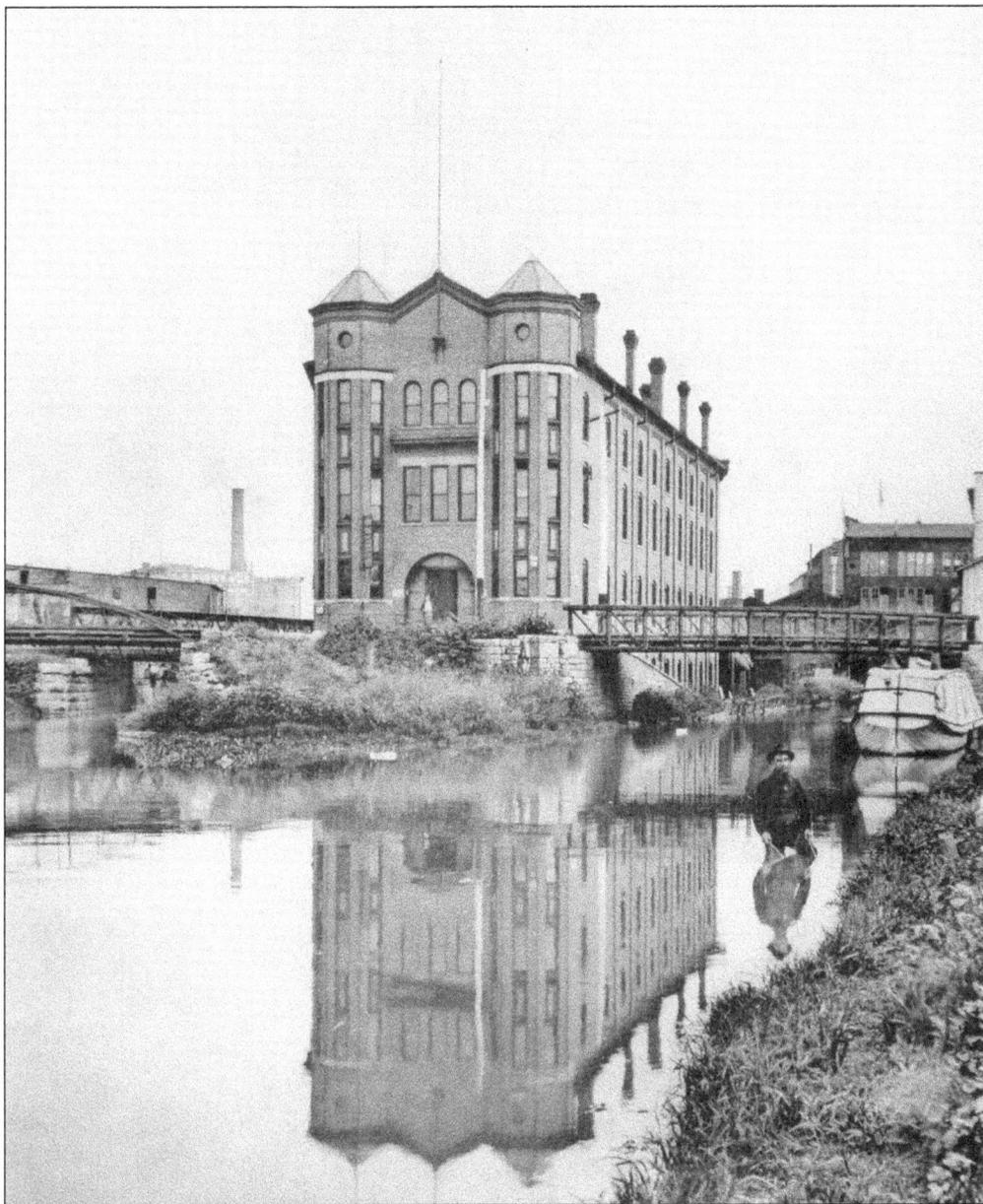

As completed in 1828, navigation on the original Miami Canal terminated at a basin to the left of the Armory building shown in this 1890 photograph. A non-navigable feeder canal fed the canal to the right of the Armory from a dam on the Mad River. Once the Miami Extension Canal was authorized and built in the 1830s, this feeder was opened to navigation. The canal to the left of the Armory building led to the Dayton basin. Later, in the 1840s, the basin was extended by a privately built canal created by the Cooper family, which converged with the state's canal at the Mad River crossing. The privately built route proved more popular with canawlers, and the state acknowledged this by shutting down its own main line to navigation and allowing the lowering of bridge crossings in 1872. Interestingly, both routes required a numbered lock—No. 21 on the state-built route, No. 21a on the Coopers' line. The state-built old line was, from 1872 on, referred to as the Mad River feeder. (Courtesy of David Neuhardt.)

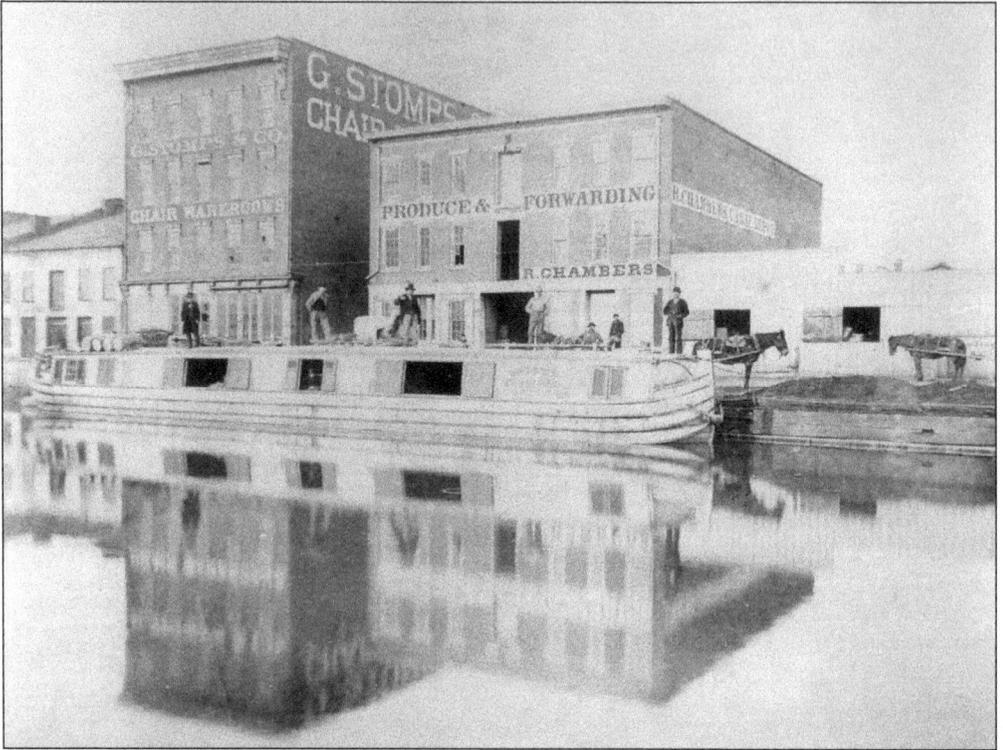

One of the treasures of Dayton's canal history is the still extant Chambers warehouse, located at Dayton's basin on the old-line canal route. Chambers entered into the grocery wholesale business in 1838 and built the brick warehouse shown above in 1850. The *St. Louis of Dayton*, shown above docked in front of the Chambers building, was one of several boats owned and operated by Chambers and was a familiar sight on the canal between the Dayton warehouse and Cincinnati. The image below shows the *Gem of Dayton* excursion boat and a full load of partiers ready to cast off at the basin. (Both, courtesy of David Neuhardt.)

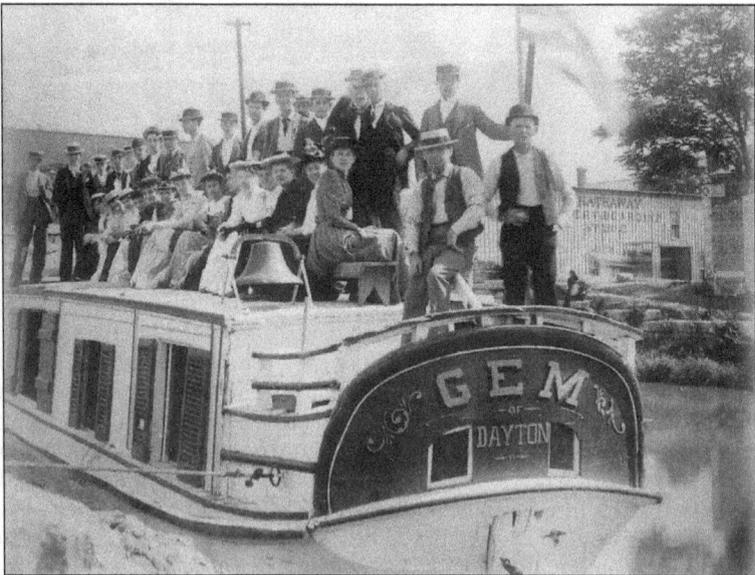

Two

THE MIAMI
EXTENSION CANAL
DAYTON TO JUNCTION

Plans were progressing rapidly for further development of the Miami Extension Canal. Four divisions were identified: a 32-mile line between Dayton and Piqua, another 32-mile line north from Piqua to St. Marys, a 12-mile segment referred to as "Deep Cut," and, finally, a 33-mile segment to Junction. An act of Congress on May 25, 1828, granted the State of Ohio some public land to sell, assisting the state in financing the construction of the canal to that point. The proposal was also granted to Indiana to extend its Wabash and Erie Canal into Ohio to Lake Erie. The Miami Extension Canal would join the Wabash and Erie at Junction, Ohio. Federal land given to help finance both Ohio canals represented a full 25 percent of the $8 million construction costs.

Samuel Forrer joined the Board of Canal Commissioners and continued as chief engineer to supervise the work on the Miami Canal and the Miami Extension Canal. Forrer mapped the canal to follow the Great Miami River and its tributary Loramie Creek up the Loramie summit and, from there, down the watershed of the Maumee River to Lake Erie. The topography of the summit required the creation of several reservoirs to water the canal. Mercer County Reservoir (now known as Grand Lake St. Marys) began in 1835 and created a lake nine miles long and two miles wide—the largest man-made lake in the world at that time. Two other reservoirs were built to complete the supply: the Loramie Reservoir and the Lewistown Reservoir.

The engineers faced the formidable task of taming the wilderness lying north all the way to Lake Erie. The terrain through which the canal was cut presented seemingly insurmountable obstacles at times. An area known as "the Great Black Swamp" was passable only by following the course of rivers running through it. Inevitable disease was transmitted by swarming insects, and typhus, cholera, and a form of malaria plagued the workers. It was calculated that one man died for every mile of canal. A decision was made to cut through a formidable ridge of blue clay north of St. Marys rather than take a more costly route around it. It took nearly four years to create the canal channel, which was 52 feet deep, 200 feet across at its crest, and over a mile long—it was consequently named Deep Cut.

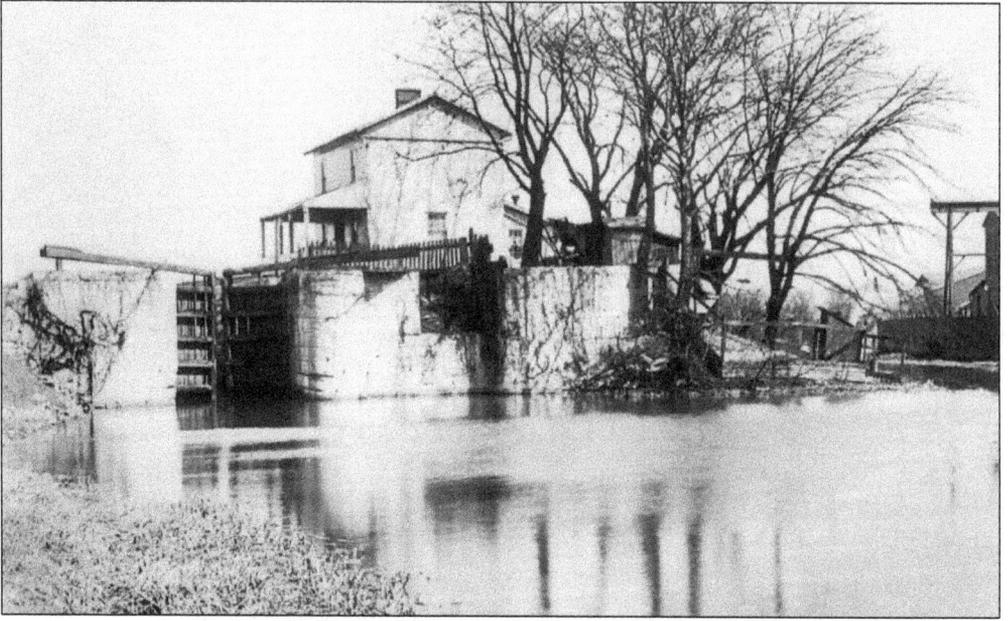

Lock 20s marked the beginning of infrastructure built by the state for the Miami Extension Canal. The image above shows Lock 20 to the left, the lock tender's house in the center, and the Mad River feeder's waters—diverted from a 245-foot-long dam on the river—entering the canal at the right. Though Lock 20's lift of 13.6 feet was the greatest on the canal, it powered no associated mills. The Barney & Smith railcar factory did build an assembly plant near the lock in 1904–1905. The 1911 photograph below shows a northern-end view of Lock 20, which had been waterless since 1903, when the upstream Great Miami Aqueduct had one of its many failures. This section of canal remained dry until 1912. (Both, courtesy of the Canal Society of Ohio.)

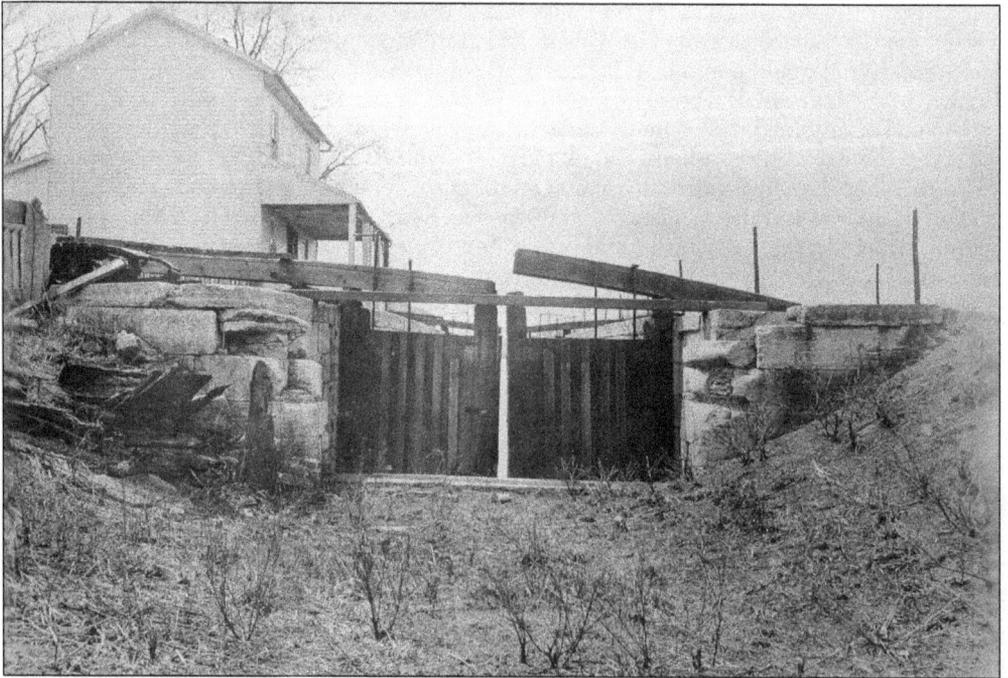

These two 1911 photographs show the 250-foot Mad River Aqueduct in the same waterless condition, due to the Miami Aqueduct failure to the north. The Mad River crossing was nearly as much of a maintenance nightmare to canal engineers as the longer structure over the Great Miami. If watered, the photograph above would display water gushing out of every crack and crevice of its wooden trough. The view below gives a rare down-the-chute dry view of the Mad River Aqueduct, which displays construction methods typical of all of Ohio's canal aqueducts. Hawes Strawboard Works and smokestacks are shown to the left. (Both, courtesy of the Canal Society of Ohio.)

Upon crossing the Mad River Aqueduct, the minimum width and depth of the Miami and Erie Canal increased to 50 feet wide at the waterline and five feet in depth. Curiously, the width of locks and aqueducts remained the minimum required to allow a single 14-foot-wide canal vessel to pass. The photograph above shows the Smith Distillery complex, adjacent to Lock 17s in present-day Huber Heights. The brick building was the distillery, and the somewhat decayed wooden building to its left was the barrel-aging warehouse. The photograph below shows the numbered blocks of Lock 17 prior to its disassembly in the late 1940s and subsequent relocation to Dayton's Carillon Park. (Both, courtesy of David Neuhardt.)

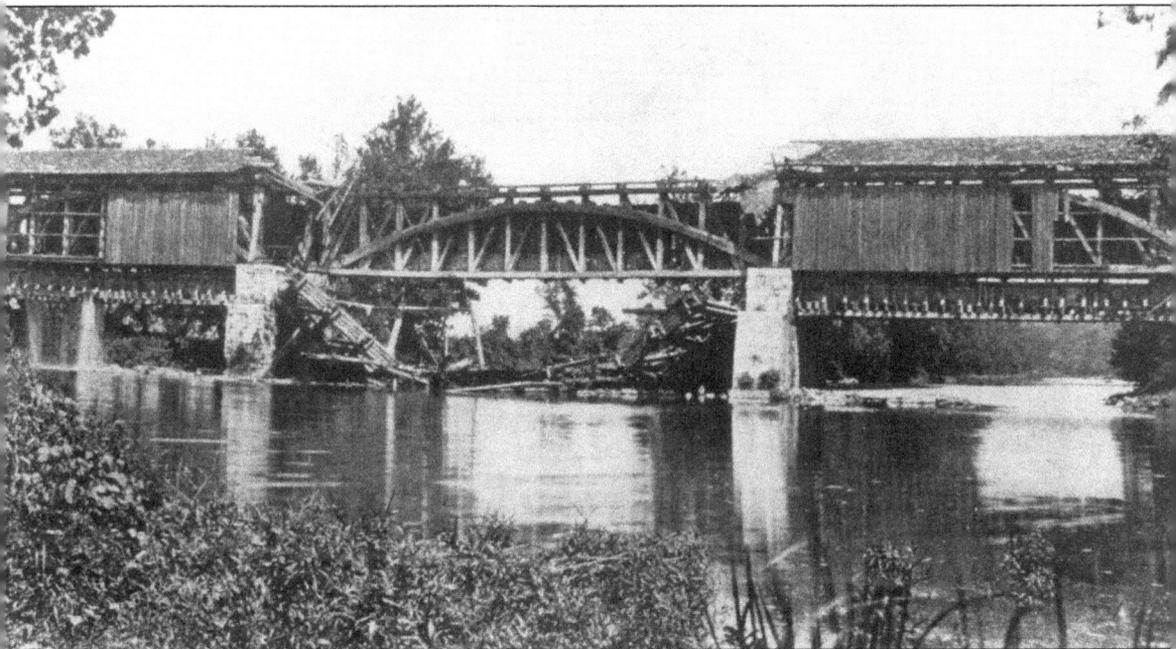

The Great Miami Aqueduct was both the longest and most troublesome aqueduct on the Miami and Erie Canal. Three spans totaling 300 feet were required to span the Great Miami below. A sharp and difficult 90-degree bend to the west was required by a boat before crossing the river. This was a feature that more than one boatman claimed made the aqueduct particularly treacherous to navigate in foul weather. The aqueduct was originally built as an open-trough type and was later converted to a covered aqueduct in 1857. This image shows the covered trough aqueduct after its 1903 collapse. The aqueduct was later rebuilt with a steel frame and an open flume in 1912. This reinforced structure collapsed barely a year later as a result of the catastrophic 1913 flood. The aqueduct site now lies in the shadow of the Taylorsville Dam. (Courtesy of the Canal Society of Ohio.)

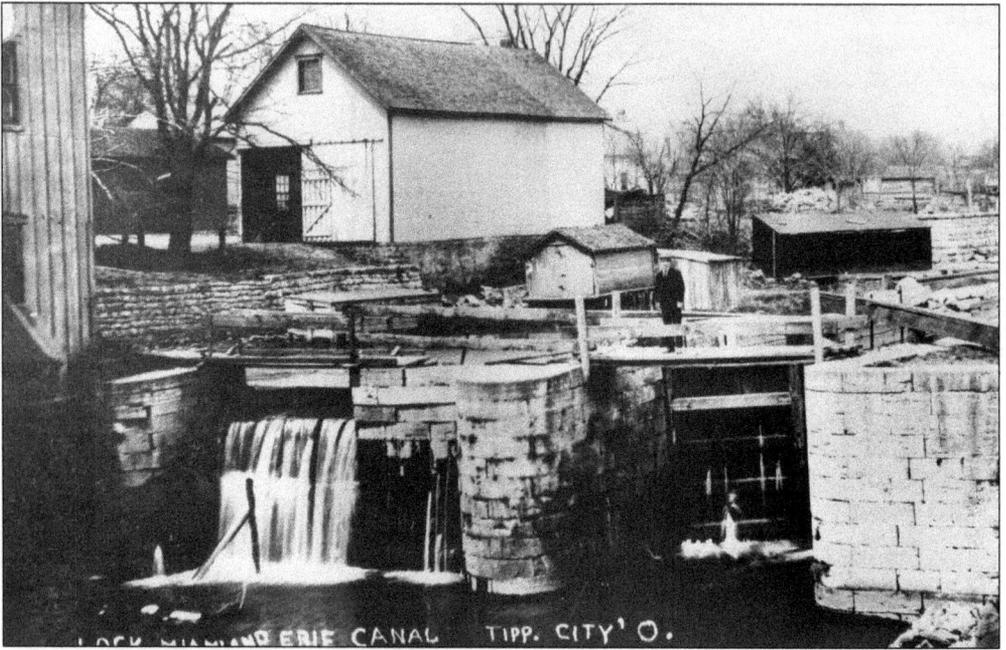

Upon exiting the Great Miami Aqueduct, the canal took another northern 90-degree turn and paralleled the route of the river through the now-vanished village of Tadmor before reaching the town of Tippecanoe. Tippecanoe was platted in the same year as the successful 1840 presidential campaign of Whig candidate William Henry "Old Tippecanoe" Harrison. The image above shows Tippecanoe's Lock 15s and a portion of the Tipp City Roller Mill to its left. The photograph below shows a rare view of a wooden waste weir north of town. Tippecanoe City was known as such until its name was legally changed to Tipp City in 1938. (Both, courtesy of David Neuhardt.)

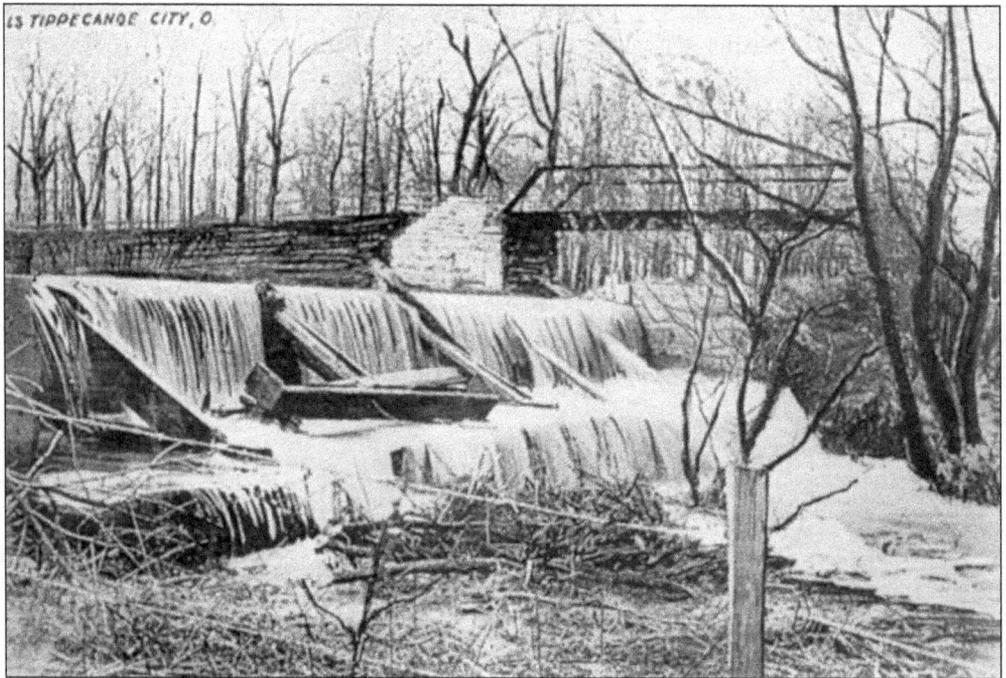

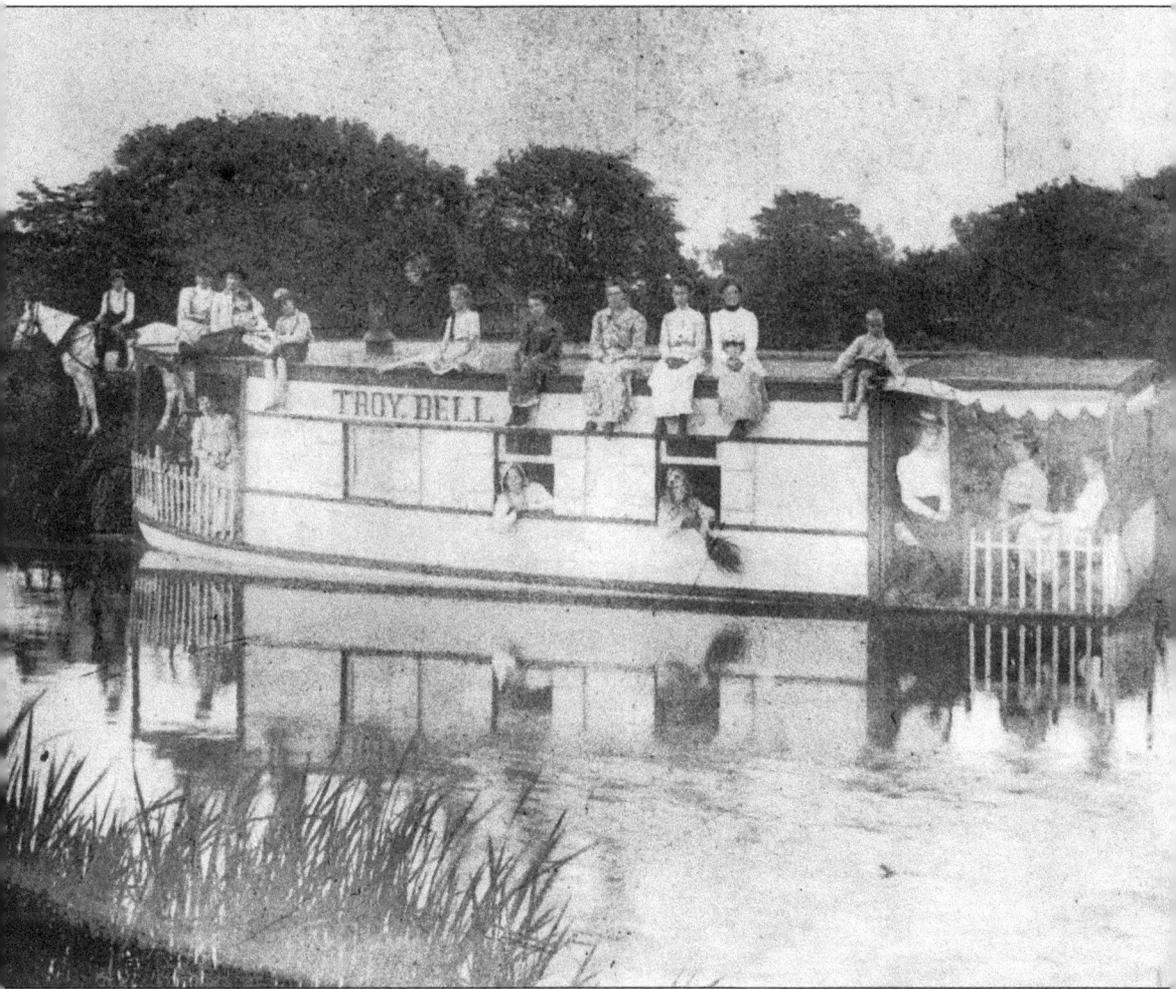

The *Troy Bell* was one of the last boats to ply the waters of the Miami and Erie Canal. Small pleasure craft were a common sight on the canal in its twilight years. The *Troy Bell* was constructed by a Trojan carpenter named J.W. Herman in 1899. After a summer of fishing at one of the canal's reservoirs, Herman sold the 33-foot-long craft to two buyers who operated it as an excursion and gambling boat. Reportedly, a card player on a losing night sank the craft with a gunshot through its hull. This c. 1900 photograph shows the boat being towed on one of those pleasure cruises. The boat later served as a floating studio for an itinerant photographer who hired teams to tow him from town to town. The renamed *Troy Belle* became home to several hermits from 1905 to 1939 as it rested beside the canal's former towpath. (Courtesy of the Piqua Public Library.)

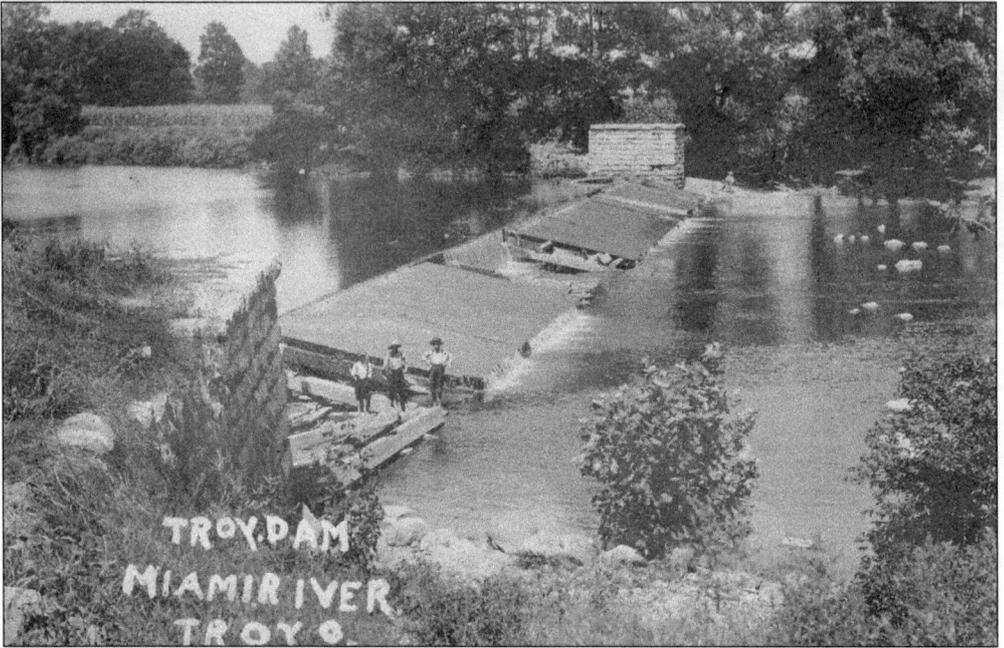

The Troy feeder dam, shown in this image from around 1900, was located on the Great Miami River several miles south of the city of Troy. It fed waters into the canal at Lock 14s and sustained navigation south to the Mad River feeder in northern Dayton. The canal needed constant replenishment to replace the water lost to leaks and evaporation. (Courtesy of David Neuhardt.)

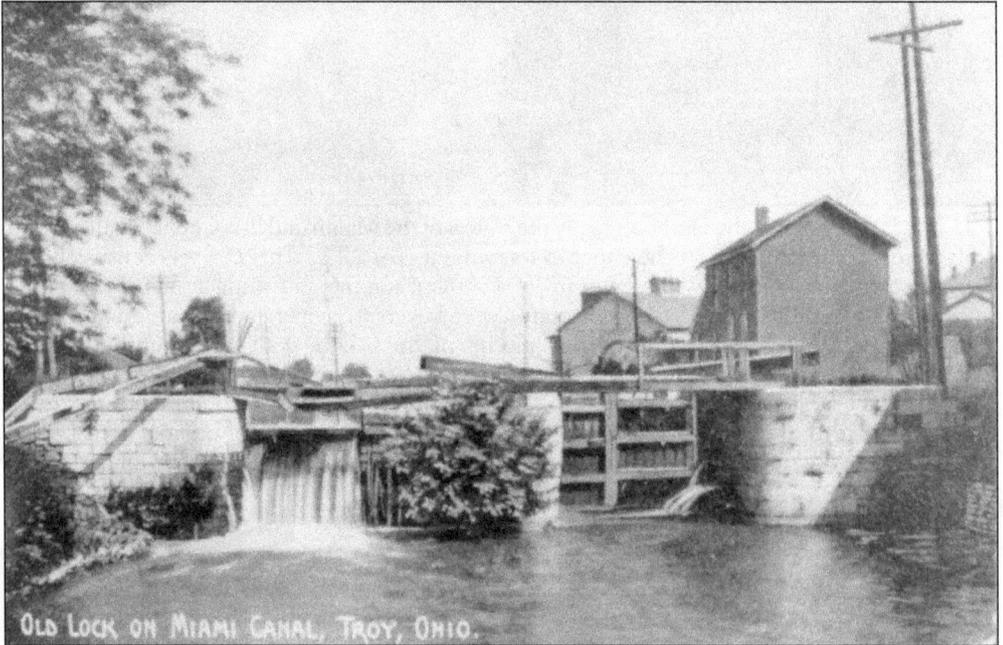

Troy is the county seat of Miami County. The town's idyllic setting made it a popular honeymoon destination in the mid-to-late 19th century. Lock 12s, shown in this postcard, was located north of the city center. Troy later became a center for manufacturing of aircraft, prefabricated homes, and welding equipment. (Courtesy of David Neuhardt.)

60

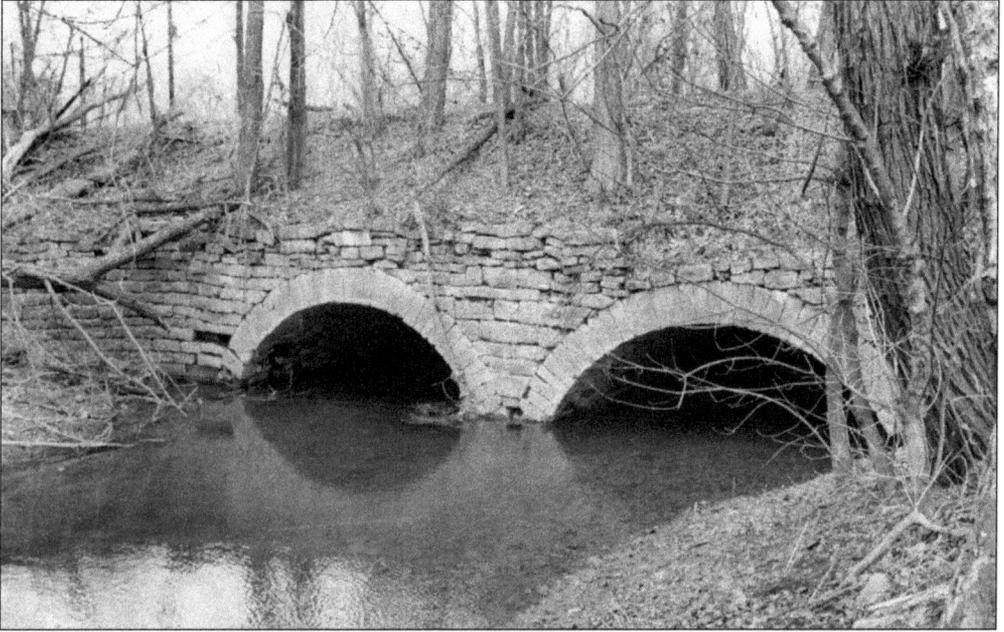

The photograph above shows the twin-arched Eldean culvert, located north of Troy. State engineers learned belatedly that while culverts were an expensive way to cross streams, they more than made up for their expense in low maintenance costs over their life spans. The image below shows Lock 10s, also known as Farrington's or Slosson's Lock. A distillery and covered bridge over the nearby Great Miami River were part of this original site. The well-preserved covered bridge still crosses the river. (Above, courtesy of the Canal Society of Ohio; below, courtesy of Piqua Public Library.)

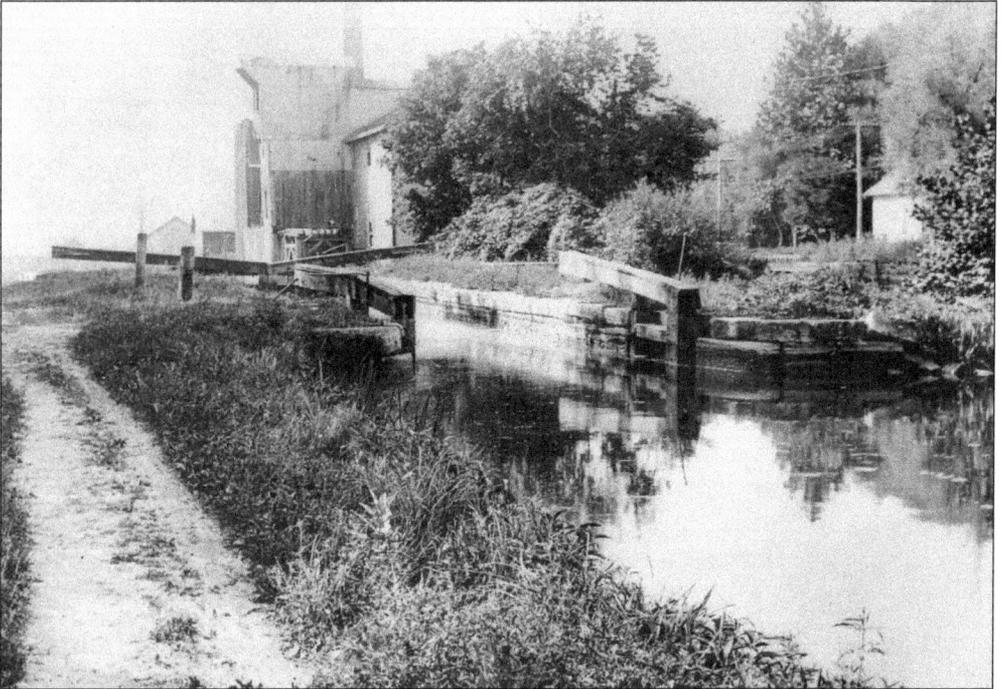

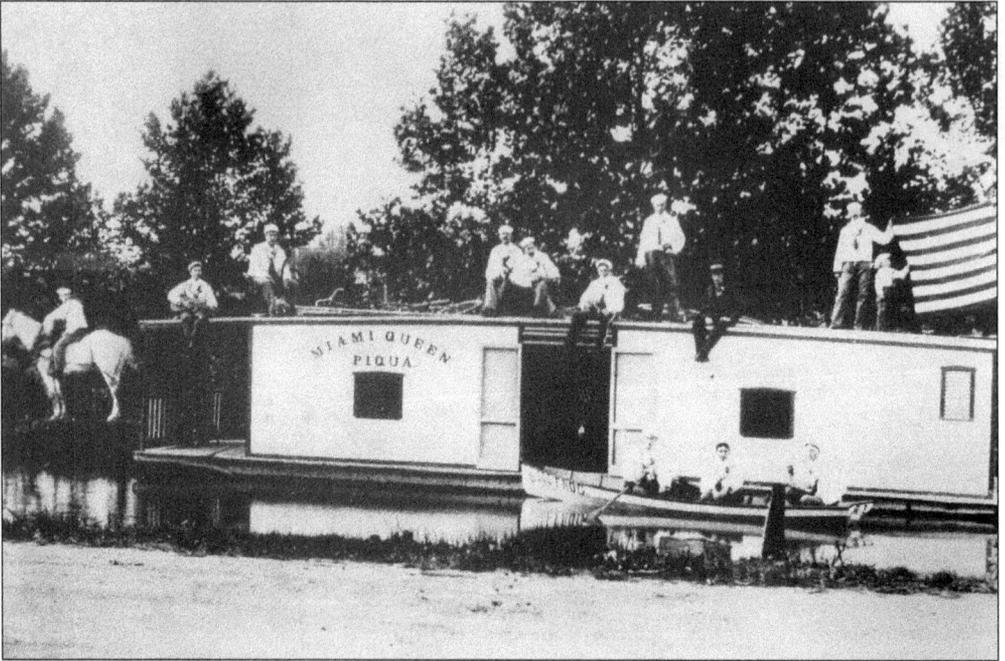

Picnic excursion boats were very popular in the waning days of the canal. Several were owned and operated by local manufacturers. The *Miami Queen* (above) was built in the 1890s by the Piqua Handle Company and appears to be on its way to or from Miller's Grove. Northeast of Piqua on a strip of land shoehorned between Loramie Creek and the canal, Miller's Grove was a popular destination for city folk seeking a day of fun and sun in a parklike rural setting. The photograph below shows the state-owned *W.T. McLean* maintenance boat docked in Piqua. (Both, courtesy of the Piqua Public Library.)

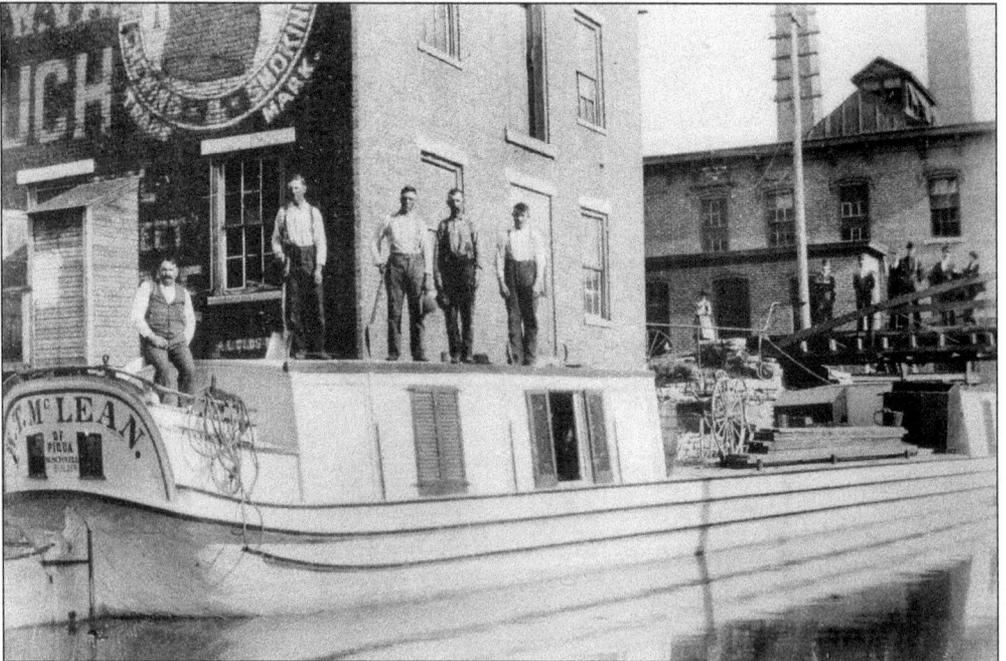

Bridges were constructed over the canal in nine places within the Piqua city limits. Four of these led directly to bridges spanning the Great Miami River. The image above shows the steam-powered Main Street canal swing bridge, which attached to a steel truss bridge over the adjacent river. The small building in the foreground housed the steam engine. It was built in the 1880s and destroyed in the 1913 flood. The photograph below shows the beautifully constructed, flat-arched Ash Street canal bridge. The bridge became a favorite subject of postcards in the era leading up to 1900. It was built in 1845 and demolished in March 1901. (Both, courtesy of the Piqua Public Library.)

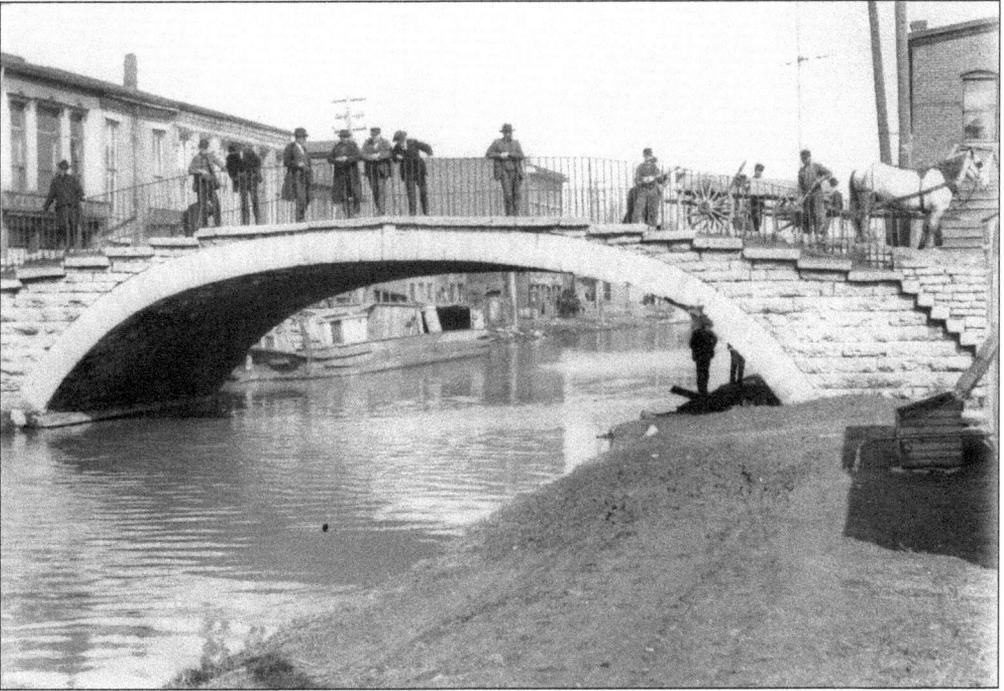

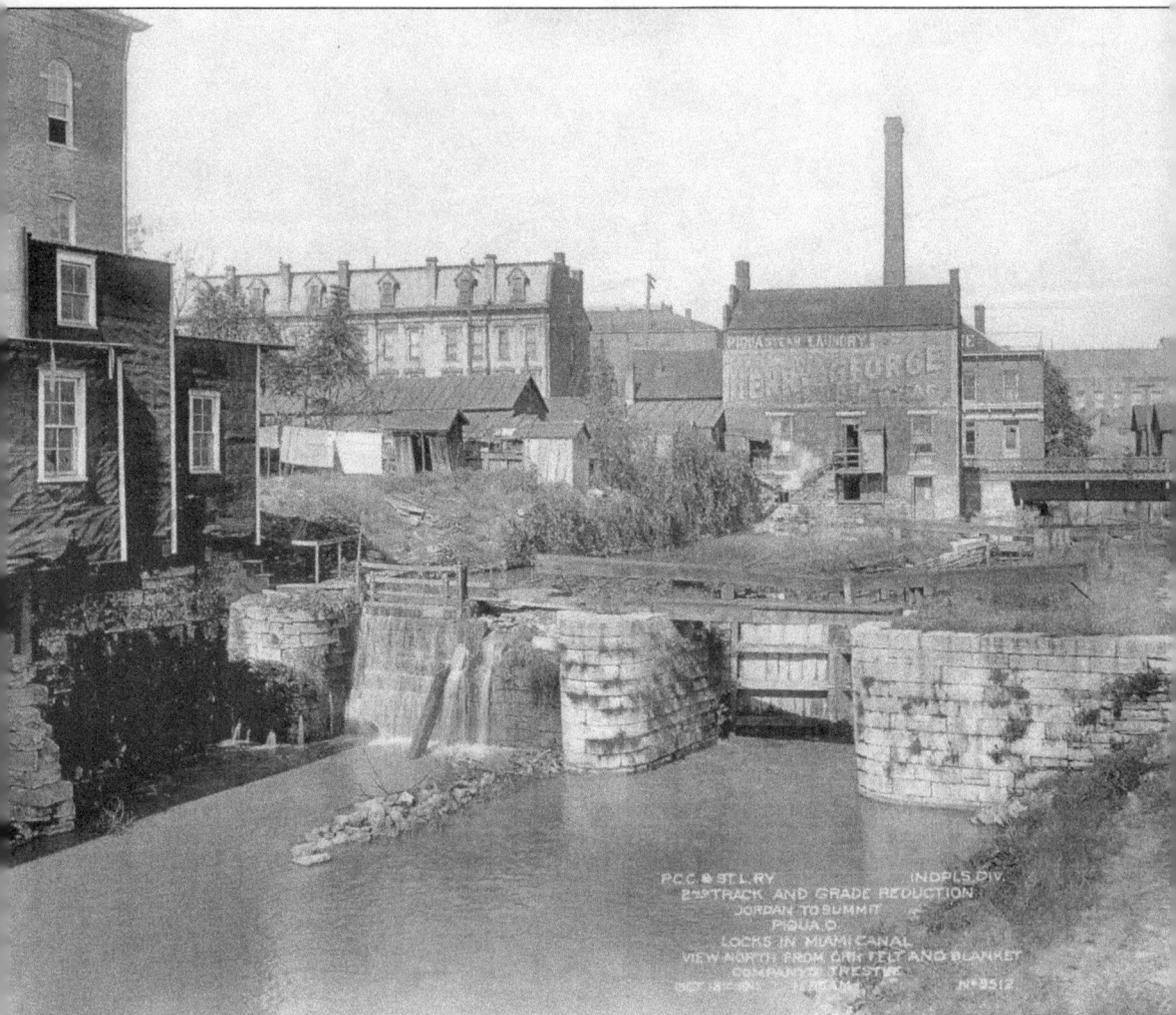

PCC & ST L RY INDPLS DIV.
2ND TRACK AND GRADE REDUCTION
JORDAN TO SUMMIT
PIQUA. O.
LOCKS IN MIAMI CANAL
VIEW NORTH FROM C.H. FELT AND BLANKET
COMPANY'S TRESTLE
OCT 18 190... H DEAM N° 3512

Piqua was first surveyed and platted in 1807 as the village of Washington. This name proved to be unpopular and was changed to Piqua in 1816. Piqua was incorporated as a town in 1823, and then attained city status in 1850. Construction of the canal reached Piqua in early 1837. Due to the usual financial panics and disease epidemics that plagued 19th-century public works projects, Piqua remained the northern head of navigation for the canal until 1843. Piqua grew in population and prospered as a regional market center during this period. Over the years, Piqua became a notable producer of linseed oil, lumber products, and undergarments. One of the canal's 10 toll collector's offices was located in town. Lock 9s was located near the city center and powered several milling operations over the years. The Piqua Rolling Mill is shown to the left of the lock. (Courtesy of the Piqua Public Library.)

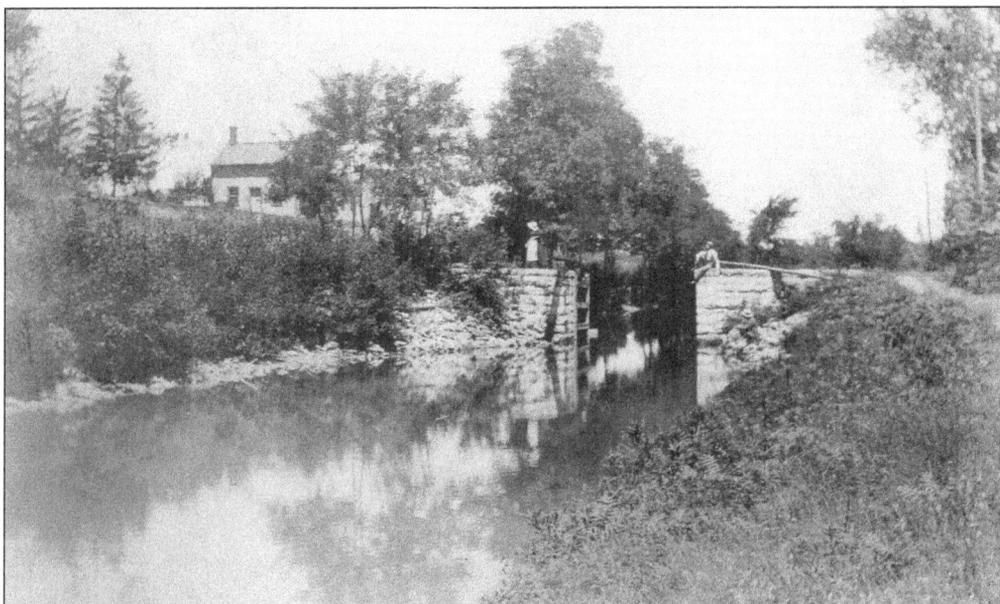

The Piqua Guard Gates are located just north of the city center. The guard gates' sole purpose was to shut off the water supply heading downstream towards Piqua during flood conditions or when maintenance was necessary. The structure's one-gate design did not allow for the raising or lowering of boats. (Courtesy of the Piqua Public Library.)

The canal's crossing of the Swift Run overflow was originally accomplished with the construction of a small wooden weir structure. This proved to be unpopular with boaters after several of them were swept into the adjacent river during high water conditions. That structure was later replaced with the small wooden-flumed aqueduct shown in this 1916 photograph. (Courtesy of the Canal Society of Ohio.)

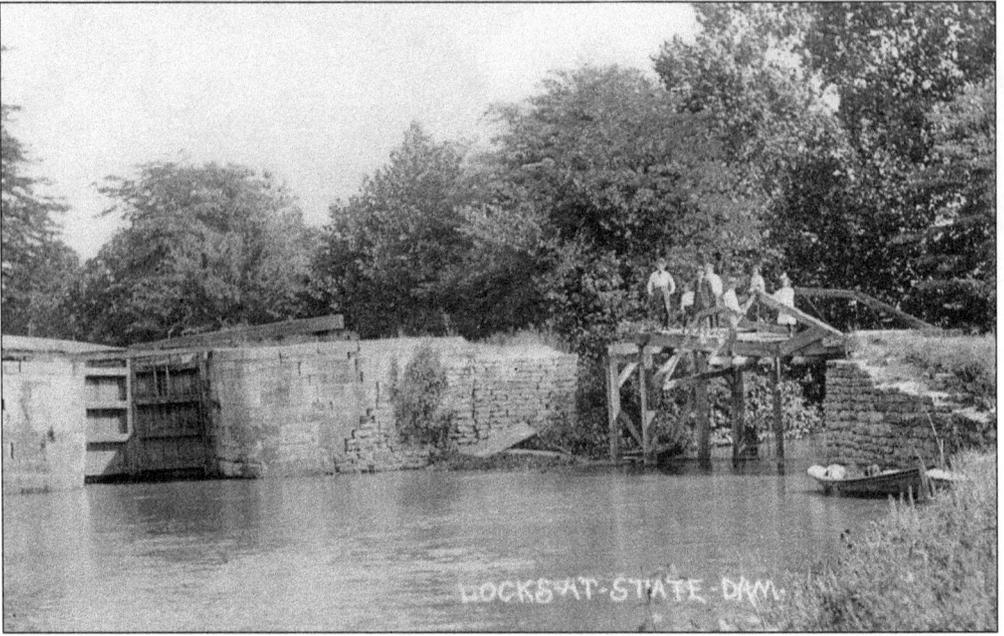

This 1900 photograph shows Lock 8s, north of Piqua. The people to the right are standing on a tow bridge that spanned the feeder channel from the state dam on the adjacent Great Miami River. Lock 8 was the only lock in Miami County that had no associated milling operation benefiting from its available waterpower. (Courtesy of David Neuhardt.)

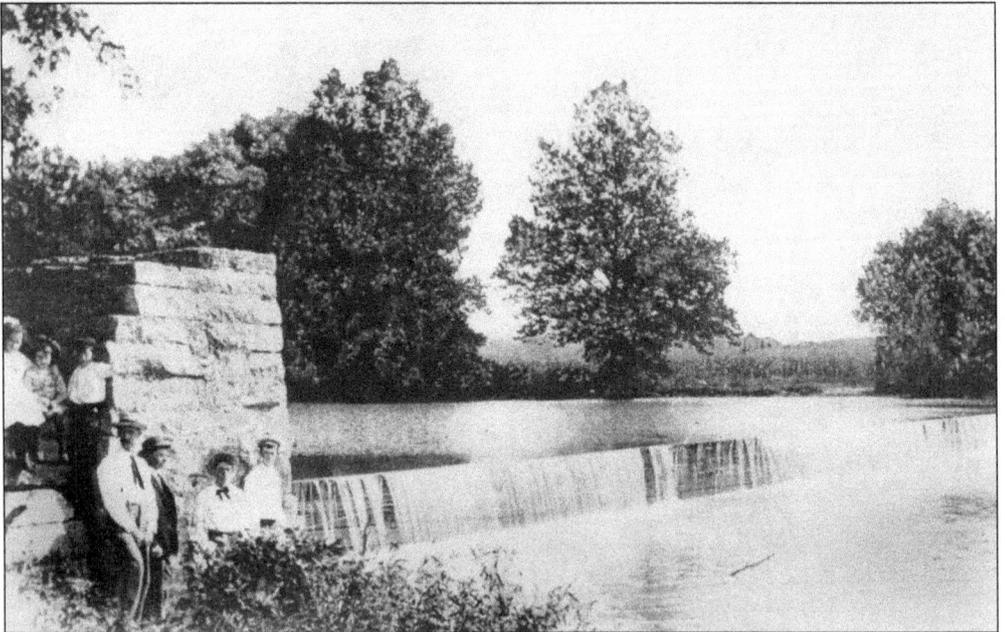

The state dam adjacent to Lock 8 diverted water from the Miami River into the canal and was the reason that Piqua was the head of canal navigation from 1837 through 1843. The dam was built of the normal wooden-crib design, with stone abutments. These structures were relatively inexpensive to build and seemingly in need of constant mending or replacement. (Courtesy of David Neuhardt.)

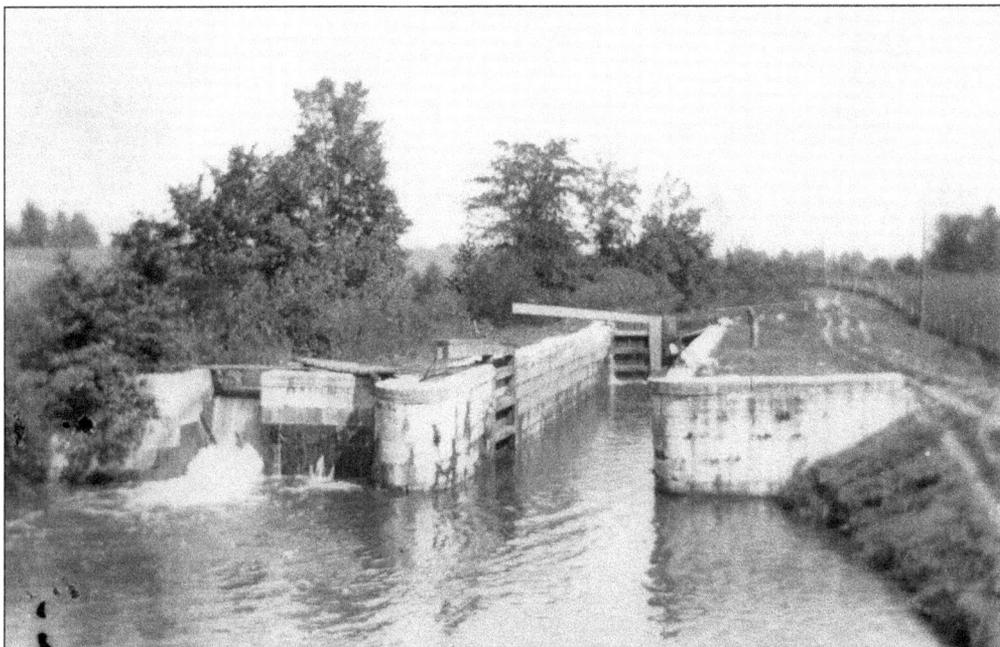

Lock 7s was the first of seven canal locks in Shelby County. The head of water generated at the lock powered the grinding stones of the Landsman/Loramie Mill (below) from 1851 until the early 20th century, when waterpower was replaced by a locally built French Oil turbine. The Loramie Mill processed flour, cornmeal, and animal feed until ceasing operation in the early 1950s. Locals have said that in later years, the mill's owner would operate the mill when needed as a favor to his farming neighbors. This local landmark collapsed from old age in January 2007. (Both, courtesy of the Canal Society of Ohio.)

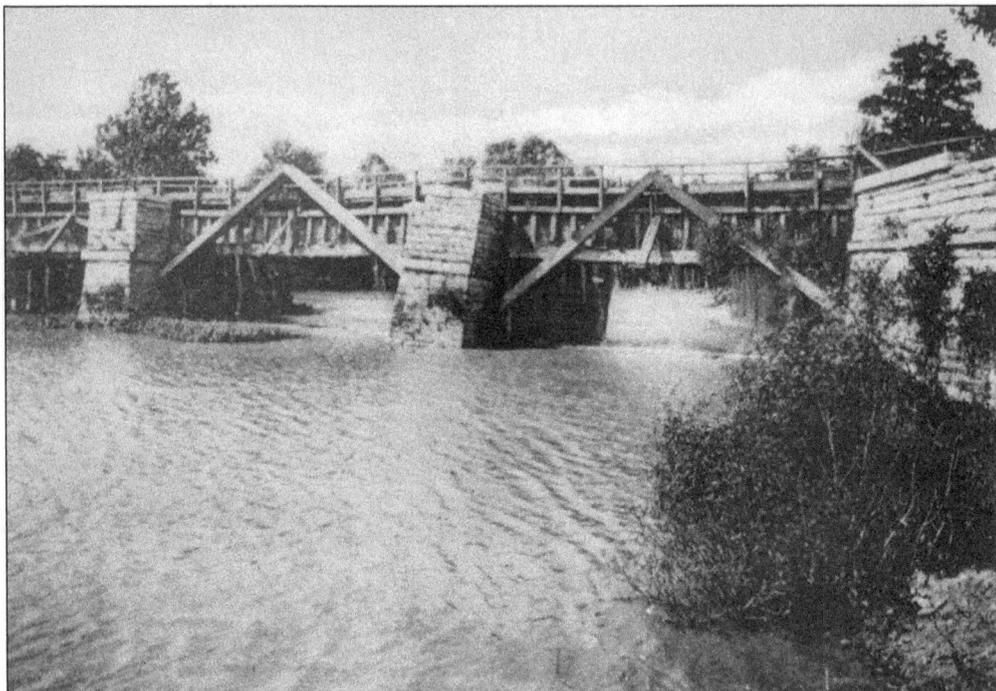

The next lock north was Lock 6s, which was known as Crooked Lock because it was off the axis of the five other locks that led to the Loramie summit on the north side of the Loramie Creek crossing. The Loramie Creek Aqueduct crossed Loramie Creek over three spans totaling 202 feet in length and was as troublesome and leaky as any other wooden-flumed aqueduct. (Courtesy of the Canal Society of Ohio.)

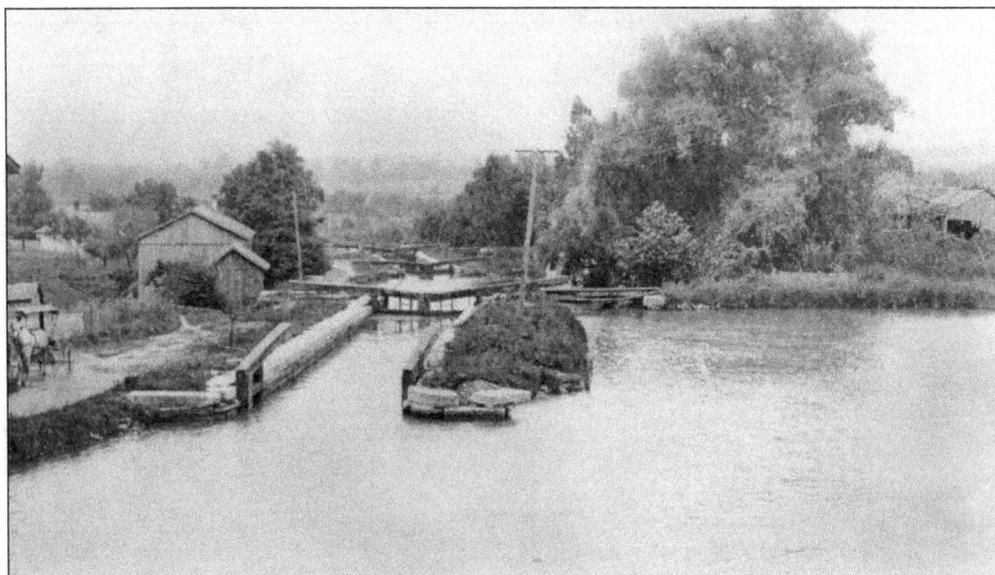

Lockington was expected to become a manufacturing powerhouse. However, despite a potential head of 67 feet of waterpower available with the descent of the staircase of locks at Lockington, only one mill ever took advantage of it. This image captures the descent of Locks 3s, 4s, and 5s descending the Loramie summit. (Courtesy of the Canal Society of Ohio.)

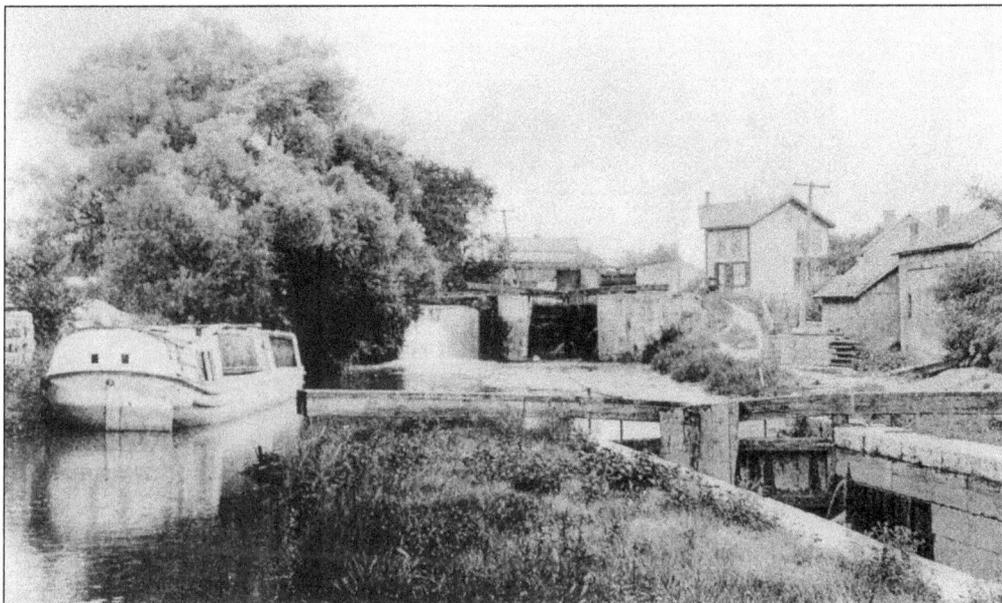

The village of Lockington is the first of several settlements in Shelby County that owe their existence to the canal. Most have faded from memory. Some were platted and never built. Lockport, as Lockington was originally named, was platted at the plateau of the Loramie summit in 1837. The village was 512 feet in elevation above the canal's southern terminus at the Ohio River, and 374 feet above the northern terminus on Lake Erie. The photograph above shows the ascending Locks 3s, 2s, and 1s. The photograph below shows a wooden weir below Lock 3s that diverted excess water to a holding pond that powered the Piqua Hydraulic. Impounded waters at this pond were conveyed along a path parallel to the Miami and Erie for industrial use in Piqua. (Both, courtesy of David Neuhardt.)

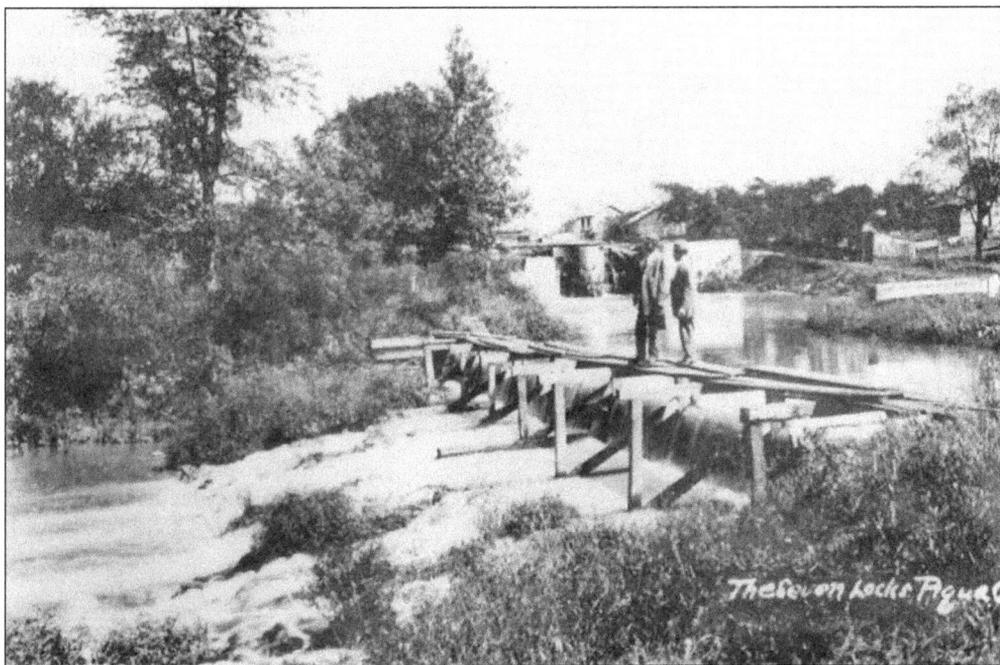

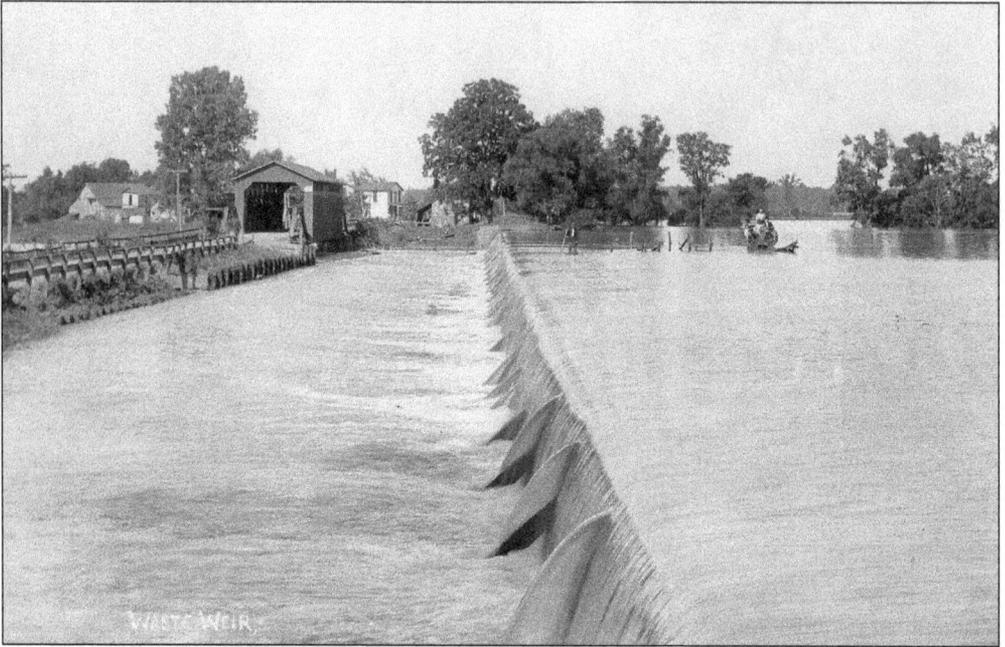

WASTE WEIR

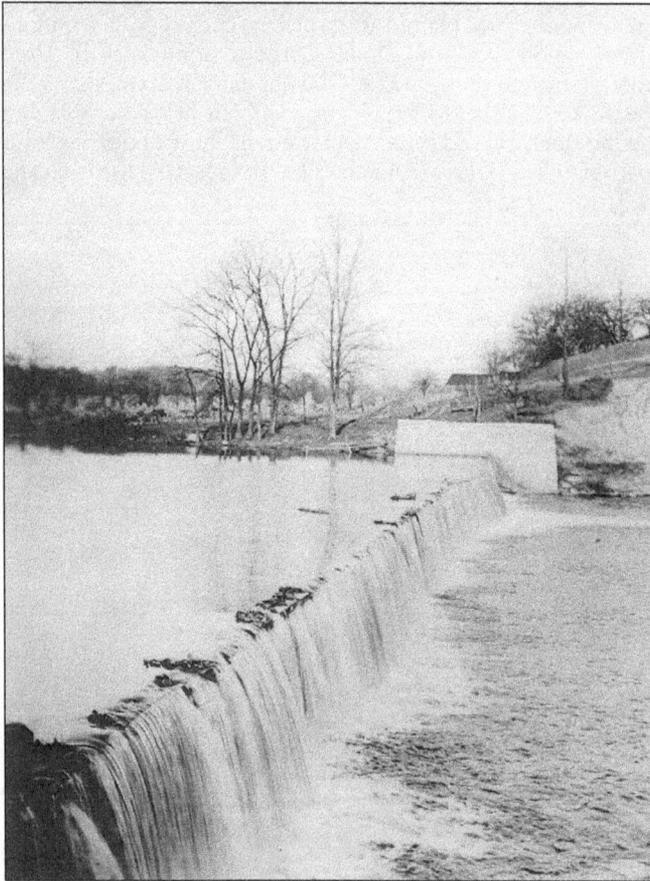

The 23 miles of the Loramie summit necessitated the construction of two reservoirs to supply water because of the insufficient size of the streams on the summit. The southernmost of these was the Lewistown Reservoir. It was built in Logan County and sent its impounded water 20 miles by way of the Great Miami River. A dam at Port Jefferson diverted this water 13 miles farther by way of the navigable Sidney feeder to the canal near Lockington. The photograph above shows the surplus water of the reservoir spilling off and into a channel that led to the Great Miami River. The photograph at left shows the dam on the Great Miami that diverted water into the Sidney feeder. (Both, courtesy of David Neuhardt.)

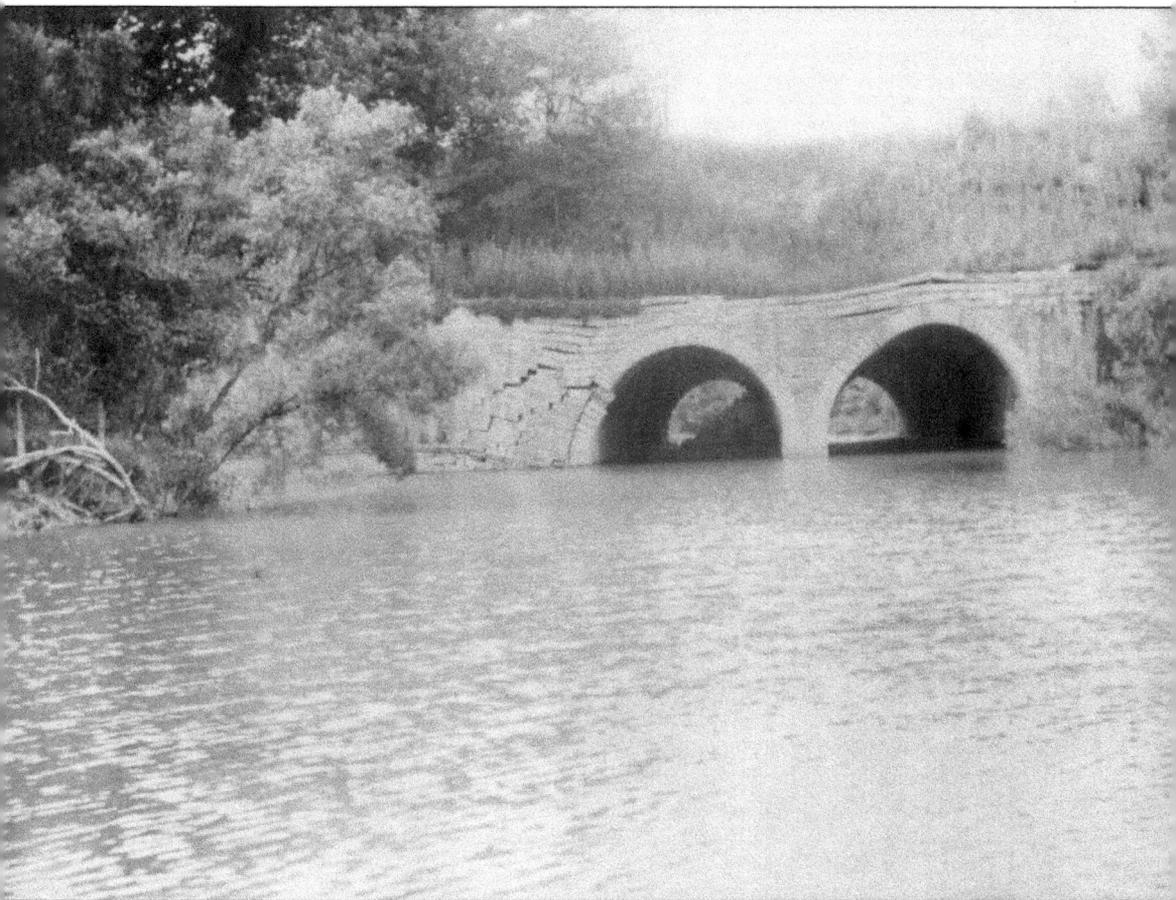

The double-arched Turtle Creek culvert was located on the 23-mile level of the Loramie summit. Construction on this massive structure commenced in 1837, but, due to financial panics, epidemics, and lawsuits filed by the state against the contractors, work was not completed until 1843. According to an 1845 Ohio Board of Public Works report, the culvert had a final construction cost of $174,256. The Turtle Creek culvert's twin masonry arches stood 22 feet wide and 16 feet tall. Six other stone-arched culverts and several timber-box culverts carried the canal over streams on the summit. Unless there were severe drought conditions, a canal boat could speedily traverse the summit without the time-consuming need to lock through. This photograph shows the culvert in 1916. In 1982, Shelby County engineers preemptively removed the decaying culvert ahead of its imminent collapse and the resultant blockage of Turtle Creek. (Courtesy of the Canal Society of Ohio.)

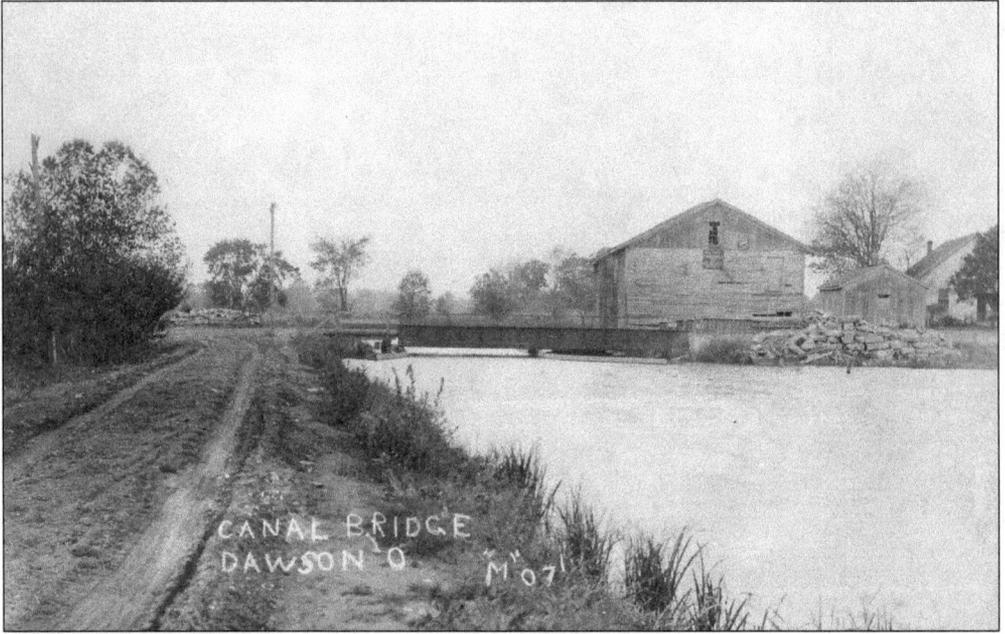

CANAL BRIDGE
DAWSON O. M 07

Many large basins and ice ponds were located along the canal in the vicinity of Dawson's Station (above). Originally established as the religious community of Hamlet, Dawson represented the southern extent of a string of settlements known as New Germany, which stretched as far north as Ottoville. The village once supported a post office and a warehouse and was a stop on the Big Four Railroad line. The photograph below, from around 1900, shows another hoist bridge crossing of the canal in the village of Newport. Even smaller towns availed themselves of this new technology, much to the delight of bridge manufacturers. (Above, courtesy of David Neuhardt; below, courtesy of Mark Renwick.)

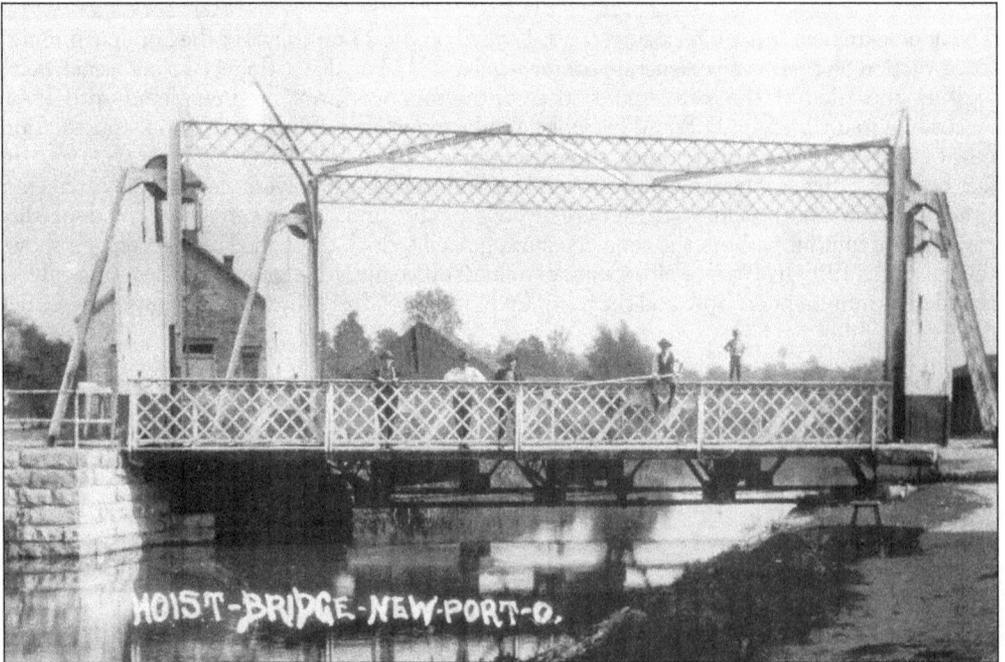

HOIST-BRIDGE-NEW-PORT-O.

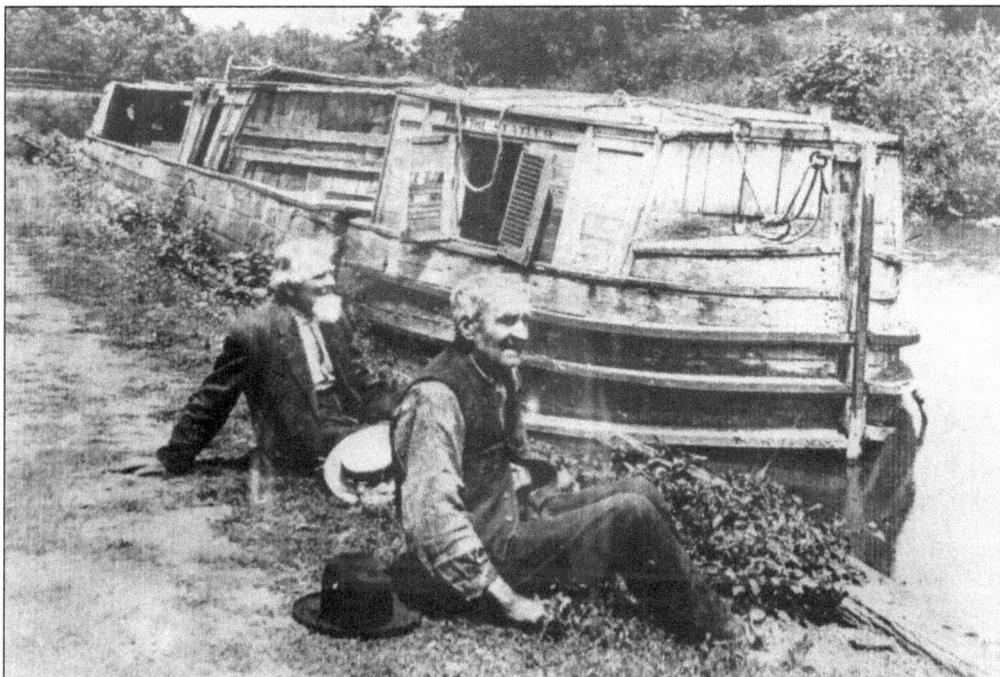

The *DeCamp Statler*, a stone hauler, is reputed to be the last freighter to operate in Shelby and Miami Counties. It carried its last load of gravel through Piqua in 1911. The boat was towed back north and left to rot along the canal banks in the village of Newport. The gentleman to the left in the 1912 photograph above is identified as Adam Connover, a retired boat captain. William Combs Sr., the father of the boat's last owner, is thought to be the fellow to the right. Another view of the *DeCamp Statler*'s final resting place is shown below. (Both, courtesy of the Canal Society of Ohio.)

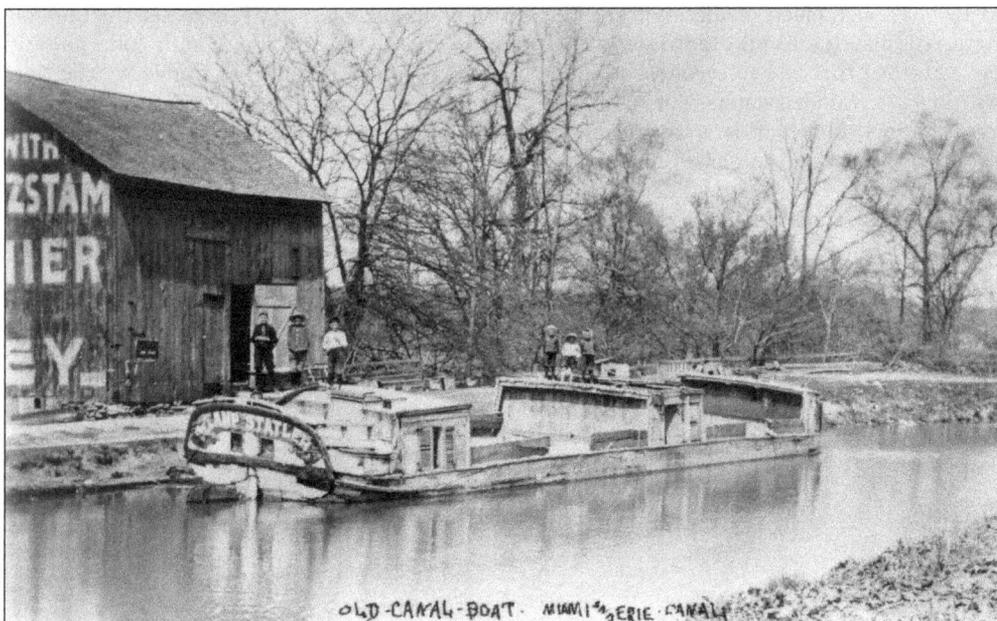

OLD-CANAL-BOAT. MIAMI & ERIE CANAL

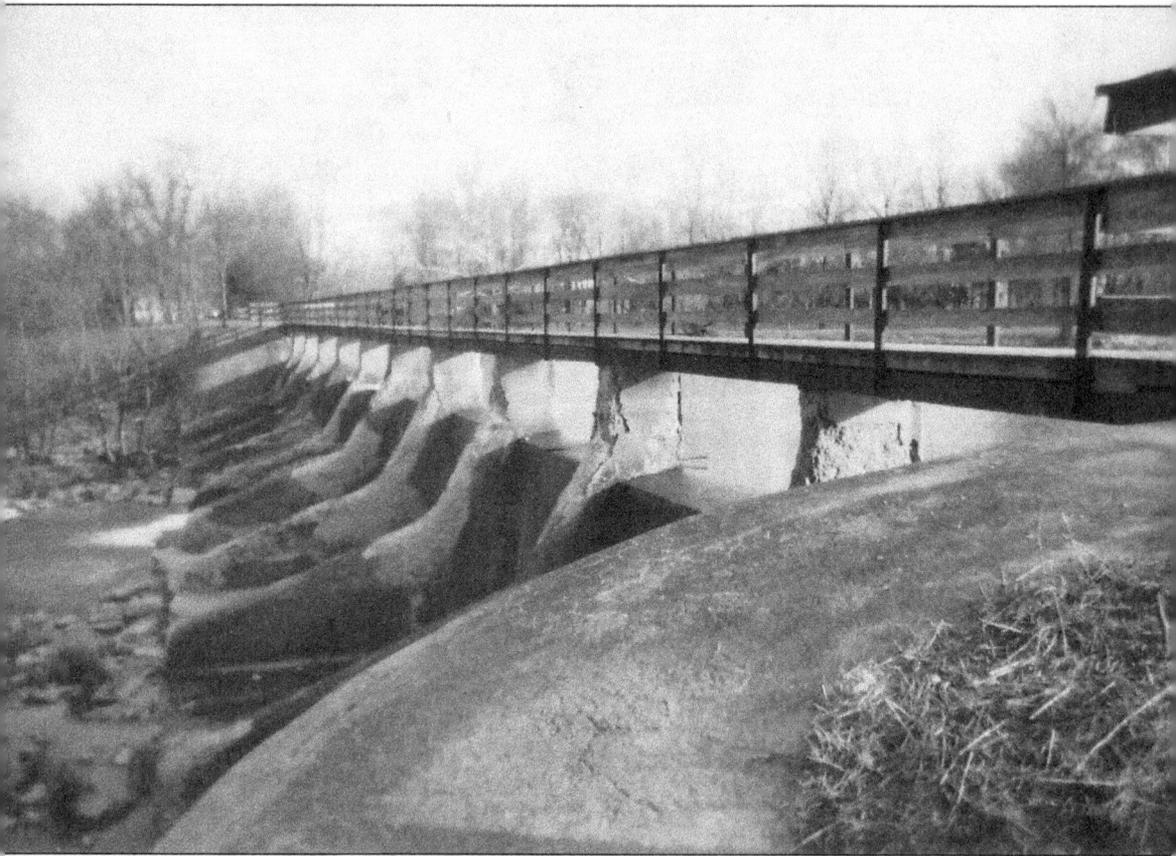

The Loramie Reservoir (now Lake Loramie) watered the summit both north and south. A force of laborers built an earthen dam across Loramie Creek to create the 1,500–1,800-acre reservoir in 1843. Though much smaller than the Lewistown and Mercer County Reservoirs, the Loramie Reservoir played an important role in maintaining water levels on the 23-mile-long summit. As with the other two reservoirs, the state chose for financial reasons not to remove the trees within its impounded waters. The reservoir fed waters to the canal by way of a narrow, half-mile-long channel. This photograph shows the reservoir's concrete waste weir in 2005. The weir was designed to shed water in excess of what was needed for canal purposes from the reservoir into Loramie Creek. The reservoir later became part of Ohio's state park system and is maintained by the Ohio Department of Natural Resources. (Authors' collection.)

The village of Berlin was founded by German immigrants in 1837 near the remnants of a trading post established in 1767 by Peter Loramie, a French Canadian. The canal came through in 1841 and brought a degree of prosperity. The village was later renamed Fort Loramie in honor of the French fur trader. This c. 1910 image shows the canal running parallel with Fort Loramie's Main Street. (Courtesy of Neal Brady.)

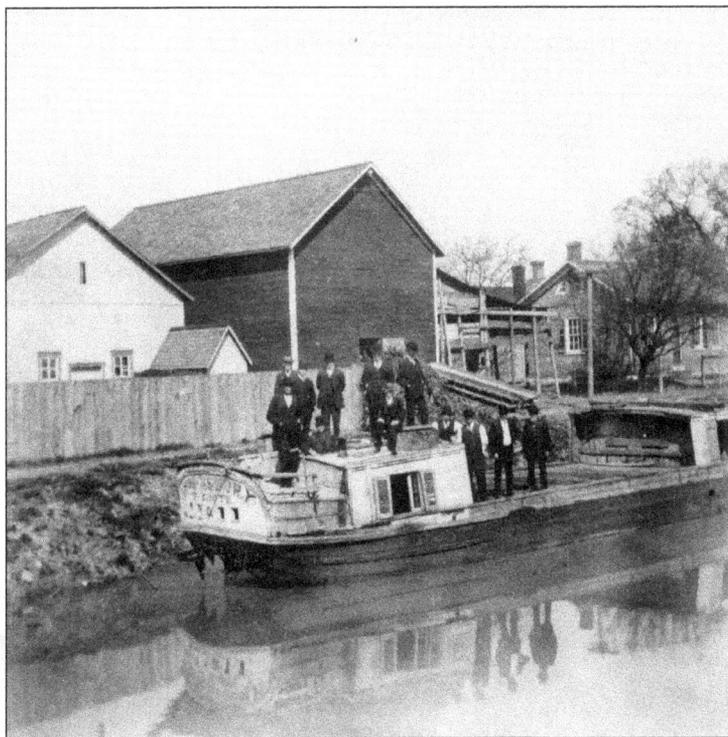

Minster was another of the New Germany settlements established along the canal. Incorporated in 1839 as Muenster, the town name was later anglicized to Minster. It is in the center of a remarkable concentration of large Catholic churches— there were once 45 in a 20-square-mile area. This photograph shows the *Thos. Asbury* docked on the canal's east bank between Third and Fourth Streets in Minster. (Courtesy of the Minster Historical Society.)

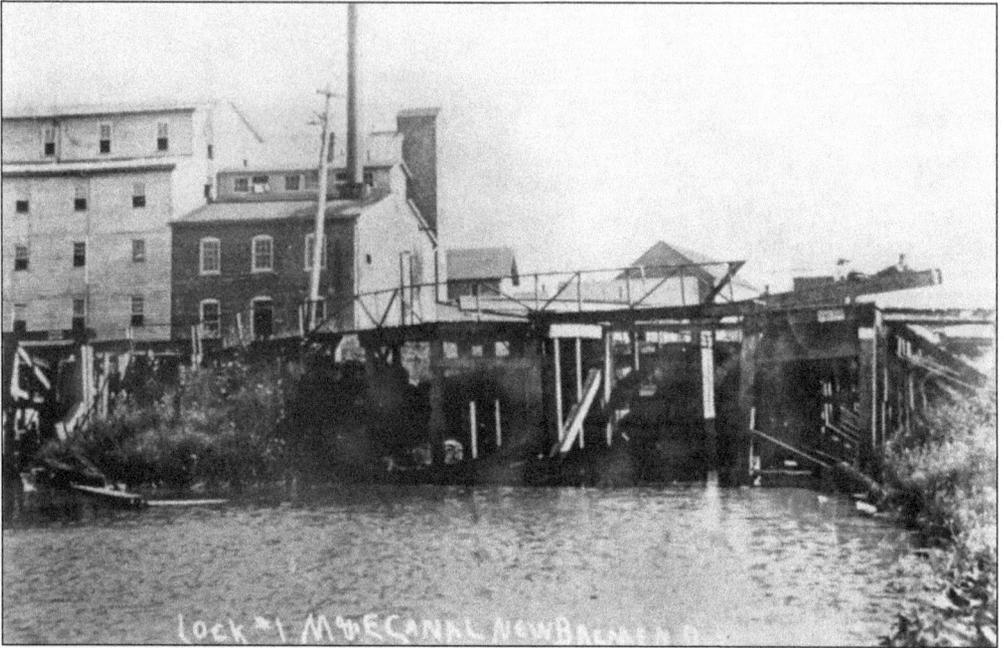

Lock 1n in New Bremen marked the end of the 23-mile-long level of the Loramie summit. It is 374 feet in elevation above the canal's original northern terminus at Lake Erie in Toledo. Several adjacent mills were powered by the fall of water generated at the lock. Lock 1 was originally of wooden construction, as were most of the canal locks between New Bremen and Defiance. This was allegedly due to a lack of suitable stone in the area, but it was more likely a cost-cutting measure. These photographs show the lock before (above) and after (below) it was replaced with concrete around 1910. The lock tender's house is shown in the upper center of the image below. (Above, courtesy of Neal Brady; below, courtesy of David Neuhardt.)

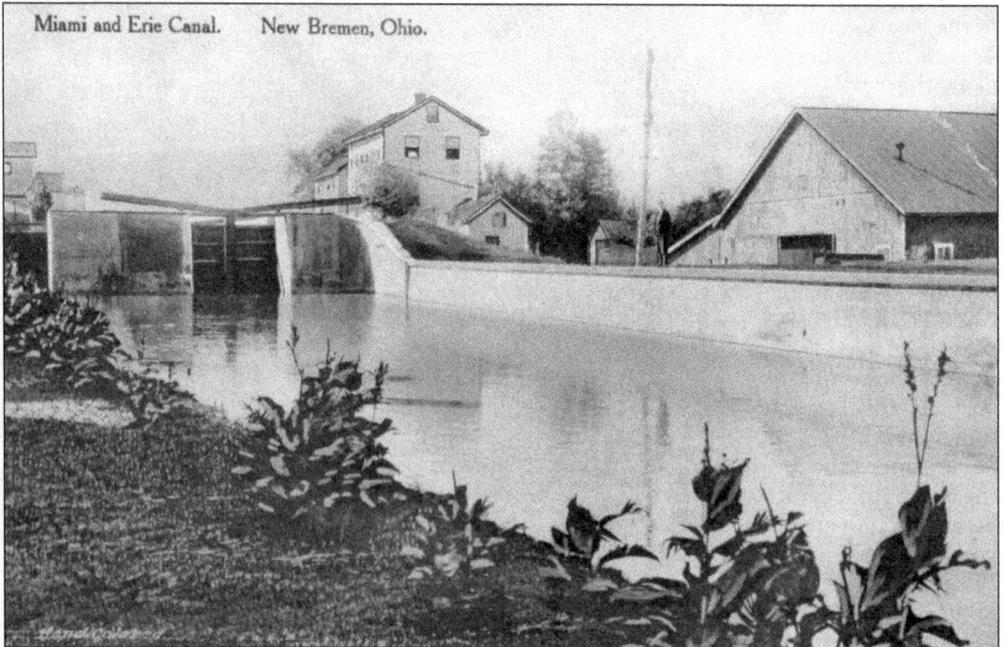

MIAMI & ERIE CANAL - NEW BREMEN, OHIO

New Bremen was another one of the New Germany settlements founded along the route of the canal. Platted in 1833, Bremen, as it was originally known, attained village status as New Bremen in 1837. This undated postcard shows a scenic view of the canal as it approaches the village. (Courtesy of David Neuhardt.)

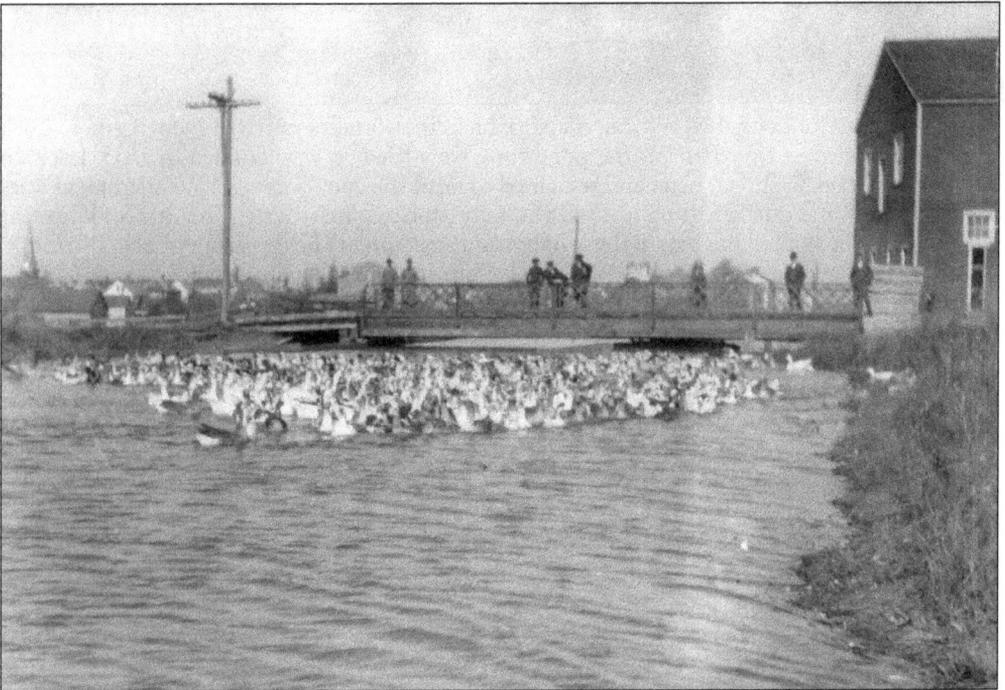

A group of spectators view a flock of geese awaiting their fate from the Plum Street swing bridge in this 1905 photograph. The poultry processing plant is to the right. New Bremen also had a steam-operated lift bridge at Monroe Street. (Courtesy of the Canal Society of Ohio.)

77

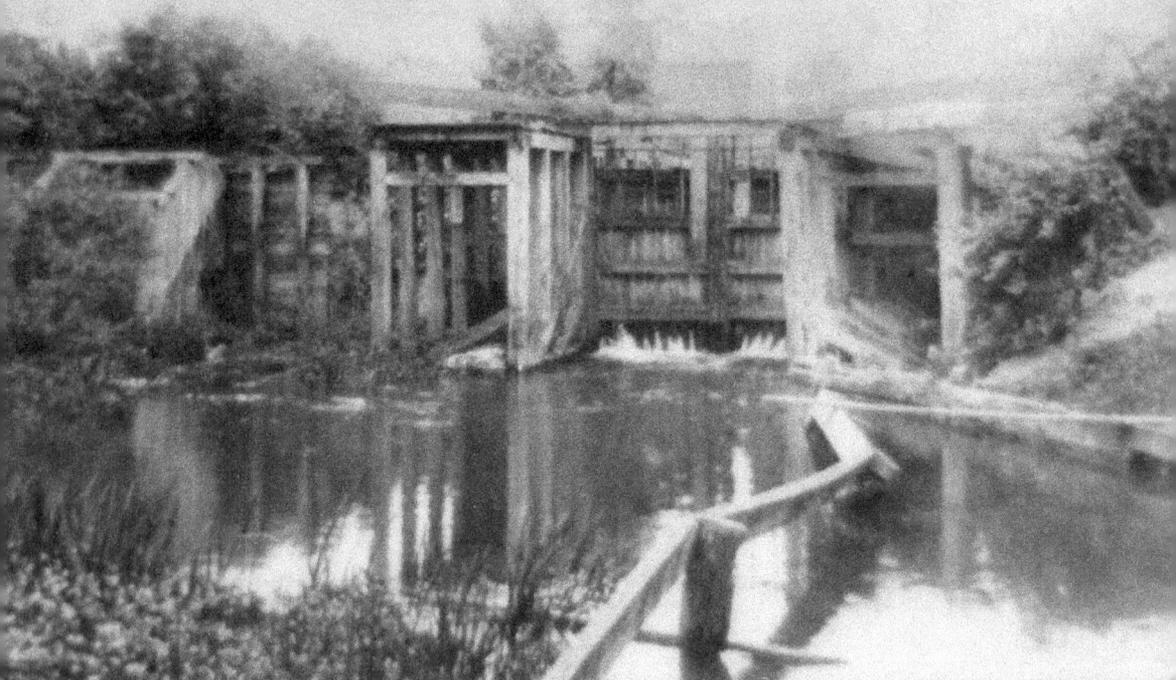

The community of Lock Two is located approximately two miles north of New Bremen. Lock Two was founded as New Paris at the same time New Bremen was founded in 1833. Lock 2n was built of wood, as shown here, and remained so until the canal's demise. Wooden locks were much cheaper and quicker to build than their cut stone counterparts. The downside to this frugality was the limited lifespan of these important structures. The three-story Lock Two Grain & Milling Company mill was built beside the lock in 1854 and remained in business until 1981. The original mill building was destroyed by an explosion in 1903 and was replaced a year later by the brick building that can still be seen today. Lock Two is at the approximate midpoint of the canal between Cincinnati's southern terminus and the canal's northern outlet in Toledo. (Courtesy of David Neuhardt.)

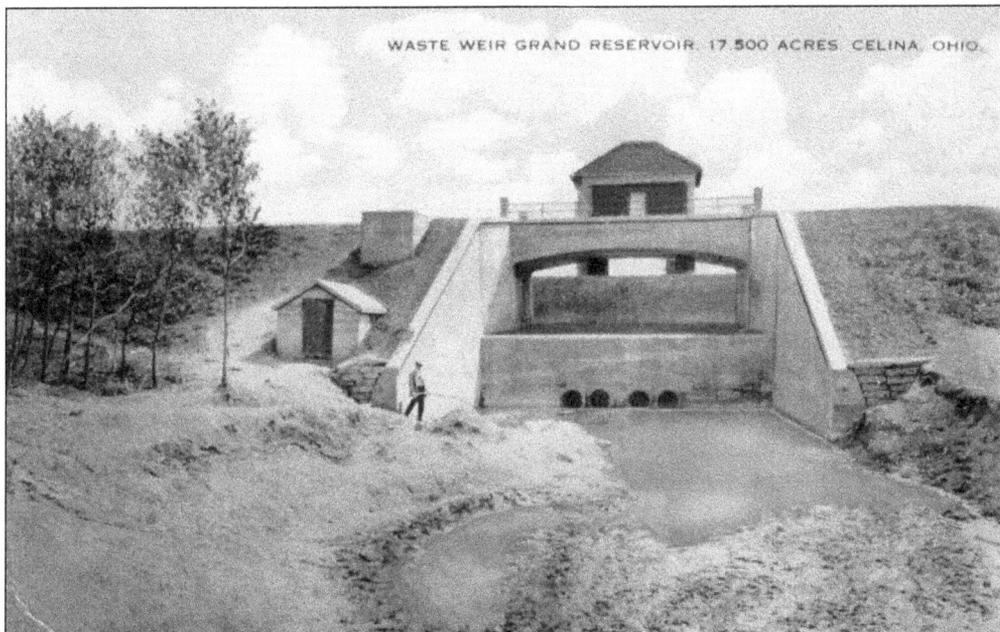

WASTE WEIR GRAND RESERVOIR. 17,500 ACRES CELINA. OHIO.

The nearly 18,000-acre Mercer County Reservoir was both the most ambitious and most expensive of the state's feeder reservoirs. The reservoir, now called Grand Lake St. Marys, was once the largest man-made lake in the world. This image shows a waste weir at the western edge of the reservoir that shed off water superfluous to the needs of the canal. (Courtesy of David Neuhardt.)

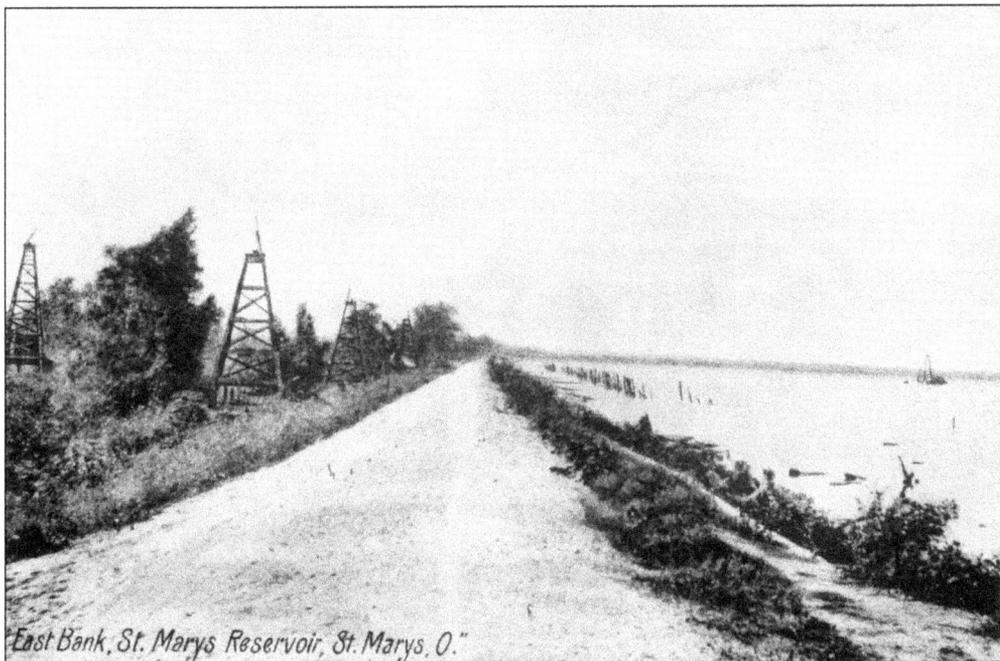

"East Bank, St. Marys Reservoir, St. Marys, O."

The reservoir can also lay claim to being the site of the world's first offshore oil wells, as displayed in this 1905-era postcard. Large reserves of petroleum and natural gas were discovered in the region in the late 19th century. The boom did not last, but, at its peak in 1896, a total of 150 wells recovered 23 million barrels of oil. (Courtesy of Neal Brady.)

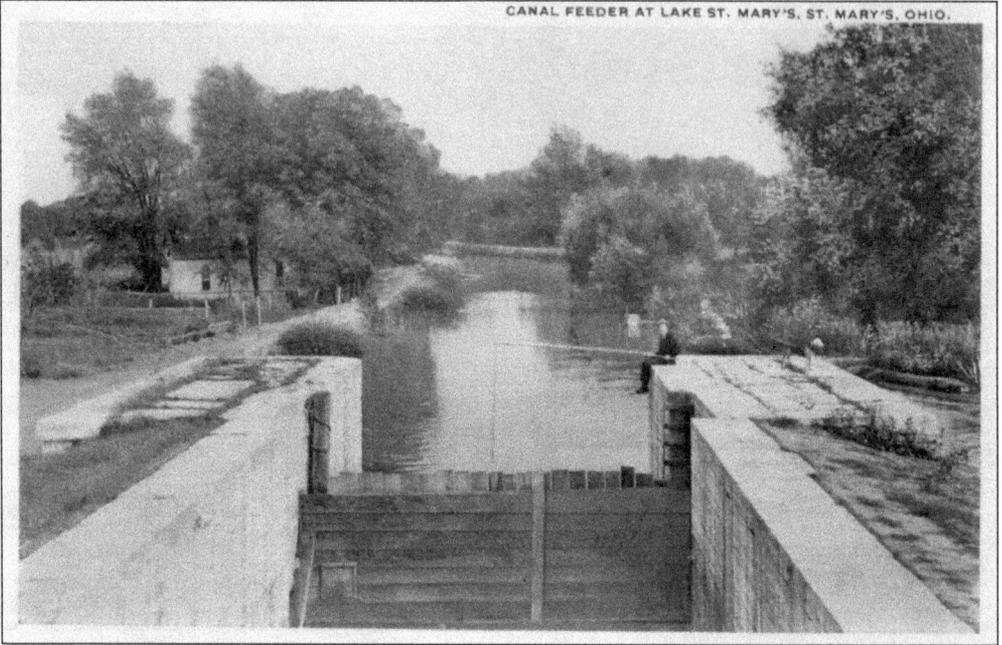

CANAL FEEDER AT LAKE ST. MARY'S, ST. MARY'S, OHIO.

A bulkhead lock on the eastern end of the reservoir led to a navigable feeder to the canal. A canal boat wishing to lock through into the reservoir could, at its peril, pole across the shallow lake to Celina, one of several smaller communities that lined the reservoir shores. Tree stumps lurking below the waterline sank more than a few boats that made the attempt. (Courtesy of David Neuhardt.)

Located just upstream from the junction with the feeder from the reservoir, the 99-foot-long, wooden-flumed St. Marys Aqueduct carried the canal over the St. Marys River and on into the city of St. Marys. The aqueduct was refurbished in the early 1900s with a steel superstructure and continued to convey water to its municipal customers until the flume collapsed in 1943 and was replaced with steel tubes. (Courtesy of David Neuhardt.)

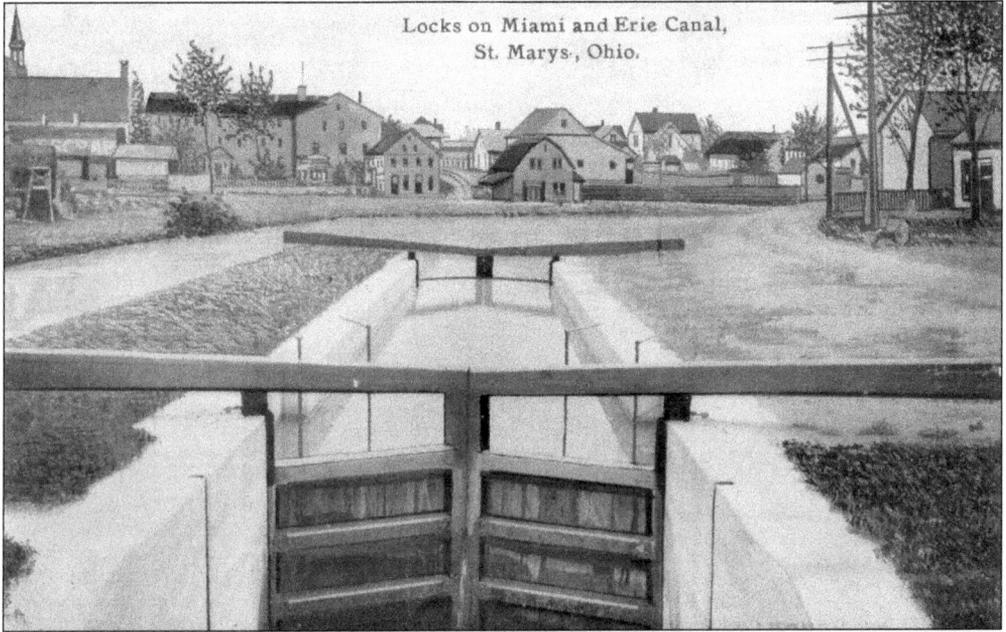

Locks on Miami and Erie Canal,
St. Marys, Ohio.

Seen here are a c. 1910 view of Lock 12n (above) and a c. 1900 view of Lock 13n (below). Both are located in the center of St. Marys. The view above shows the St. Marys mill hydraulic race veering off to the left. This race paralleled the canal at a higher elevation, where its waters powered several mills that returned the spent waters back into the canal. Lock 13 is shown beneath the East High Street Bridge in the photograph below. Both locks were originally of wooden construction and were replaced by concrete structures in 1908 by contractor S.W. Parshall at a combined cost of roughly $20,000. (Above, courtesy of David Neuhardt; below, courtesy of Neal Brady.)

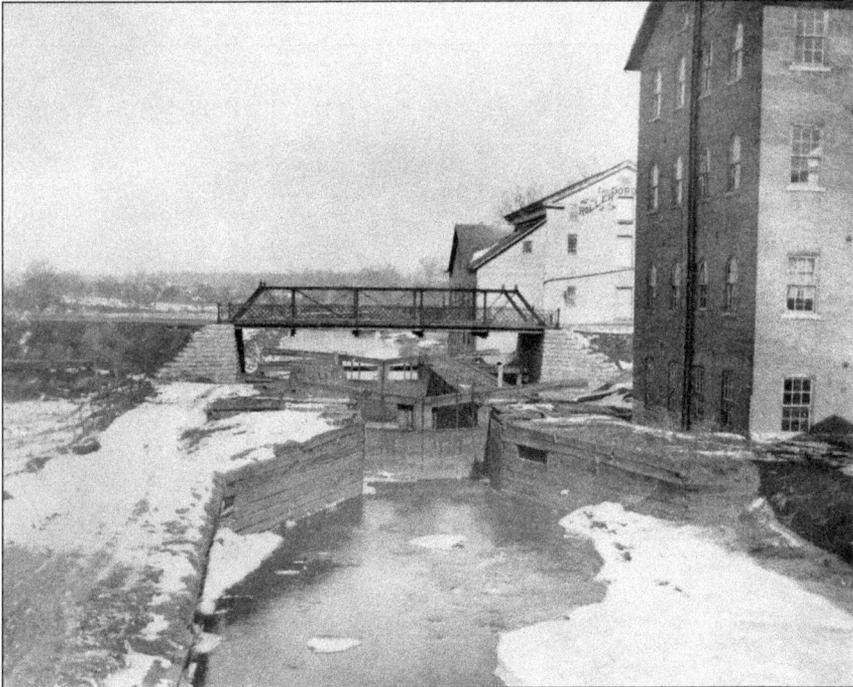

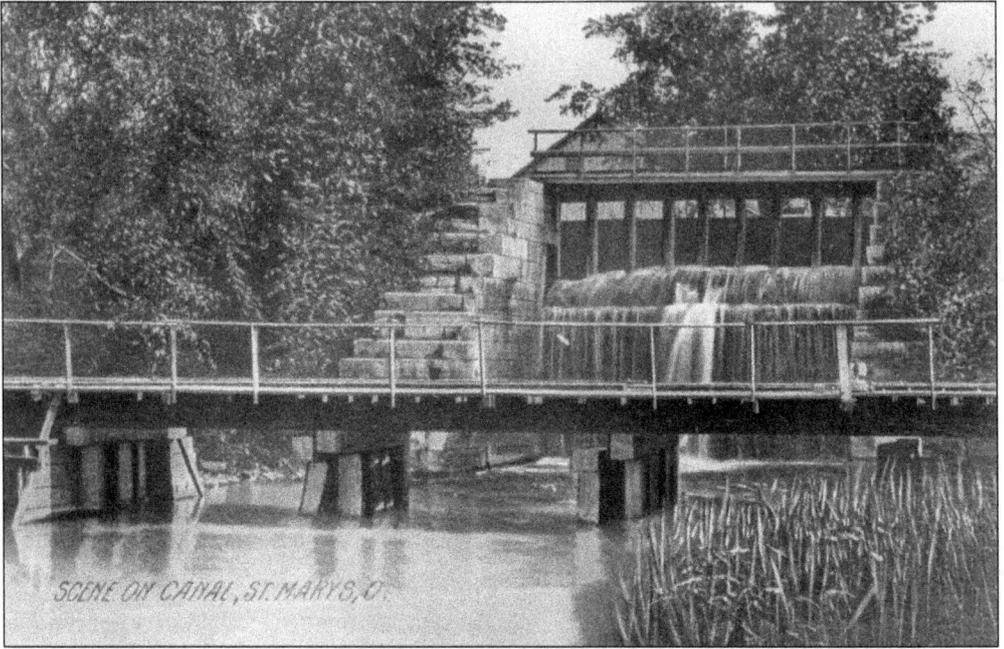

SCENE ON CANAL, ST. MARYS, O.

The Tumbles, shown above, returns the excess waters of the hydraulic race down to the canal below. Note the interurban railway trestle paralleling the canal in the foreground. A gristmill below Lock 13n, as well as the St. Marys water plant and powerhouse (below), leased water from the hydraulic race for cooling purposes for over 100 years. The municipal power plant was the last lessee of canal water in the region. The plant was mothballed in 2007. The town's energy requirements are now served by a regional cooperative. (Both, courtesy of David Neuhardt.)

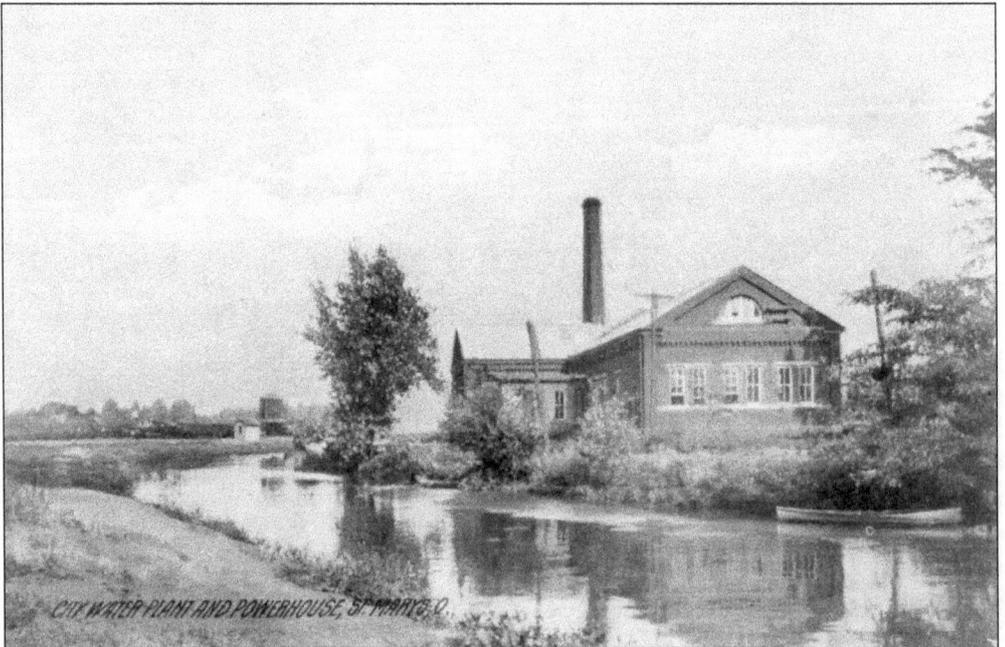

CITY WATER PLANT AND POWERHOUSE, ST MARYS O.

The small, unincorporated community of Lock Fourteen existed approximately five miles downstream (north) of St. Marys. This small hamlet consisted of a school, two lumberyards, a church, a general store, and the Osborne sawmill, powered by Lock 14n. The sawmill and surrounding village fell victim to arson in 1865 and were never rebuilt. Lock 14 was another wooden lock, later replaced by concrete. Schneider Brothers built the replacement in 1906 at a cost of nearly $11,000. However, the Ohio Department of Natural Resources (ODNR) discovered that Schneider cut a lot of corners when executing their 1906 contract. While restoring the lock in 2003, it was found that Schneider Brothers filled their concrete forms with all manner of debris and rubbish in order to reduce their expenditure on the cement. Sadly, the ODNR was unable to resurface the lock as planned, opting instead for a complete replacement of the structure. (Courtesy of Neal Brady.)

Legend says that two canal boaters, Bill Jones and Jack Billings, were both in love with the same woman, Minnie Warren, who eventually chose Billings as her beau. One night, Jones discovered Warren and Billings together on Bloody Bridge, shown here, and beheaded Billings with an axe during an ensuing melee. In shock, Warren flung herself from the bridge and drowned in the canal below. (Courtesy of the Canal Society of Ohio.)

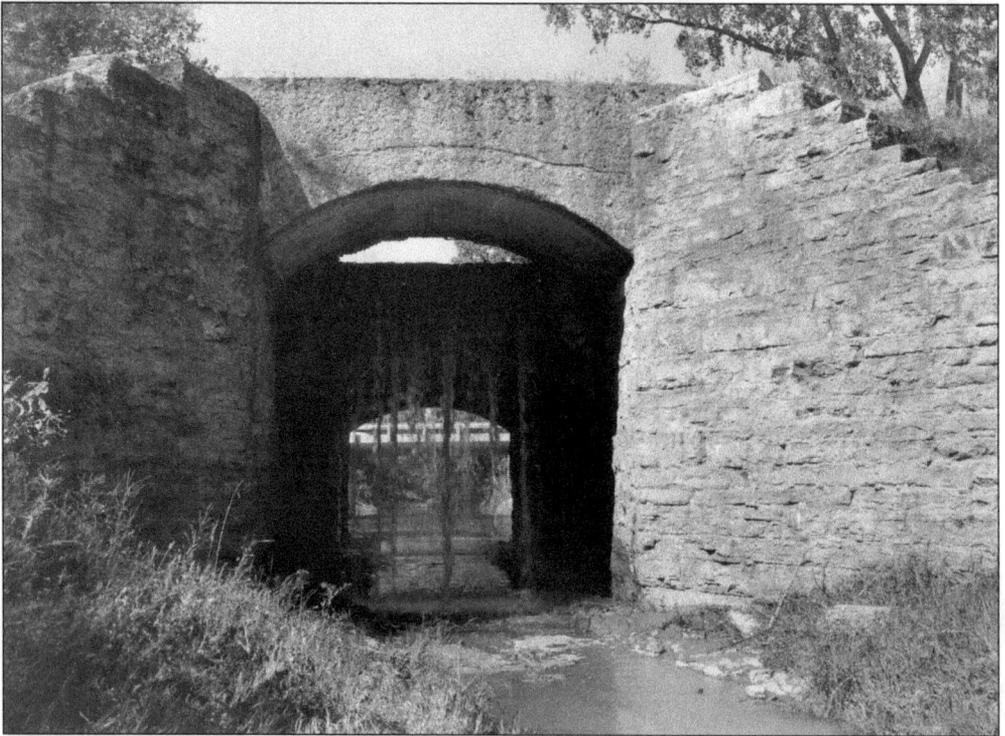

The Six Mile Aqueduct is one of the more attractive structures on the Miami and Erie Canal. It was constructed originally as a large culvert, later converted to a wooden-covered aqueduct, and, in 1907, converted to a concrete-flumed aqueduct, as shown here. One side of the flume is cut lower in order to shed excess waters into the creek below. (Courtesy of the Canal Society of Ohio.)

Deep Cut is located south of Spencerville. Crews of laborers armed with only shovels, horse-drawn scrapers, black powder, and oxen cut the canal through a 6,600-foot-long hard blue clay ridge. As many as 300 laborers spent over three years excavating this trench to 52 feet at its lowest depth. Local legend relates that the cut was dug from both ends; one end by Irish Catholics, the opposite by Irish Protestants. When they met, fights were sure to ensue. The photograph above is a northern view of the cut near its deepest point. The image below shows a bridge crossing the canal at the southern end of the cut. (Above, courtesy of the Canal Society of Ohio; below, courtesy of David Neuhardt.)

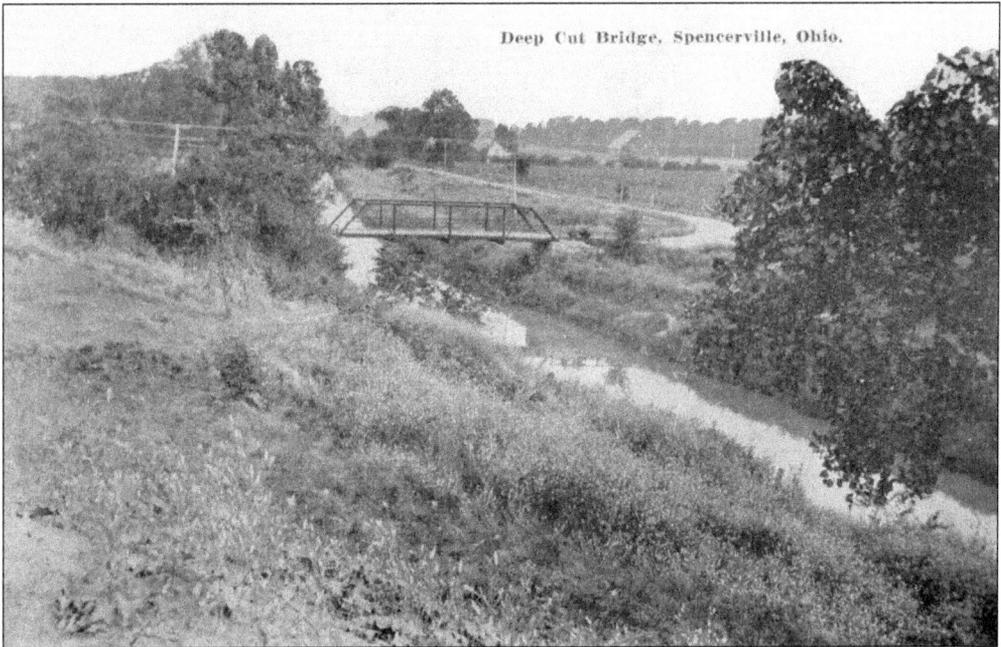

Deep Cut Bridge, Spencerville, Ohio.

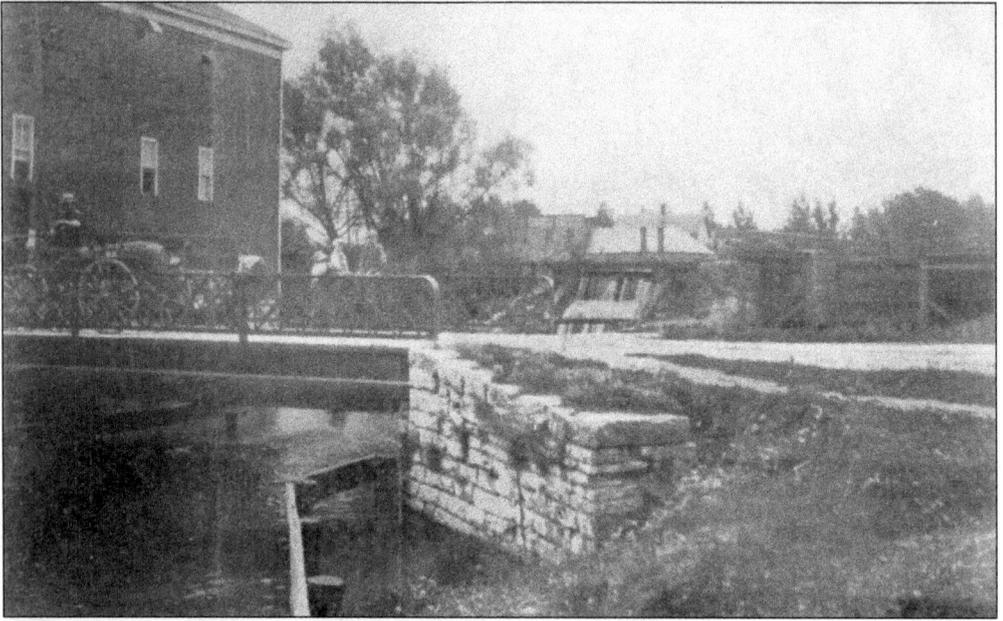

Spencerville is a classic example of a town that grew along the Miami and Erie Canal. In 1843, while the canal was being excavated northward, a trading post was established to meet the needs of the construction crews. The towns of Spencer and Acadia sprung up on opposite sides of the canal and eventually merged into Spencerville in 1867. The image above shows the wooden Lock 15n (Spencerville Lock), and the photograph below shows the freighter *H.W. Meyers* approaching the lower Lock 16n (Acadia Lock). (Above, courtesy of David Neuhardt; below, courtesy of the Canal Society of Ohio.)

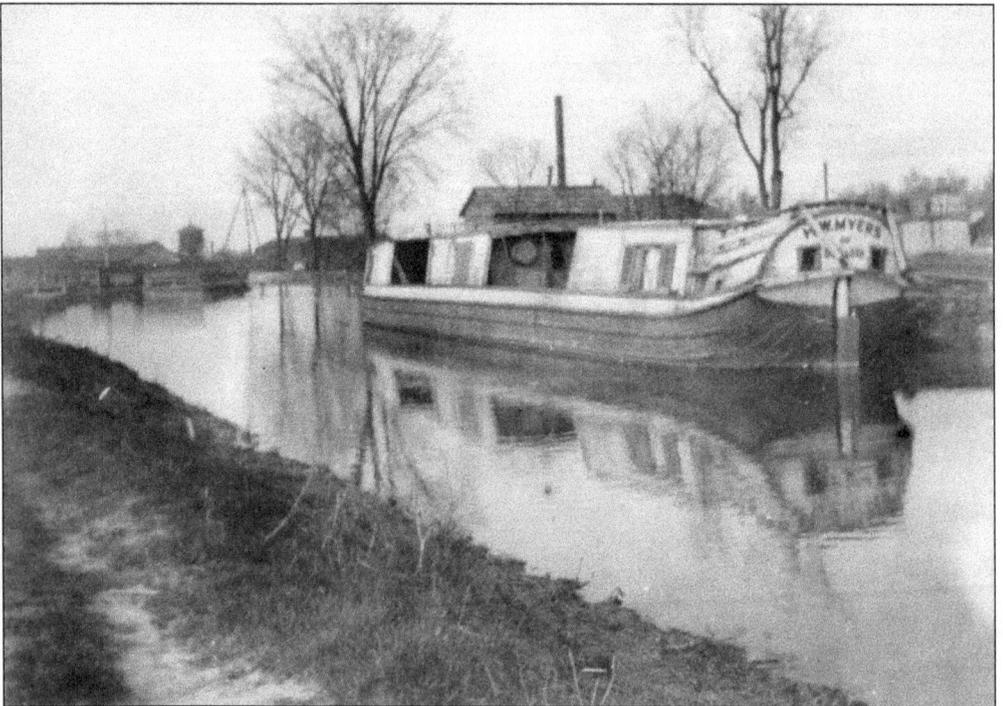

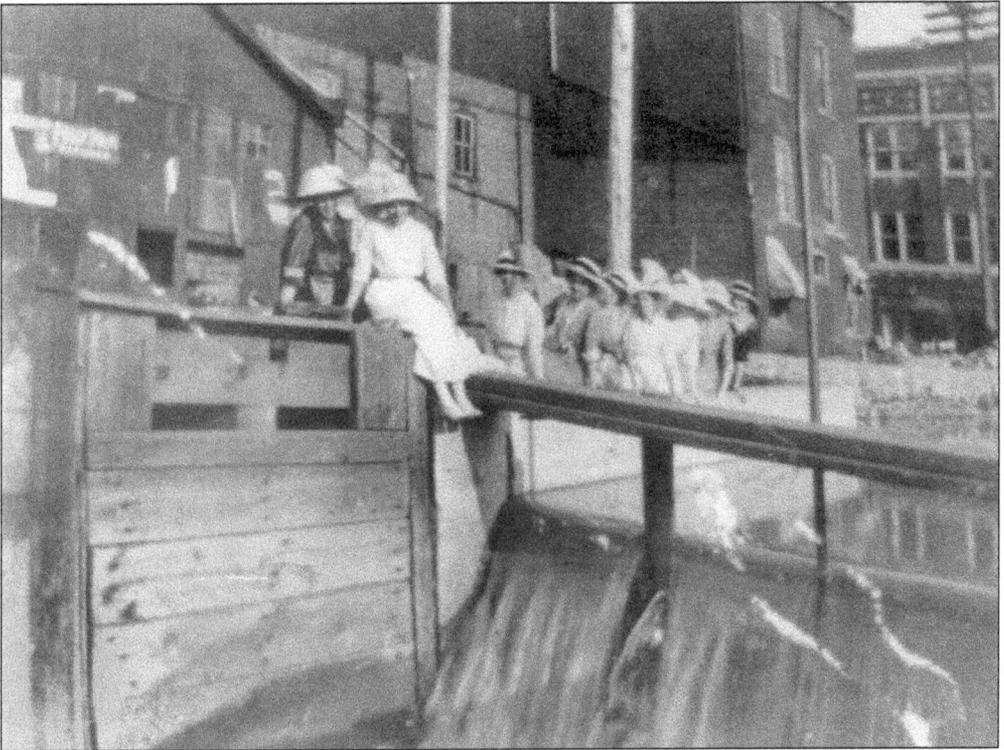

Like Spencerville, Delphos was originally two towns, and each had its own lock. The towns merged and were incorporated as Delphos in 1845. Delphos is another community founded by German immigrants. Father Otto Bredeick was instrumental in the founding of Delphos and, later, Ottoville. The photograph above shows a group of fetching young ladies posing beside the bypass spillway of the wooden Lock 23n in the town's central business district. Lock 23 powered the Delphos Grist & Flouring Mill. The photograph below shows the state repair boat *Homer Meachum* docked in town. (Both, courtesy of the Canal Society of Ohio.)

Erie Canal

Stone Lock 24n (above) is located on the northern outskirts of Delphos. Originally built of locally available white oak, it was, for unknown reasons, rebuilt in cut stone sometime in the 1880s. Lock 24 powered the adjacent Delphos Paper Mill. The image below shows the Jennings Creek Aqueduct, located a short distance downstream of Lock 24. This 1916 photograph shows the aqueduct with a hastily built, narrow flume that still provided water for milling purposes but precluded any navigation on the waterway. By 1916, there would have been no boat navigation on this section of the canal. (Both, courtesy of the Canal Society of Ohio.)

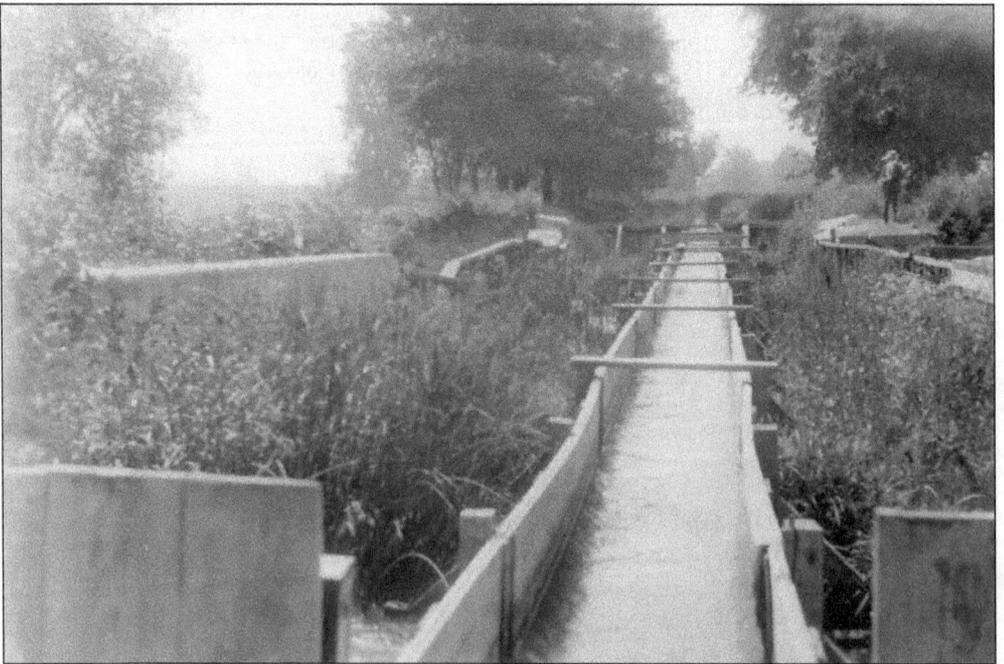

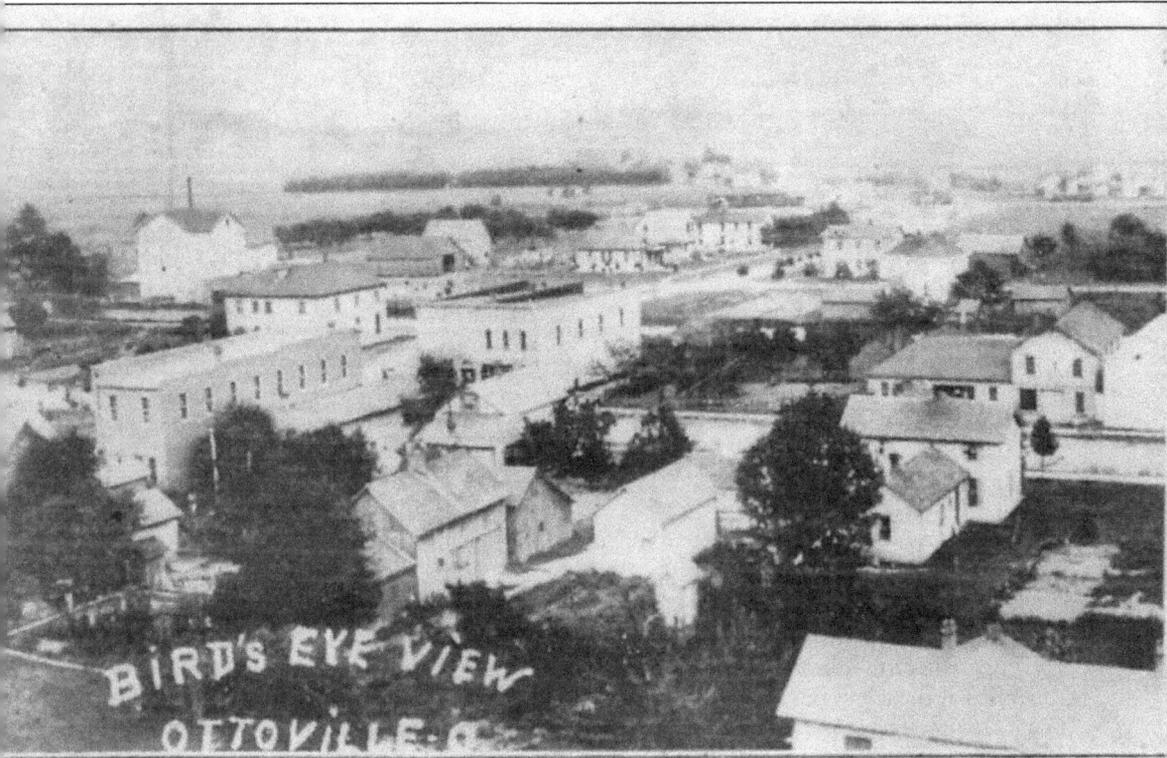

BIRD'S EYE VIEW
OTTOVILLE, O.

Ottoville is the most significant town on the canal's six-mile route through Putnam County. It was also the northernmost of the Catholic settlements of New Germany situated on the route of the Miami and Erie Canal. The Miami Extension was completed and opened to boat traffic on July 4, 1845. The only permanent resident of what would later become Ottoville was lock tender Wilhelm Reckart, who was in charge of two locks, 27n and 28n. Reckart supplemented his meager state wages by opening the area's first tavern. Meanwhile, the aforementioned Father Otto Bredeick platted out what eventually became the village of Ottoville and secured water rights for a sawmill at Lock 27. This bird's-eye view of Ottoville shows the canal passing diagonally through the village at upper left. The E.L. Odenweller Flour Mill is also in the upper left. (Courtesy of David Neuhardt.)

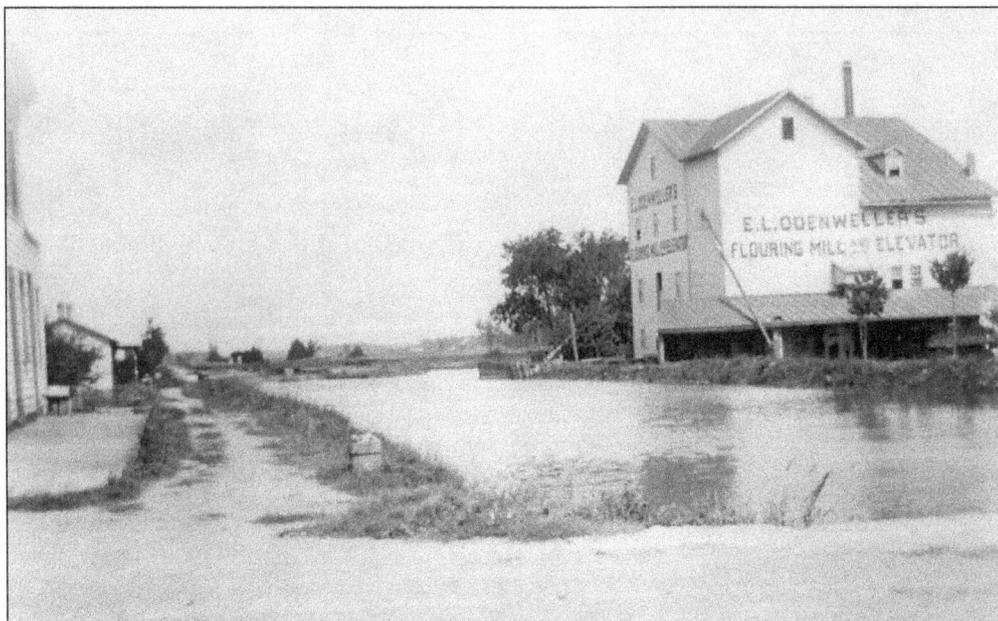

The E.L Odenweller Mill (above) has been in continuous operation since about 1878. Originally known as the Ottoville Mills, it was a flouring mill, and its stones were turned by waterpower generated at the adjacent Lock 28n. Odenweller purchased the mill in the late 1890s, hence the name change. The power source soon changed as well, first to oil and then to electricity around 1920. The Odenwellers recognized in the late 1940s that the flour business was dwindling and switched to the processing of animal feeds. The mill is now in its fourth generation of family ownership. The image below shows the lock tender's house beside the canal at Lock 28. (Both, courtesy of the Canal Society of Ohio.)

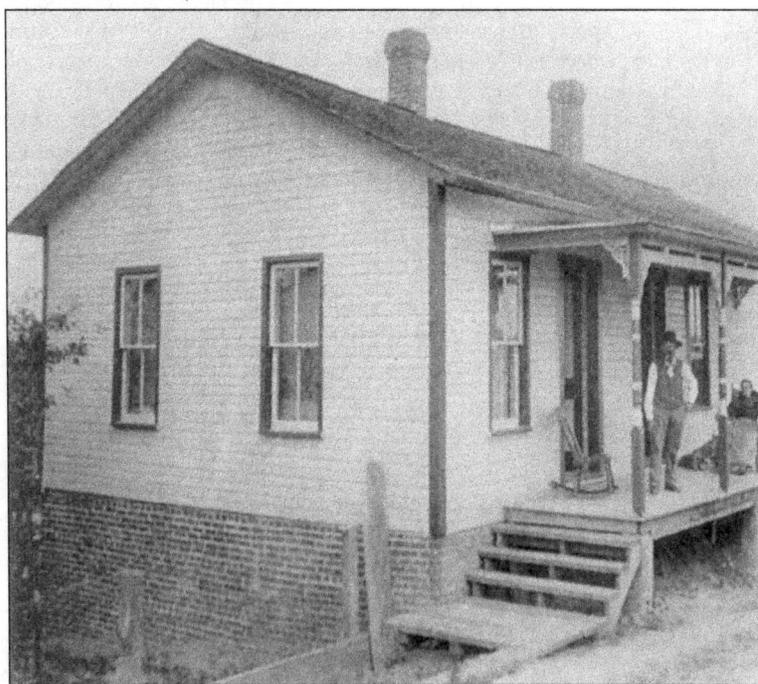

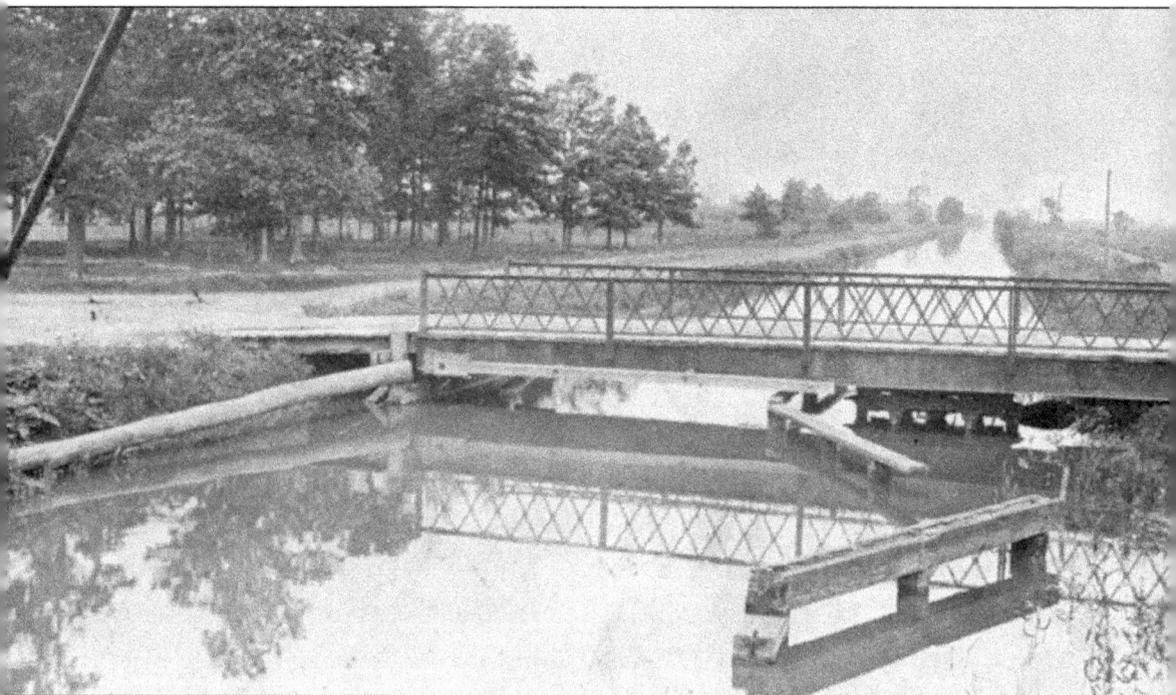

Paulding County was, and still is, the most rural county on the route of the Miami and Erie Canal. At the time of canal construction in the early 1840s, only about 1,000 people lived within the 418 square miles of the county. This area was part of the Great Black Swamp, which extended from Fort Wayne, Indiana, to Sandusky, Ohio. With the opening of the canal in July 1845, numerous hamlets sprung up along its banks. This image shows a bump/swing bridge over the canal on the northern outskirts of the unincorporated village of Mandale. Initially, the largest industry in the area was lumber. The county was covered by a primeval old-growth forest coveted by ship builders. Once the land was clear-cut, it was drained by tile and ditches and made suitable for crop cultivation. While most of the hamlets built beside the canal in the county disappeared with the forests and the canal traffic, Mandale still survives. (Courtesy of David Neuhardt.)

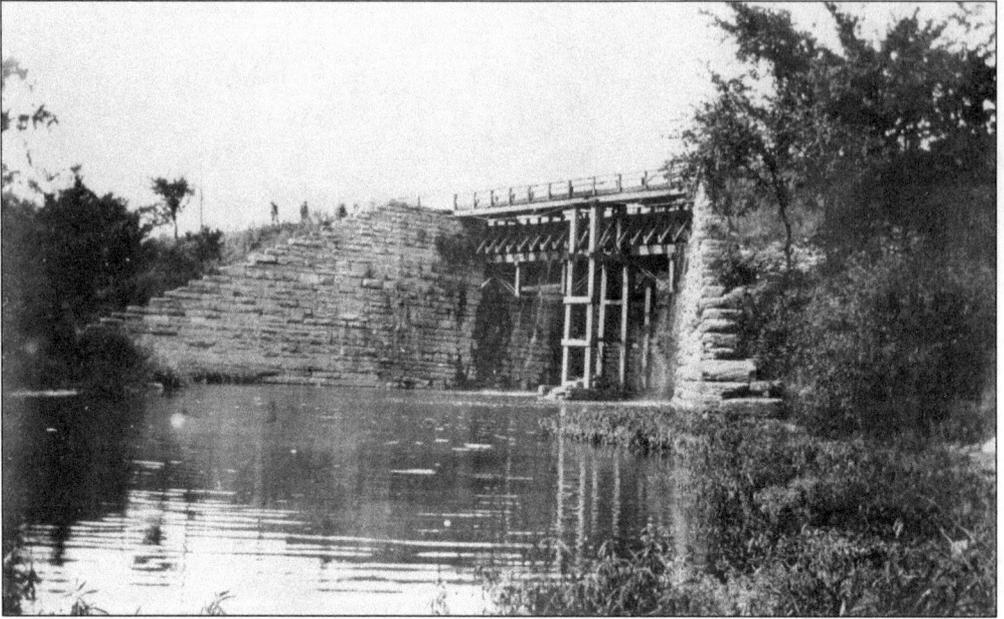

Several large streams within Paulding County required aqueduct crossings. These c. 1900 images show the aqueduct over the Little Auglaize River. The aqueduct flume was 100 feet long and required several rebuilds over its life. The small village of Newberg was established on the south side of the aqueduct crossing in 1851. Newberg, which offered postal service and the Royal Oak grocery store, served as a shipping point for locally harvested timber. Newberg faded away over time, and the town of Melrose, located a half mile downstream of the aqueduct, became the center of commerce for the area. (Both, courtesy of the Canal Society of Ohio.)

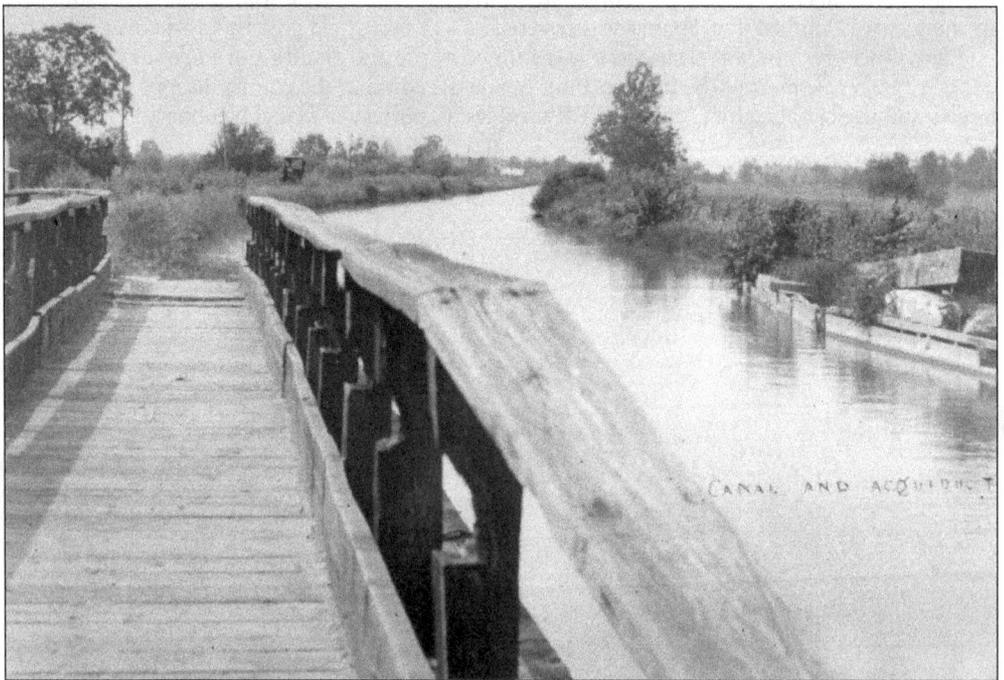

Blue Creek was another stream that intersected with the route of the canal in Paulding County. The 88-foot-long Blue Creek Aqueduct appears to have been fitted with a narrow flume, as shown in this 1916 photograph. After the devastating flood of 1913, the state only maintained the infrastructure of the canal to serve downstream water lessees. (Courtesy of the Canal Society of Ohio.)

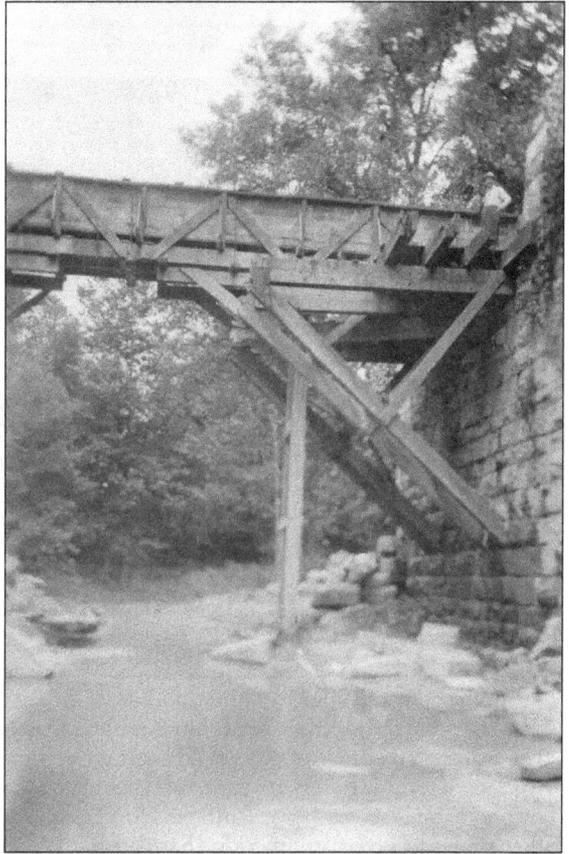

Flat Rock Creek is the last of the streams leading to the Auglaize River to be crossed by a canal aqueduct. As originally built, the Flat Rock Creek Aqueduct was 225 feet long and built entirely of wood, without stone abutments. This frugal construction plan apparently did not work out well, as the structure was replaced in 1859 with a 75-foot wooden flume mounted to stone abutments. (Courtesy of the Roscoe Village Foundation.)

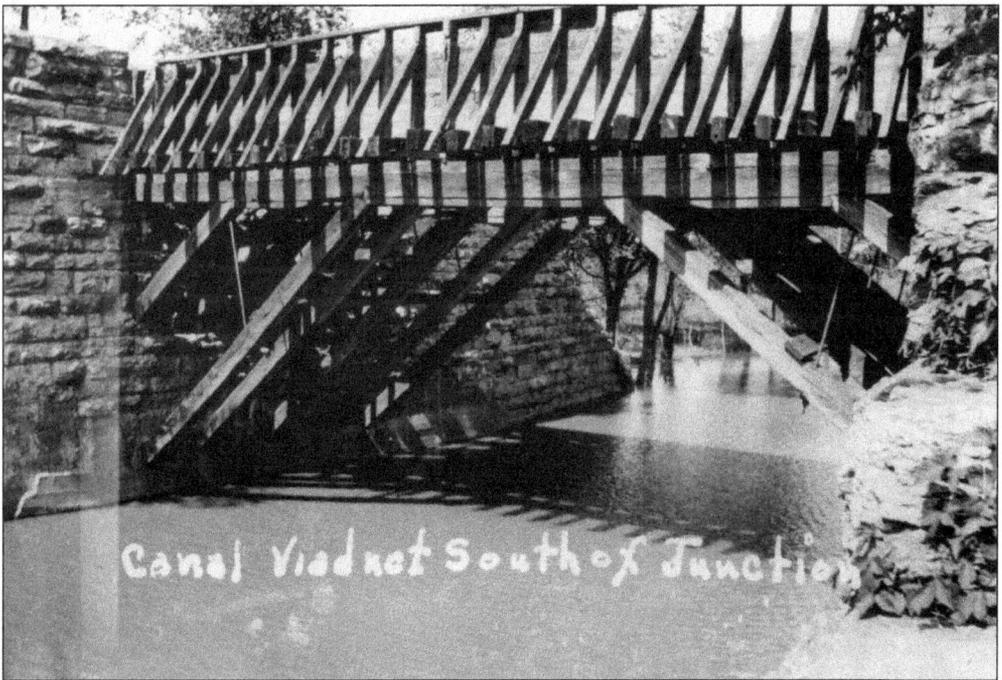

Winfield Scott Beaman, Merchant

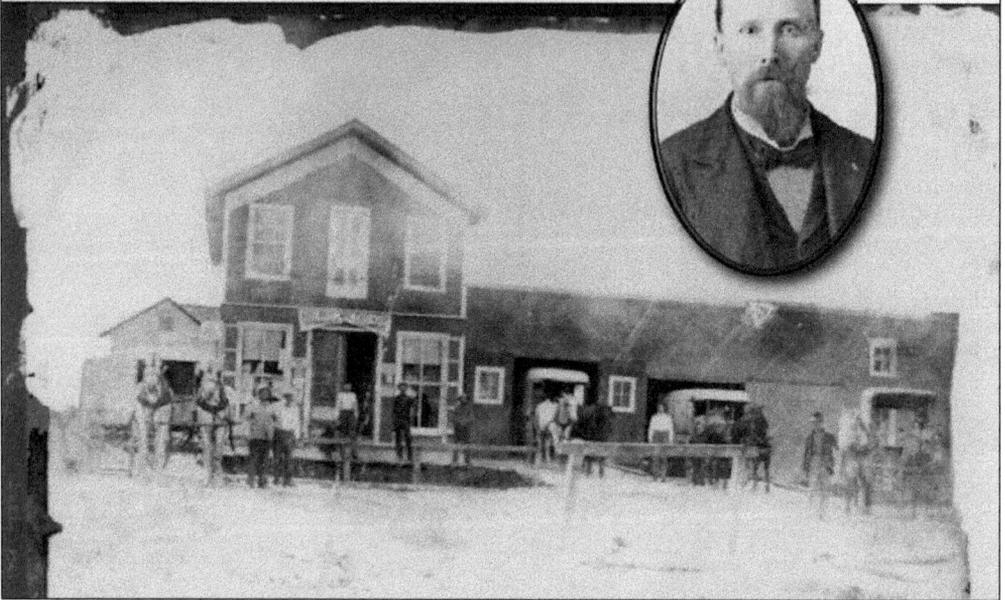

The unincorporated village of Junction was located at the junction of the Miami Extension Canal and the Wabash and Erie Canal. Junction was platted in 1842, and its location was thought to ensure that a great metropolis would soon grow there. In its heyday Junction had six churches, five groceries, three hotels, three warehouses, a canal toll collector's office—and up to 40 saloons. The photograph above shows Winfield Scott Beaman and his grocery store in Junction. The image below shows a culvert in Junction that carried the canal over Little Flat Rock Creek. Junction's fortunes faded quickly with the advent of railroad competition and the closing of Indiana's Wabash and Erie Canal at the Ohio border in 1870. (Both, courtesy of the Canal Society of Ohio.)

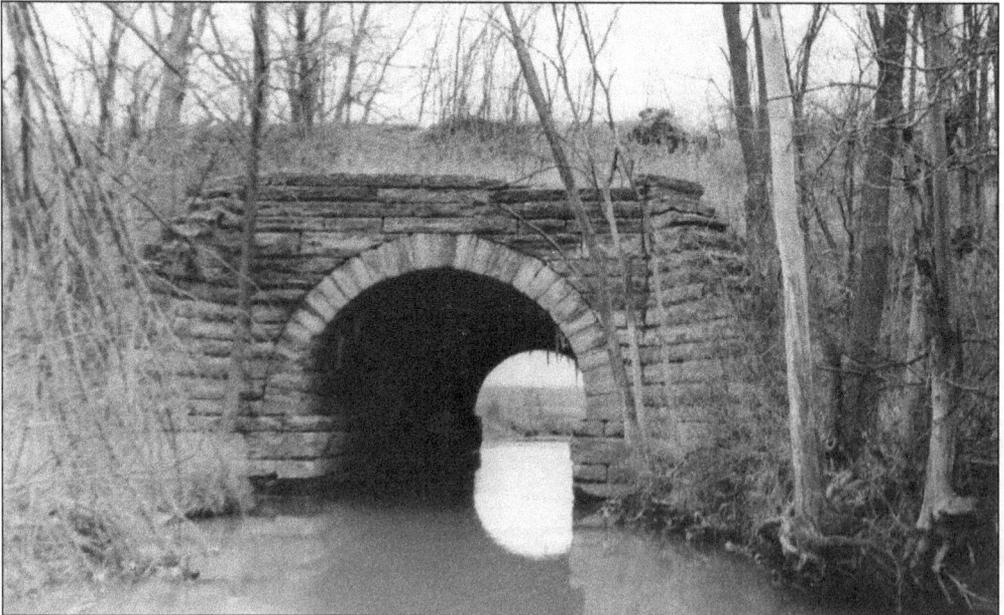

Three

THE MIAMI AND ERIE CANAL

JUNCTION TO TOLEDO

In March 1834 the State of Ohio authorized the construction, in Ohio, of the last 88 miles of Indiana's Wabash and Erie Canal. By May 1843, the Wabash and Erie reached Toledo. But, before that could occur, a dispute with Michigan over the official location of the Michigan-Ohio boundary had to be settled. The route of the proposed canal was to run through a disputed territory that included the city of Toledo. During this "Toledo War," guns were drawn, but the dispute was settled in a more peaceable style by the US government. Ohio received the so-called "Toledo Strip," and Michigan received the Upper Peninsula. Development of the canal was able to begin in May 1837 and was completed by June 1842, but not without further difficulty and delay resulting from rising prices for canal land and northern winter conditions making for slow work. At the small town of Junction, the Miami Extension Canal connected with the Wabash and Erie Canal, finally giving Cincinnati a connection with Lake Erie and beyond.

On March 14, 1849, the General Assembly passed an act stating that "the Miami Canal, the Miami Extension Canal and the Wabash and Erie Canal shall hereafter constitute one canal and be designated by the name of the Miami and Erie Canal." The finished canal was 248.86 miles in length, with one summit, the Loramie summit, 516 feet above the Ohio River to the south and 374 feet above Lake Erie to the north. Three reservoirs, three guard locks to rivers, and feeder dams would water the canal. A boat traveling the entire canal would pass through 103 lift locks, all with dimensions of 15 feet by 90 feet. On June 27, 1845, the first boat, the *Banner*, arrived in Toledo from Cincinnati after a four-day and five-night trip.

In 1851, the completed canal earned $351,897 from water rights and tolls, its peak year in earnings. That year, 400 boats traversed the Miami and Erie Canal, paying tolls at Cincinnati, Lockland, Hamilton, Middletown, Dayton, Piqua, St. Marys, Delphos, Junction, Defiance, Napoleon, Maumee, and Toledo. The state auditor's office considered Ohio's canals a "profitable venture," since the canals were earning well above the cost of construction and maintenance, and were yielding 15 percent returns to the investors.

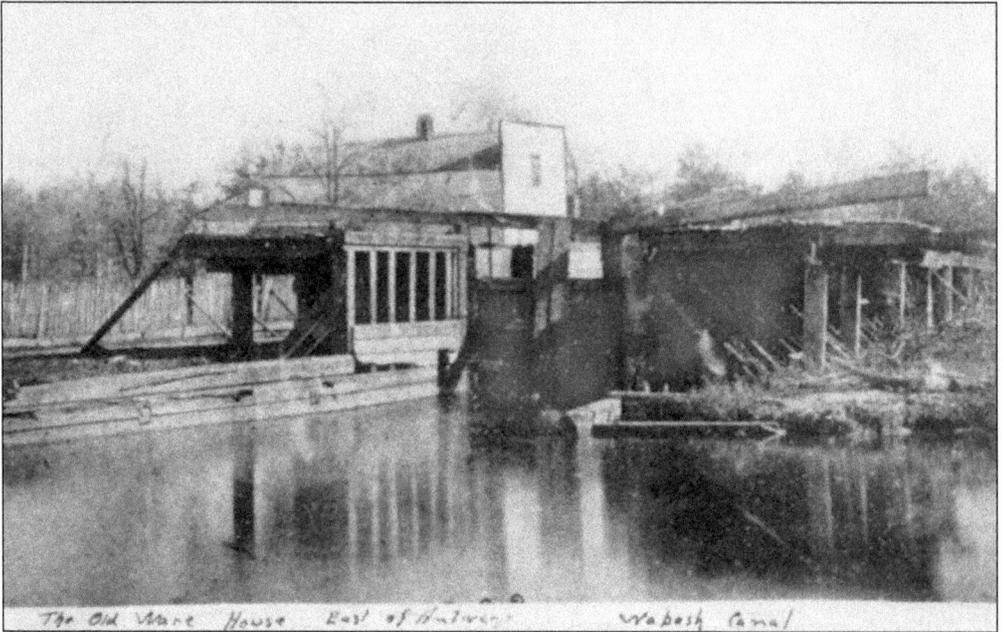

The Old Ware House East of Antwerp Wabash Canal

These images show several locations on the 18-mile segment of the Wabash and Erie Canal between Junction and the Indiana-Ohio state line. The image above shows Banks Lock, located just east of Antwerp. The image below was taken at Tates Landing, a community that sprung up at another lock on the Wabash and Erie line. At a distance of 462 miles from Evansville, Indiana, to Toledo, the Wabash and Erie Canal was the longest canal constructed in the United States. Ohio constructed 88 of those miles, beginning at the Indiana border, 18 miles west of the junction with the Miami Extension. Those 18 miles of canal were abandoned by the state in 1888 after vandals had destroyed much of its infrastructure the previous year. (Both, courtesy of Scott Bieszczad.)

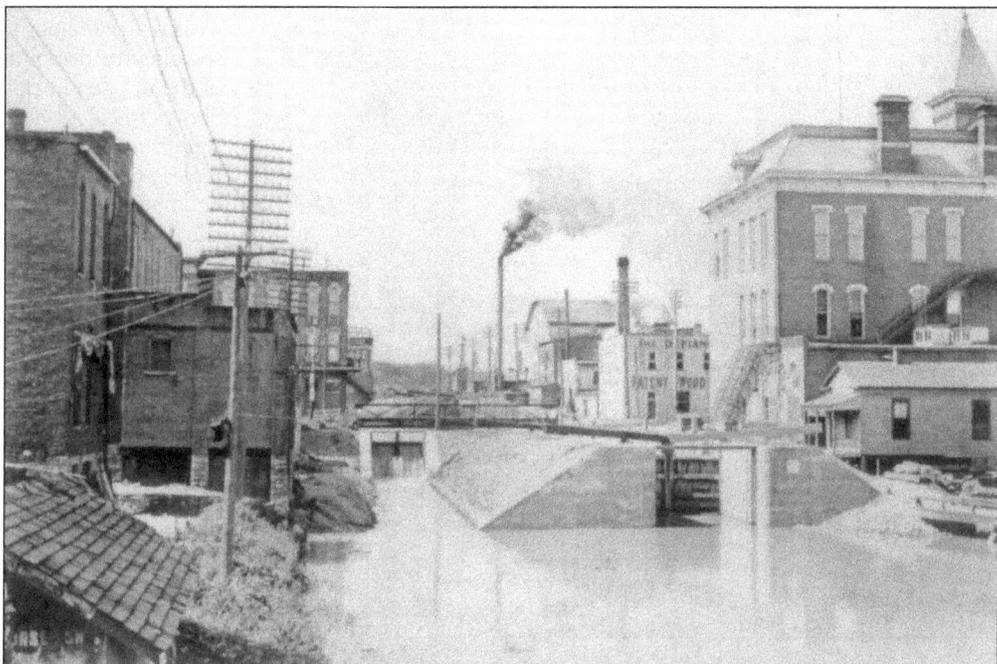

The city of Defiance was built at the site of a former military fort. It was incorporated in 1825, but did not begin to thrive until the surrounding Great Black Swamp was drained and the canal was completed through town in 1843. This image from 1907 shows Lock 37n, also known as City Hall Lock due to its proximity to Defiance's city hall. (Courtesy of the Canal Society of Ohio.)

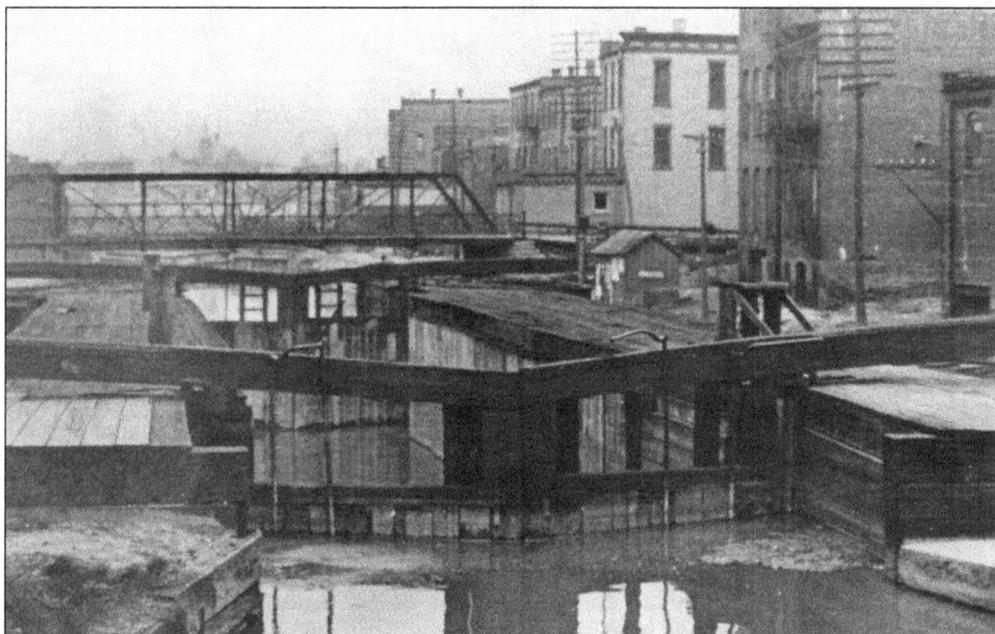

Four locks brought the canal through Defiance to the level of the Maumee River. All four locks were originally built of wood. Locks 36, 37, and 38 were rebuilt in concrete by Schneider Brothers during the state's belated refurbishment of its canal infrastructure from 1906 to 1910. This image shows Lock 38n prior to its 1908 reconstruction. (Courtesy of the Canal Society of Ohio.)

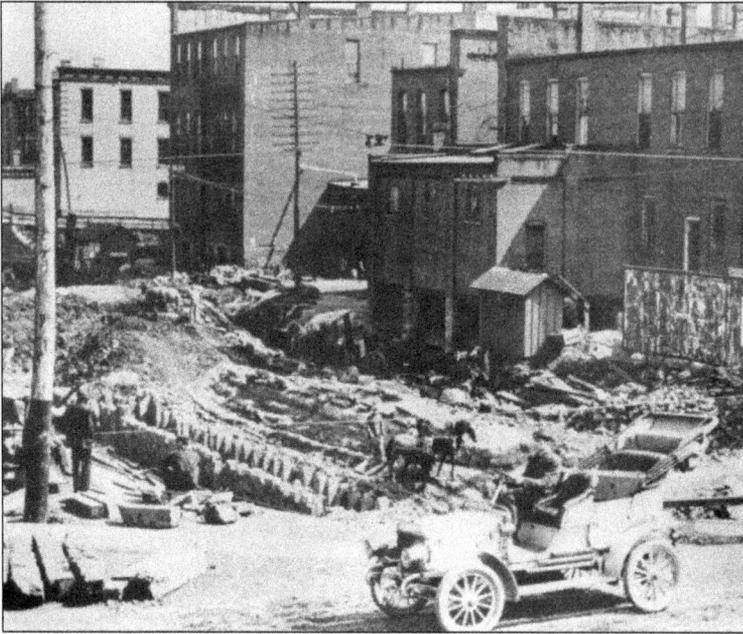

This is a 1908 image showing the demolition of the wooden Lock 38n. Schneider Brothers were contracted to replace eight locks and one culvert on the Miami and Erie Canal during the state refurbishments. Lock 38 was replaced in concrete at a cost of nearly $8,300. Though the canal width north of Junction expanded to 60 feet, lock chambers remained 15 feet by 90 feet. (Courtesy of the Canal Society of Ohio.)

Lock 39n allowed boats to enter and exit the Maumee slack water. A mule-towing bridge is shown to the left in this 1908 image. A boat heading towards Toledo would be towed to the river's northern bank. A dam located downstream at Independence maintained the water level for four miles of river navigation. Lock 39 remained of wooden construction until the canal's demise. (Courtesy of the Canal Society of Ohio.)

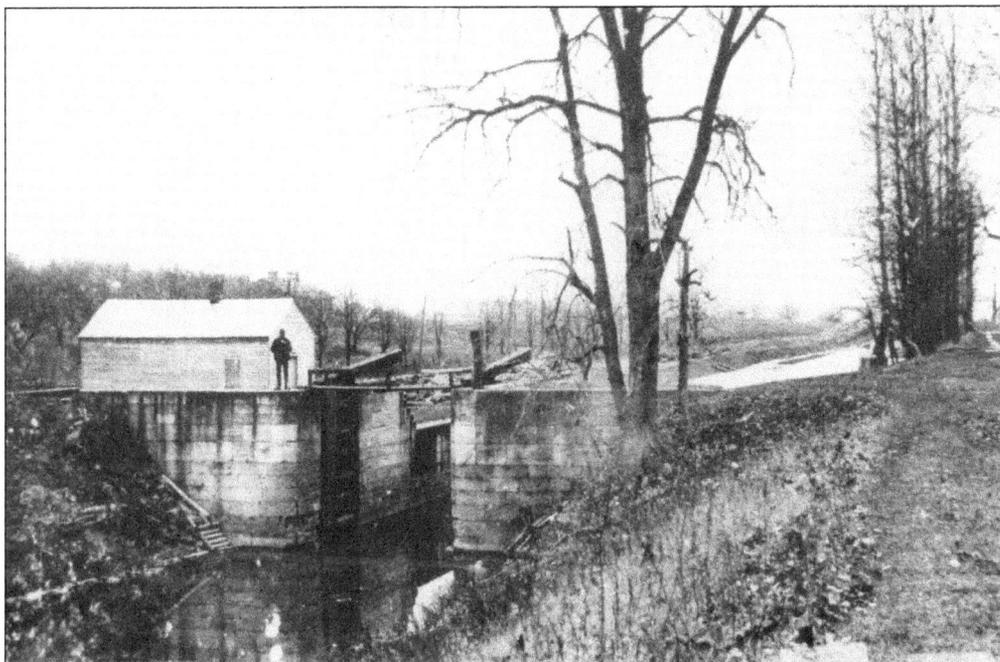

Lock 40n is a guard and lift lock. A boat would exit the Maumee slack water and reenter the canal through this lock. This 1888 photograph shows the lock and its tender awaiting customers. By the mid-1880s, only about 100 vessels still operated on the Miami and Erie Canal. (Courtesy of the Roscoe Village Foundation.)

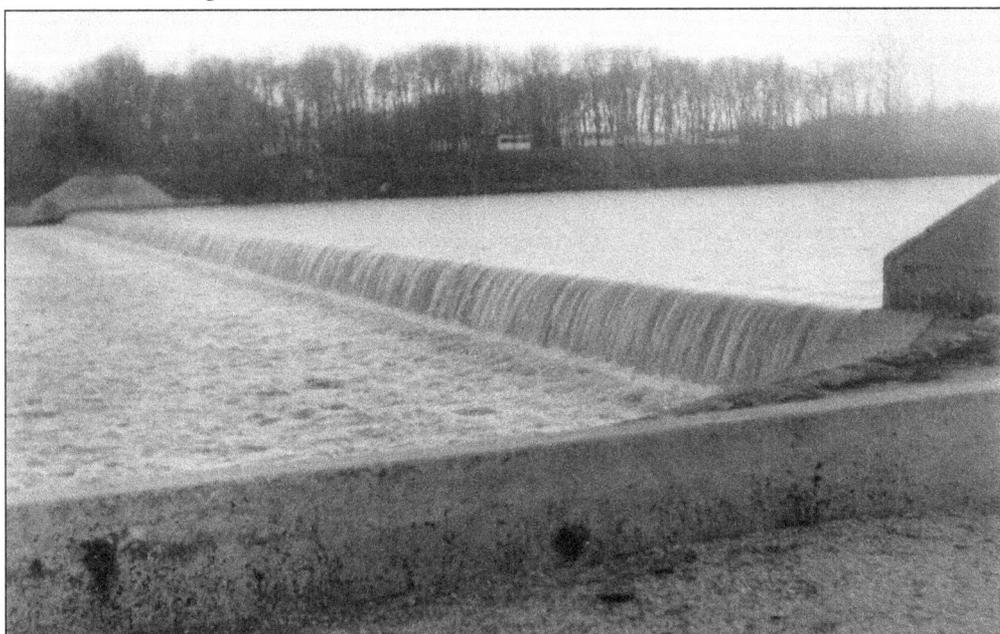

The original Independence Dam was built using the wooden crib design with stone abutments. The slack water pool retained by the dam allowed for canal river navigation from Defiance and diverted water into the canal at Lock 40n. This photograph from 1959 shows the concrete dam that replaced the wooden structure in 1924. (Courtesy of the Canal Society of Ohio.)

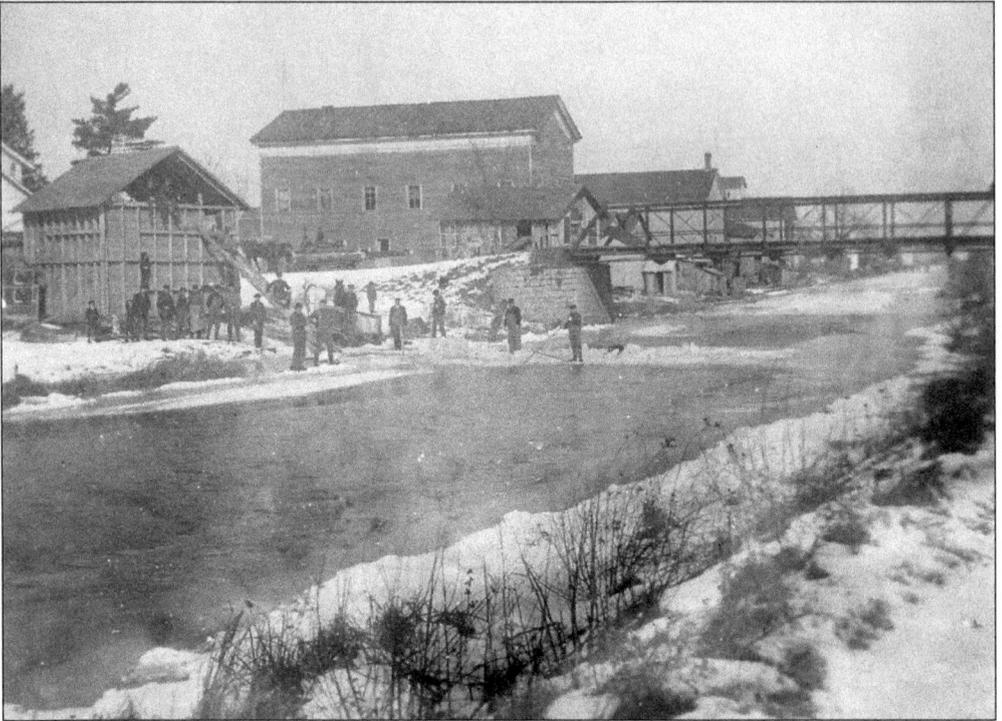

The village of Florida was located on a 23-mile level between Lock 40n and the next lock downstream at Texas. Florida was once the site of an Indian village before its settlement by whites in the 1840s. Settlers were drawn to the area by the construction of the canal. This photograph from the 1890s shows the wintertime harvesting of ice from the frozen canal. (Courtesy of David Neuhardt.)

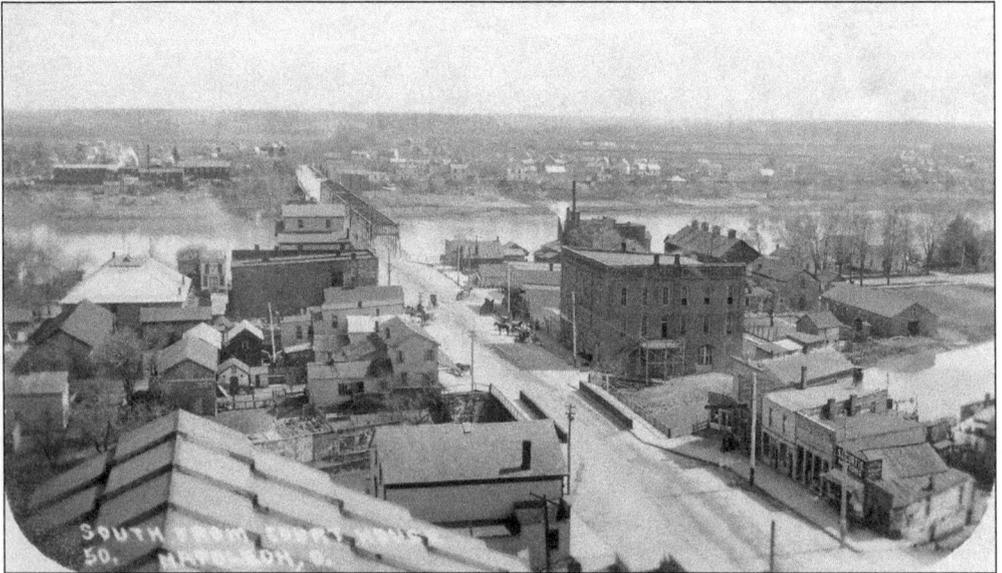

This bird's-eye view of Napoleon was taken around 1900. Napoleon was named after the French emperor and is situated midway through the canal's 23-mile level between Independence and Texas. The arrival of the canal in 1842 resulted in a boom for Napoleon, with its population hitting 500 in 1850 when it became the Henry County seat. (Courtesy of David Neuhardt.)

100

Canal contractor James Durbin was extremely proud of his work on section 53 of what was then the Wabash and Erie Canal. Proud enough, it seems, to erect a monument to himself atop the Bad Creek culvert. Durbin and his crew constructed three locks and at least four culverts in the area. The monument (right) was placed in 1842, upon the completion of his contracts. One of his culverts was the Bad Creek twin-arched culvert (below). The culvert still lies beneath old Route 24. Two of Durbin's locks, Lock 41n and Lock 42n, were removed in the early 1930s during the highway's construction. (Both, courtesy of Scott Bieszczad.)

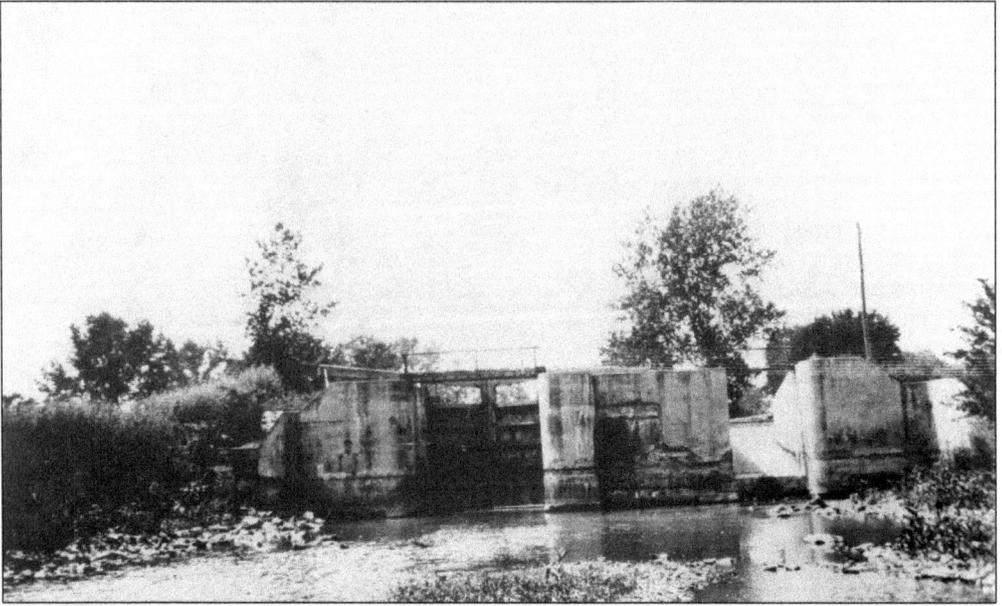

Lock 41n, in the village of Texas, shown above in 1910, marked the end of the canal's 23-mile level. Texas was founded in 1849 by contractor James Durbin and was an important trading post on the canal. Lock 41 was originally built of cut stone in 1842 by Durbin, and was later refurbished in concrete by Schneider Brothers in 1908. The photograph below, from around 1900, shows a lumber-laden freight boat passing beneath a high bridge in Texas. Texas was once a formidable rival to Napoleon for the Henry County seat, but the small village faded away in tandem with the fortunes of the canal. (Both, courtesy of the Canal Society of Ohio.)

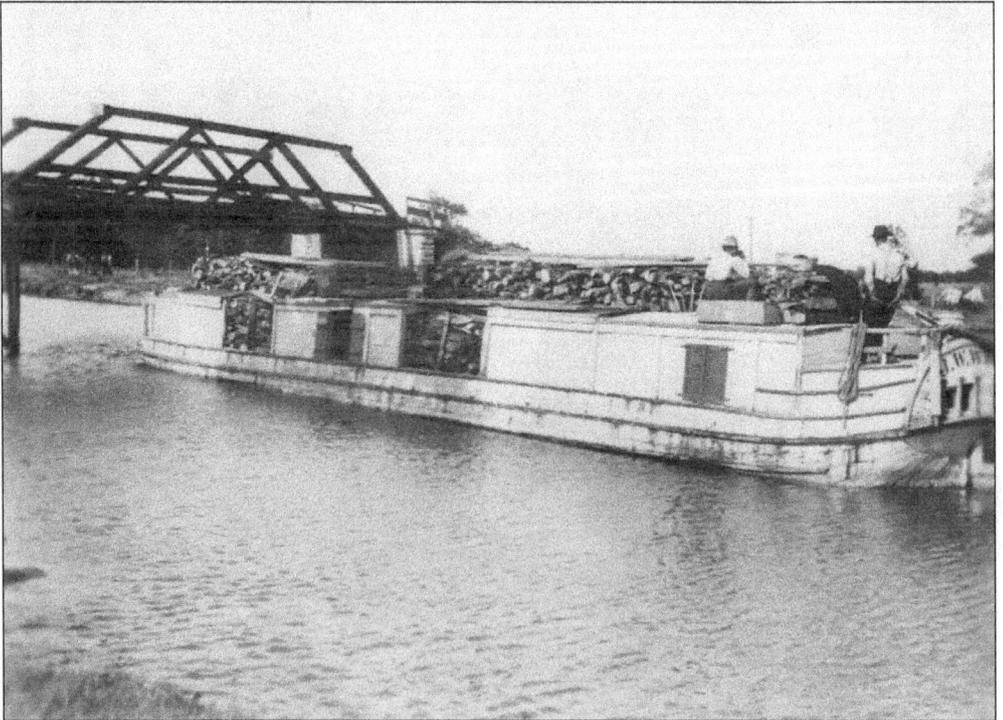

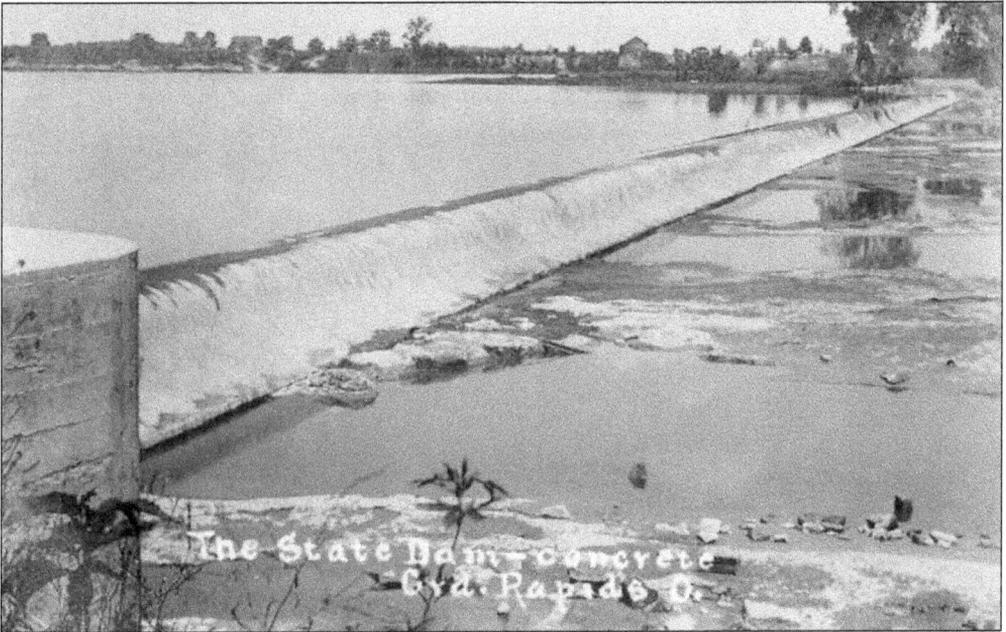

The canal reentered the Maumee River two miles downstream of Texas. A dam at Providence created a slack water pool that allowed for almost two miles of river navigation. The state dam shown above is actually two dams separated by an island in the river. This image dates to the dam's concrete reconstruction in 1908. Canal boats carried in most of the materials needed for the dam construction. The image below shows how close the canal paralleled the Maumee. Stone riprap protected the narrow towpath from erosion on both sides. (Both, courtesy of the Canal Society of Ohio.)

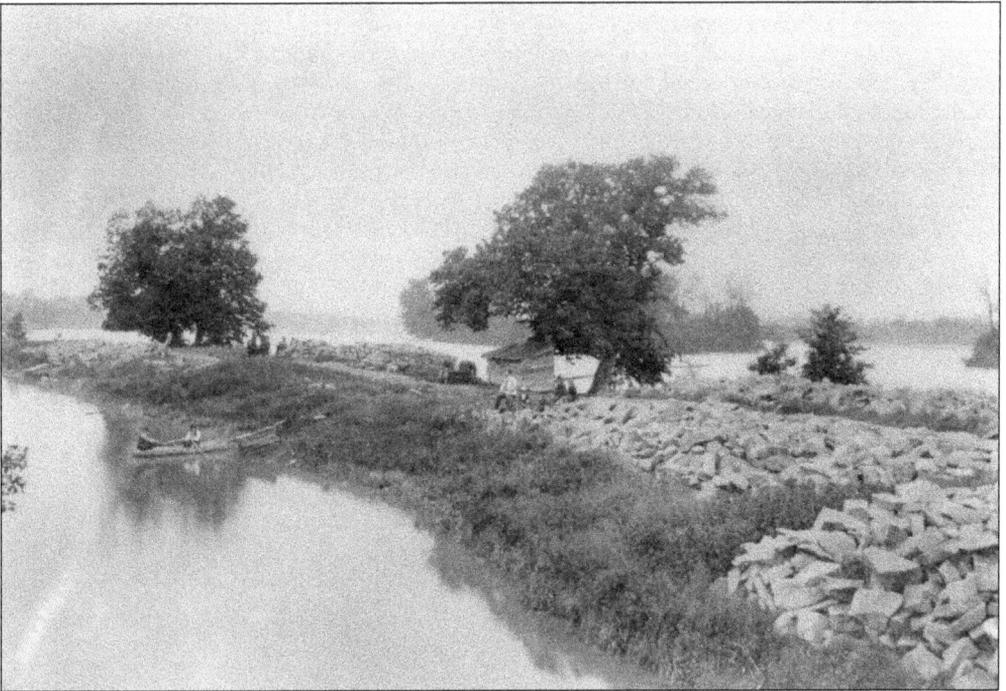

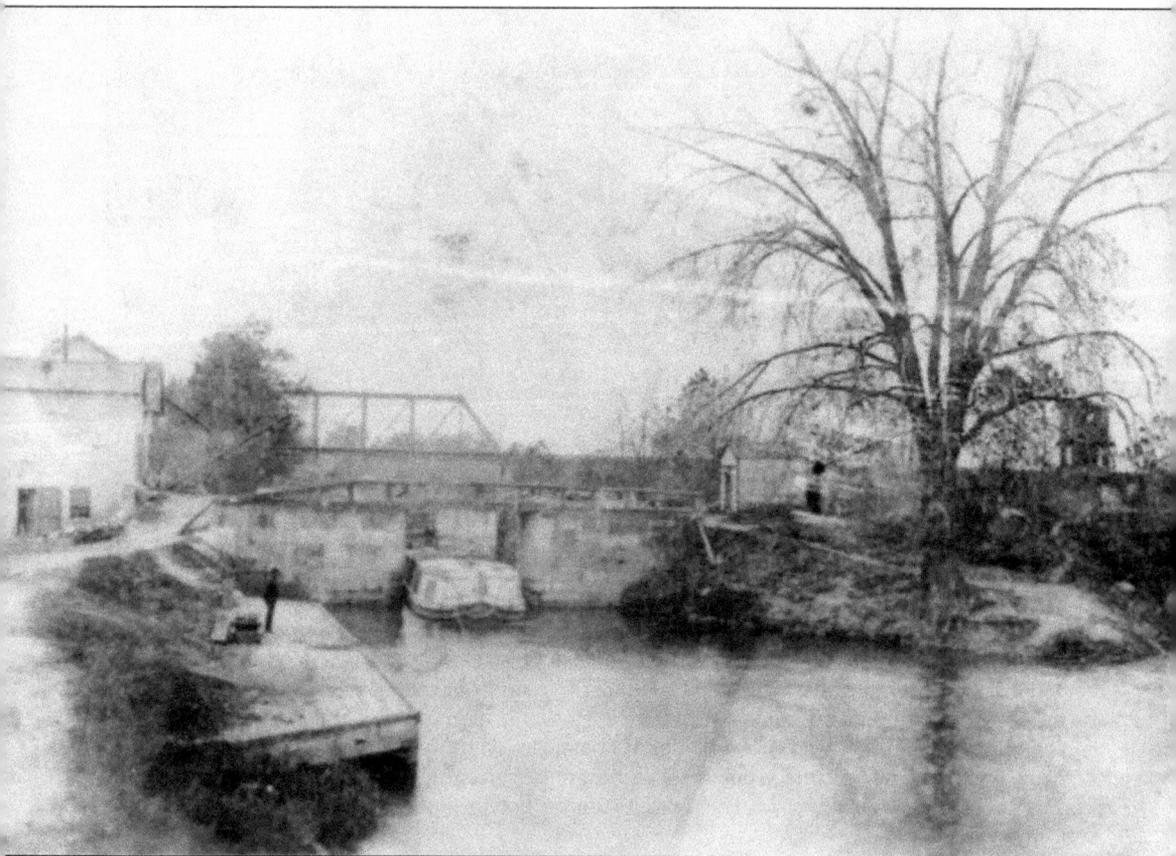

The village of Providence was founded in 1837 by Peter Manor. This c. 1880 photograph shows a canal freighter exiting Lock 44n, adjacent to the flouring mill built by Manor in 1849. Though Providence faded away after the successive disasters of fire in 1846 and a cholera epidemic in 1854, Manor's mill continued in operation under several owners into the mid-20th century. Isaac Ludwig purchased the mill in 1849 and operated it profitably until his retirement in 1886. The mill's third owner, Augustine Pilliod, modernized the business with the installation of a water turbine and generator. Pilliod's mill provided electricity to the surrounding area from 1908 to 1918. Pilliod enjoyed a comfortable retirement after Toledo Edison bought out his electricity-generating business, and the mill was sold to the Heising family. Cleo Heising ran the mill until its closure in 1972. (Courtesy of the Canal Society of Ohio.)

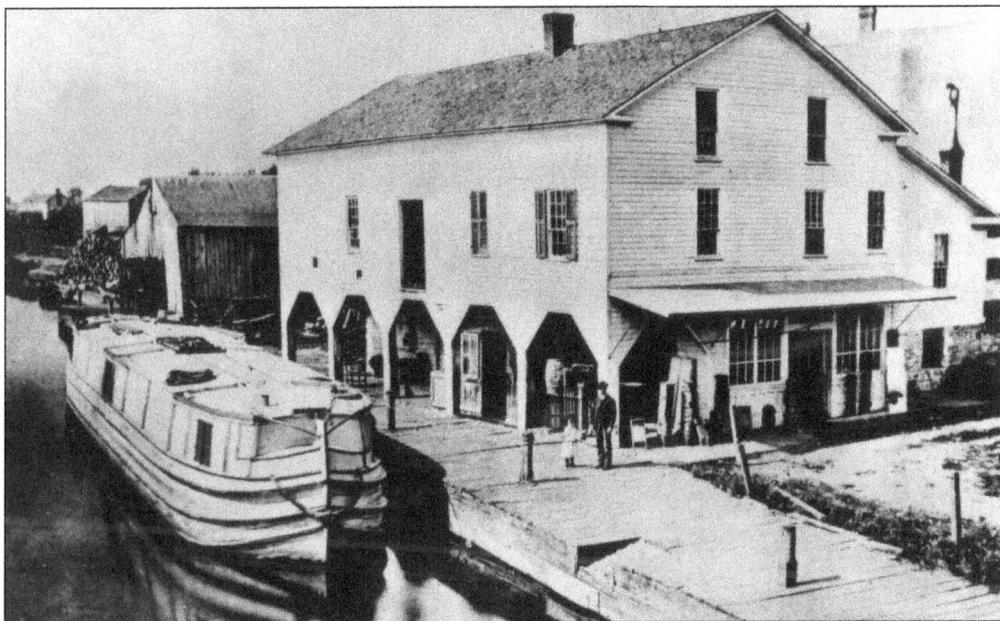

Waterville was a grain center of the Maumee Valley. Established by War of 1812 veteran John Pray in 1831, Waterville was situated on the 18-mile level between Providence and the city of Maumee. This image shows Rupp's Store in 1869. Rupp's catered to boaters, and its woodstove in back reportedly provided warmth for skaters in the winter months. (Courtesy of the Canal Society of Ohio.)

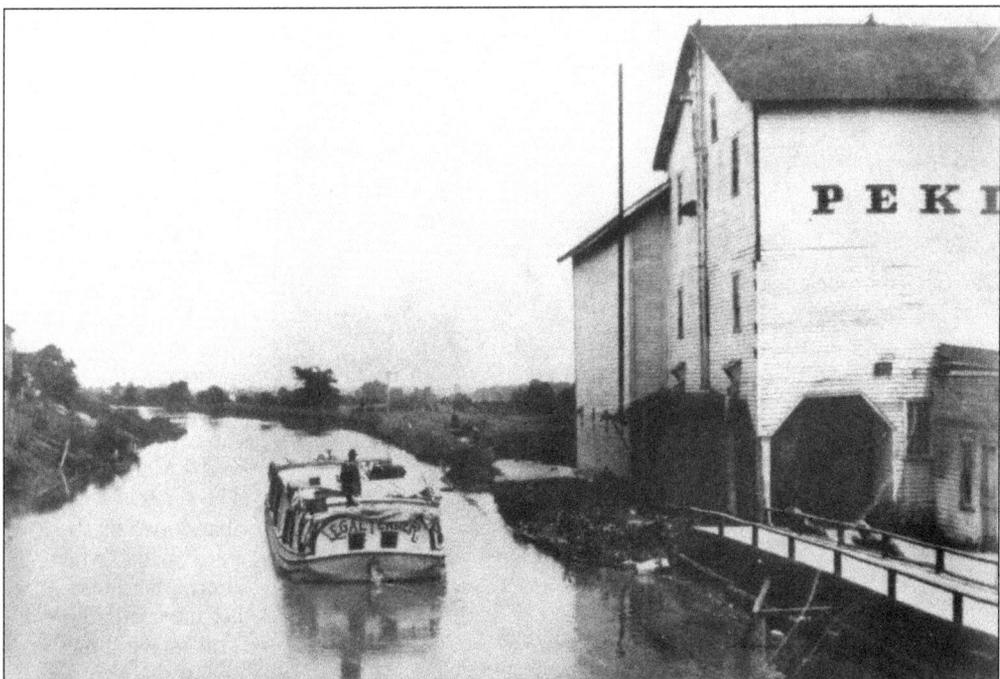

This 1880s photograph shows the *Legal Tender* passing the Pekin Mill in Waterville. The mill was built in 1846 and processed grain. Interestingly, it was powered by canal water that was expelled into the river rather than back into the canal. (Courtesy of the Roscoe Village Foundation.)

The Columbian House was established in 1828 by John Pray. It was first built as a one-and-a-half story stagecoach inn and later expanded with the three-story addition shown in this c. 1960 photograph. The building also housed Waterville's first post office and jail, as well as a ballroom on its third floor. Henry Ford rented the inn for his Halloween costume ball in 1927. (Courtesy of the Canal Society of Ohio.)

The Maumee side-cut canal was one of three northern outlets to the Maumee River, which empties into Lake Erie. Completed in 1842, its six locks brought boats down the 63-foot descent to the Maumee River. The side-cut was abandoned by the state in 1850 when alternate routes became available. This image shows one of the abandoned side-cut locks in 1962. (Courtesy of the Canal Society of Ohio.)

When the Lake Shore, Michigan & Southern Railroad (later the New York Central) tracks were laid, the railroaders had to make a deep cut to run their tracks beneath the canal. This c. 1910 image shows the steel aqueduct flume crossing the tracks, supported by stone abutments that now support the northbound lane of Anthony Wayne Trail. (Courtesy of the Canal Society of Ohio.)

The Toledo Grain & Milling Company used canal water at three locks: 48n, 49n, and 50n, to power its mill. The short pegs on either side of Lock 50, shown in the foreground of this c. 1900 image, were snubbing posts. A boat crewman would tie off to the posts in order to steady the vessel while locking through. (Courtesy of the Canal Society of Ohio.)

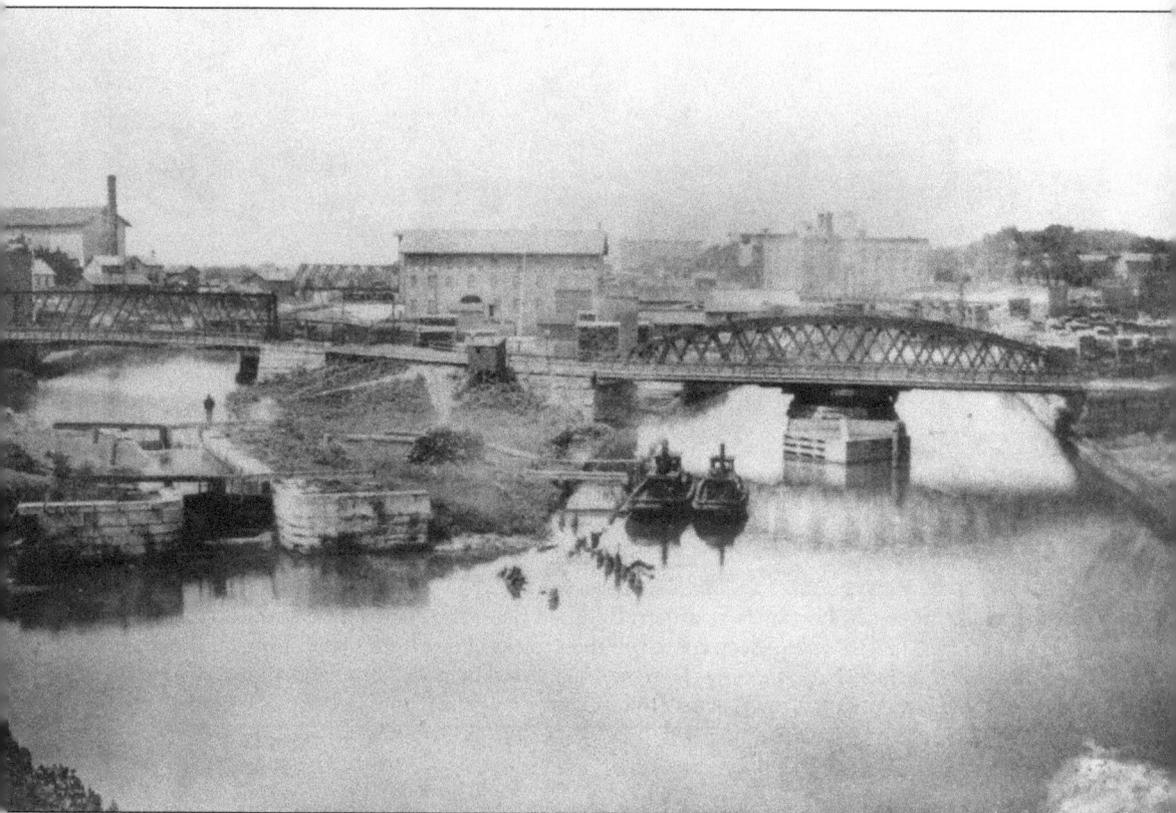

Toledo won the canal business when the Swan Creek side-cut became the canal's sole northern terminus after the state's abandonment of the Maumee side-cut, in 1850, and the Manhattan Extension, in 1864. An aqueduct over Swan Creek was dynamited by the Lucas County sheriff, effectively ending navigation to the Manhattan terminus and diverting all canal traffic to the Swan Creek outlet. Boats would descend two locks to Swan Creek, where awaiting tugboats would tow them to one of the many warehouses that lined the creek for loading or unloading. These same tugs would tow lake schooners to and from Lake Erie. This 1880 image shows two tugs to the right of Lock 52n. Erie Street spans both the canal and Swan Creek. The large building in the upper center is Detwiller's Mill, and to its right is the Lenk Brewery. (Courtesy of the Canal Society of Ohio.)

Four

THE FLOOD OF 1913

DEMISE OF THE MIAMI AND ERIE CANAL

A series of floods in the late 1800s and in the early spring of 1913, together with a canal system already weakened by neglect, brought an end to Ohio's canal era. The state and the public had lost interest in maintaining the canals in view of waning revenues from canal traffic and the burgeoning railroad system. Railroad rates were declining, allowing cheaper and faster transportation of goods and passengers by rail. On July 2, 1861, Ohio canals had been leased to a syndicate of six operators for 10 years at a rental of $20,075 per year. This lease was renewed in 1871, but the operating syndicate defaulted in 1877. When the canals were returned to the state, they were in abysmal condition. Certain sections of the dilapidated canal had been abandoned and, in spite of the state's attempts to refurbish the remaining segments, at the turn of the 20th century, canal traffic slowed to a halt. By 1903, the canal revenues from water use fees from industries far exceeded tolls from boat traffic. The grand stretch of canal that had opened with such promise was being allowed to slide into oblivion. The promise was no longer alive.

Flooding began on Easter Sunday, March 23, 1913, when dark clouds formed and dropped 6–12 inches of rain onto winter-saturated land in Ohio. The devastating water rapidly destroyed many of the important structures on the canal, leaving little of it navigable. Repairs to the canal after the 1913 flood were negligible, and the remaining stretches of watered canal were used only for pleasure craft or industrial water supply. What had been a thriving public enterprise for decades had subsided into a ghostly memory, with desolate towns and industries no longer enlivened by the canal. In 1927, the Tom Act passed the state legislature, ending canal navigation. On November 11, 1929, the Miami and Erie Canal was officially brought to an end during a ceremony on the site of the original ground-breaking in Middletown some 104 years before.

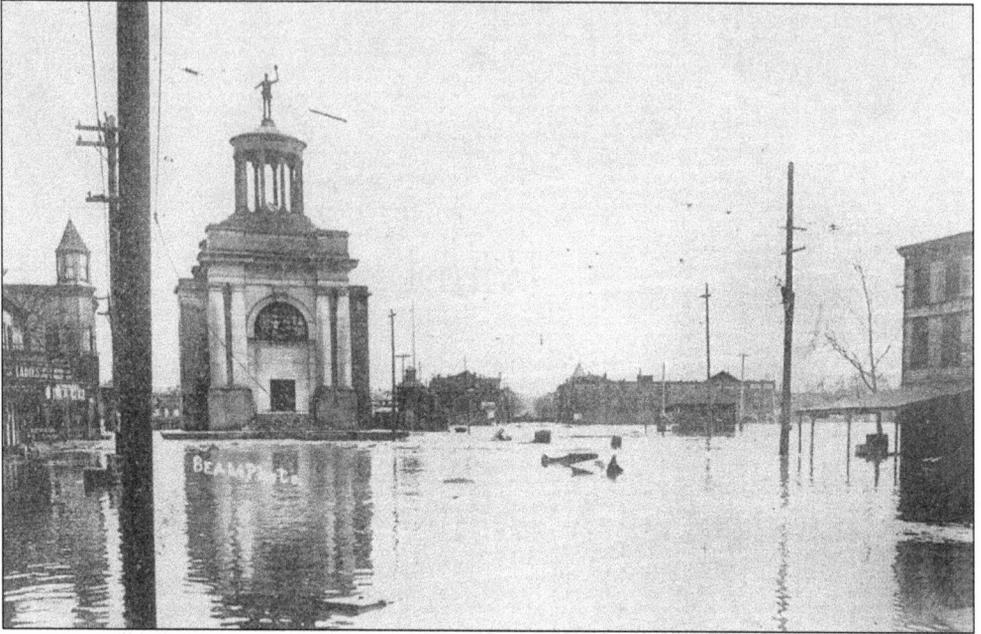

The original Miami Canal from Cincinnati to Dayton had been, from day one, the most successful section on the Miami and Erie. While other sections of the waterway had fallen into disuse, the southern 66 miles still generated significant revenues. This all ended with the great flood of 1913. Every town from Hamilton through Piqua experienced devastating loss of life and property. Hamilton, shown above, suffered over 100 fatalities in the flood. More than one third of its citizens were left homeless. The photograph below shows Middletown during the same event. Middletown was spared the great loss in lives, but its property damage was measured in millions of dollars. (Both, courtesy of the Butler County Historical Society.)

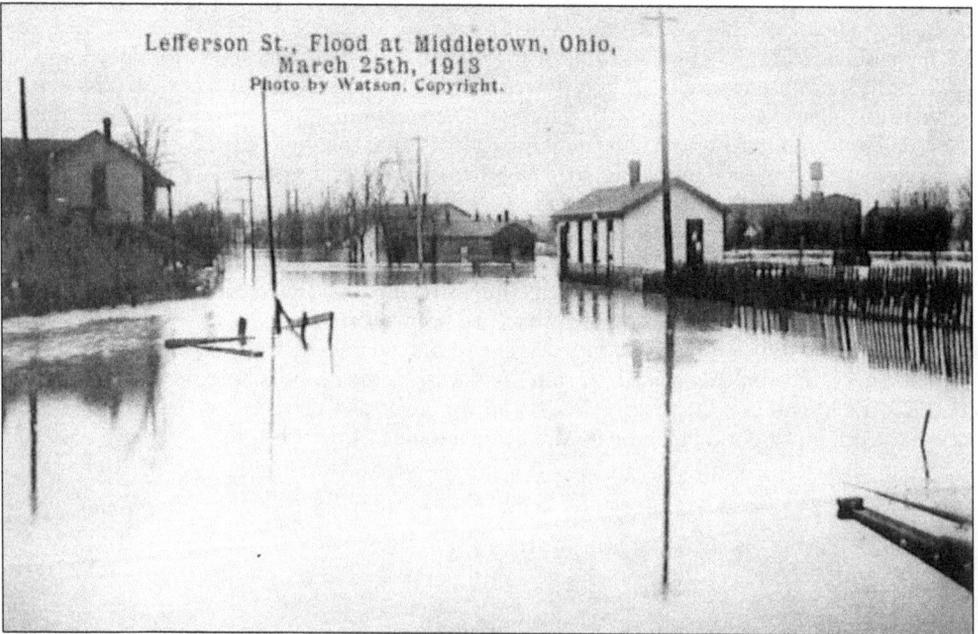

Dayton was struck particularly hard by the spring flood. The city was founded upon a floodplain near the convergence of three tributaries of the Great Miami River: the Stillwater and Mad Rivers and Wolf Creek. This unfortunate location subjected Daytonians to flood conditions on a regular basis. The 1913 event was by far the worst, with over 120 deaths and countless dollars in property loss. The image above shows the Armory building at the canal's old and new line split in the flood's aftermath. Debris removal and basic repairs to city infrastructure took the better part of a year. The image below shows the Ohio Boat Company's freighter *Dayton* flung halfway out of the canal by the force of the floodwaters. (Both, courtesy of David Neuhardt.)

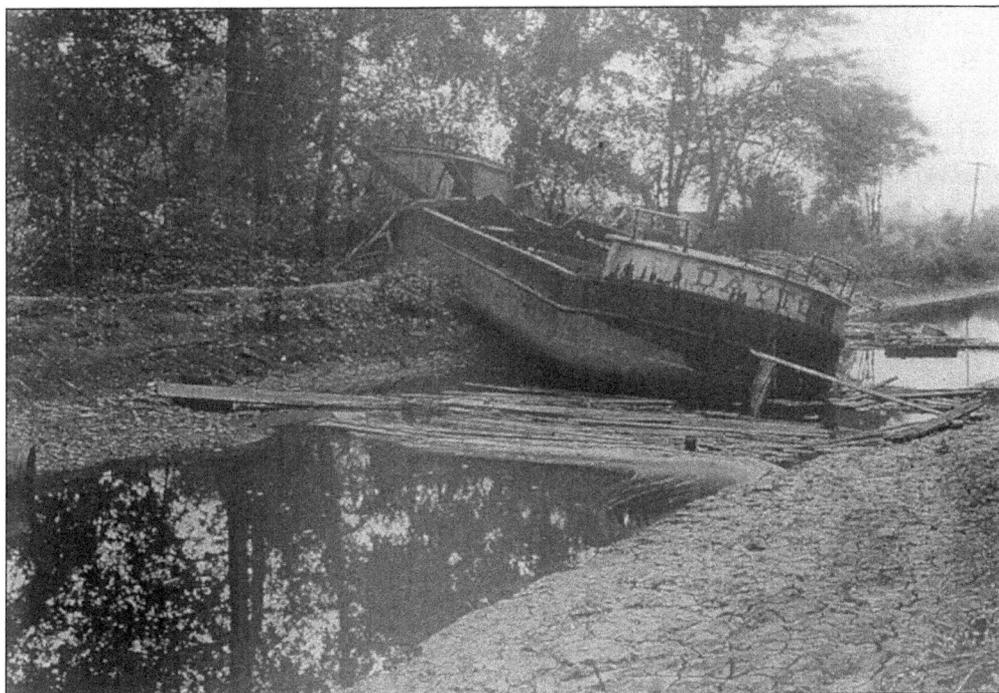

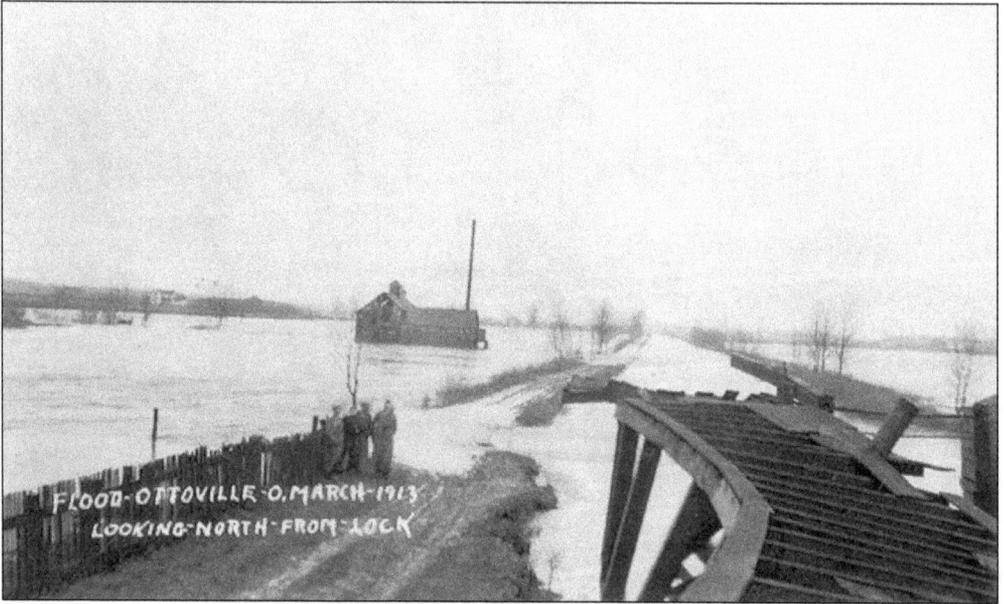

This photograph, taken from Lock 28n in Ottoville, shows the floodwaters spilled from the Auglaize River in March 1913. The canal route followed river valleys for the most part, which left it vulnerable to flood damage. Lock 28 appears to be one of the many canal structures to sustain crippling injury. (Courtesy of the Canal Society of Ohio.)

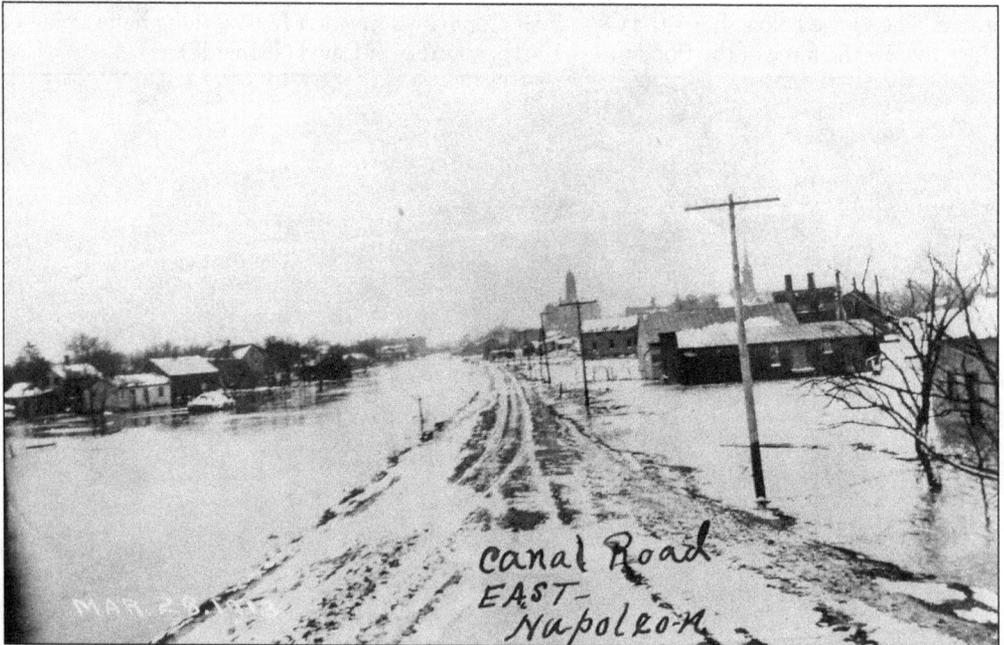

Towns and villages along the Maumee River experienced record-setting water levels during the spring 1913 flood. Deaths were minimal in the north, but property damage was calculated to be well into the millions of dollars. This image shows the flooding at its crest in Napoleon on March 28, 1913. (Courtesy of David Neuhardt.)

Five

AFTER THE FLOOD

CONSERVATION, RESTORATION, AND INTERPRETATION

The Miami and Erie Canal as a viable transportation mode was finished by the 1913 flood, but various watered sections of the old canal remained behind. In addition, massive stone structures like culverts, aqueducts, and locks sat stolidly in place, ignoring the passing years, waiting to be rediscovered. There were long, unbroken stretches of towpath that were perfect for walking paths and trails. By 1935, the state began selling and deeding small portions of the canal land to farmers, cities, and railroads, even if it seemed there was little else to be done with a 250-mile stretch of land only 120 feet wide.

For decades, most people had simply ignored those long, watery ditches. It remained for groups of interested historians to wake up to the fact that there was a deteriorating historical and recreational asset throughout the state that needed attention. By the 1960s and 1970s, throughout Ohio people were catching on to preserving regional treasures, whether it be a building, a neighborhood, a natural landscape, or, in this case, canals. Various groups and individuals began working to save canal land and related structures. The state resolved not to sell canal land that could be used in a historical or recreational context for the benefit of the pubic, thereby ensuring the continued existence of this resource.

Traveling today along the route of the Miami and Erie Canal, one can find a variety of communities that have embraced their relationship with the canal. Canal property is seen as a "linear greenway," providing recreational trails and needed green space to the region. Ways have been found to weave canal history into heritage tourism, which attracts visitors looking for sites of interest and recreation, in turn benefiting the economy of each region. Hiking trails, preserved and recreated canal structures, museums, and interpretive signage can be found today all along the 250 miles of the former canals in towns from Cincinnati to Toledo. It is worth searching for sites such as these.

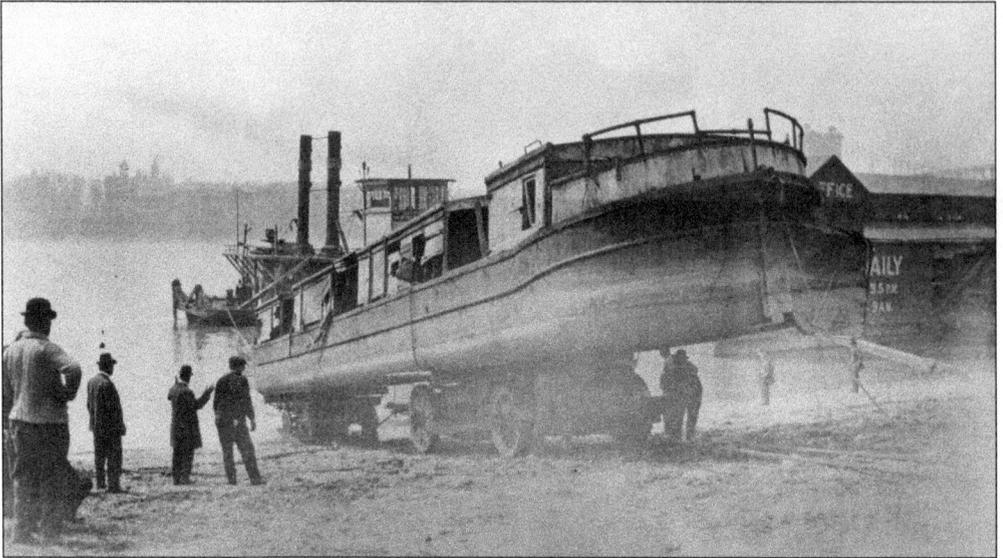

The 1913 flood rendered most of the Miami and Erie Canal unnavigable. Undamaged boats were often sold off for use on other canals. This image shows the gasoline-propelled *Ajax* being launched into the Ohio River, where a tugboat awaited to tow it to its new workstation on the canalized Tennessee River. (Courtesy of the Canal Society of Ohio.)

Cincinnati's political leaders began lobbying for a subway system in 1910, using the Miami and Erie Canal bed as its route. World War I delayed these plans until early 1920. This image shows the installation of the twin subway tubes. The subway system was never completed; work stopped in 1925. Bond payments for this aborted project continued until 1966. (Courtesy of the Canal Society of Ohio.)

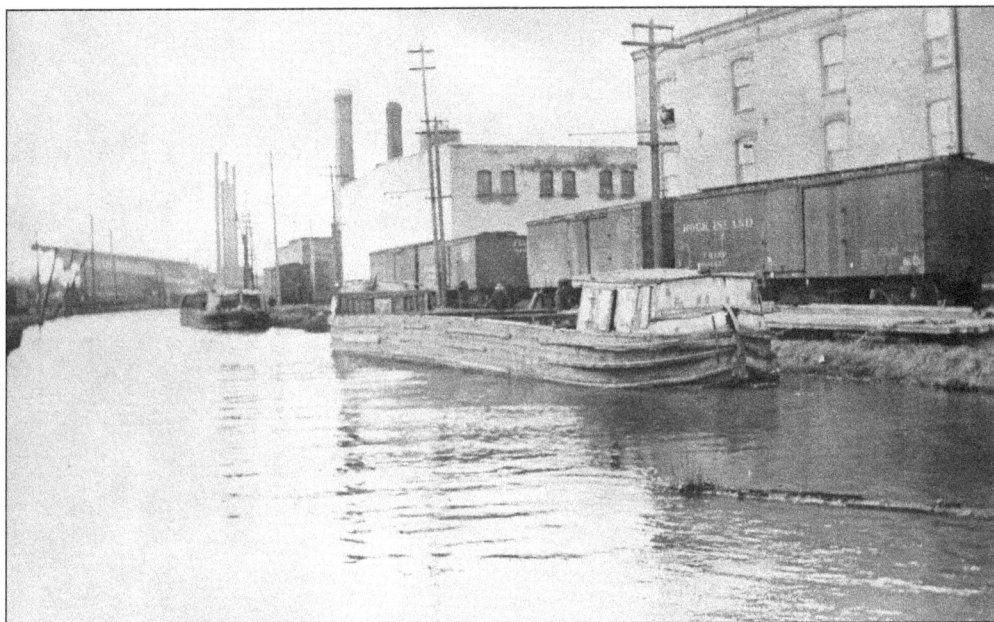

Another legacy of the 1913 flood was the ubiquitous sight of derelict canal boats abandoned by their crews and left to rot in the canal. These old freighters became favored playhouses for children and, sometimes, floating homes for the less fortunate. Some boats were repurposed into less savory uses such as gambling clubs and brothels. Concerned citizens were known to occasionally set fire to these nuisances if local law enforcement ignored their complaints. The image above shows several abandoned freighters decaying beside the Armco Steel plant in Middletown. The photograph below shows a state maintenance or line boat that appears to be straddling the canal prism in the Piqua area. (Above, courtesy of Midpointe Library of Middletown; below, courtesy of the Piqua Library.)

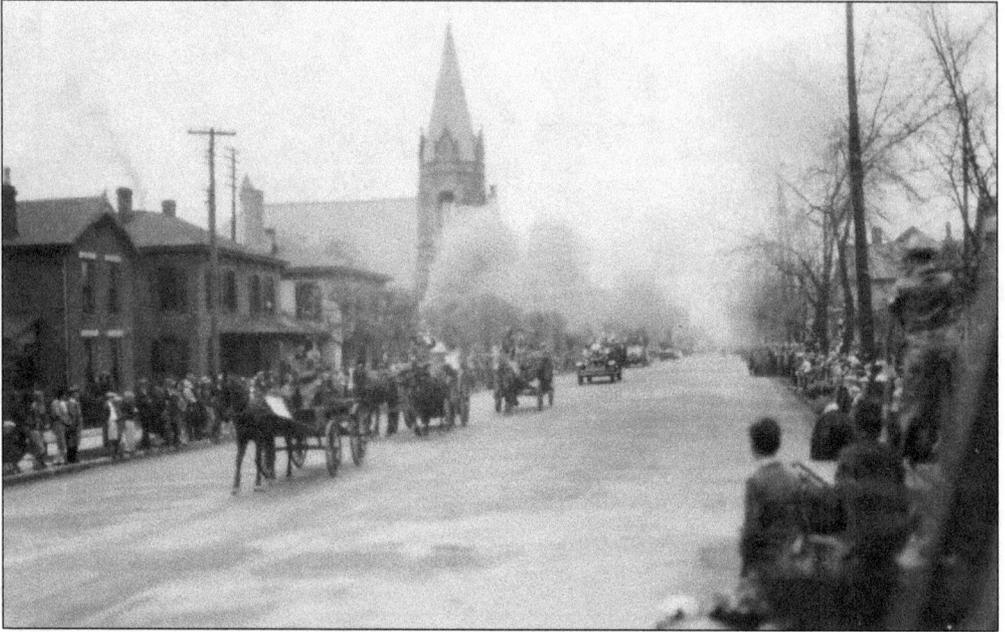

The ground-breaking for the Miami and Erie Canal took place in Middletown with great fanfare in 1825. It was only fitting that a parade in Middletown celebrated the state's official closure of the waterway in 1929. The image above, taken on October 11, 1929, shows the canal closing parade. The photograph below shows the dedication of the Clinton monument. This ceremony took place at the site of the canal's 1825 ground-breaking. New York governor DeWitt Clinton, a driving force behind that state's building of the Erie Canal, was a guest of honor at the original ground-breaking. New York's Erie Canal served as a template for Ohio's canal system. (Both, courtesy of the Midpointe Library of Middletown.)

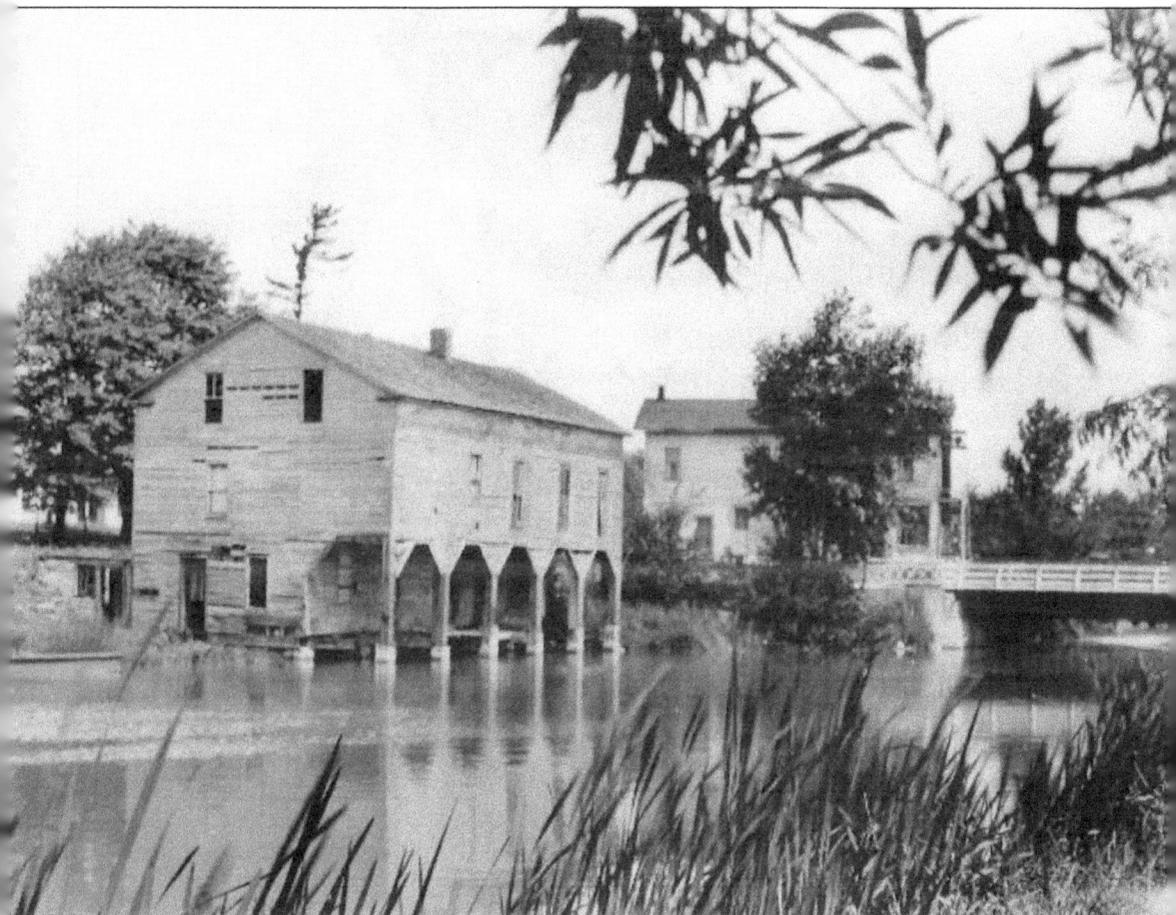

The state's official closure of the Miami and Erie Canal in 1929 opened up a floodgate of applications from city and county governments requesting deeds to state-owned land within their borders. Over the ensuing decade, the canal was filled and paved over for roadway purposes in northern Cincinnati (Millcreek Expressway, later Interstate 75), Hamilton (Erie Boulevard), Middletown (Verity Parkway), and Dayton (Patterson Boulevard). This 1930 image shows the abandoned Rupp's Store in Waterville prior to its demolition to make way for Route 24. Construction of the road required the removal of all obsolete canal locks in its path. Modern-day travelers on this highway may not realize that they are crossing over stone-arch culverts built over 160 years ago for Ohio's long-gone canal. (Courtesy of the Canal Society of Ohio.)

Many obsolete canal structures fell victim to road construction projects. The Flat Rock Creek Aqueduct, located south of Junction, was dismantled by government-hired laborers of the Civil Works Administration (CWA). The CWA was a short-lived federal job creation program designed to rapidly create shovel-ready manual labor jobs for millions of unemployed workers. Both of these images show the aqueduct just prior to its disassembly in January 1934. The cut stone blocks forming the abutments were removed, except for its lower courses at the waterline, which were saved for reuse on other local construction projects such as bridges. (Both, courtesy of the Paulding County Historical Society.)

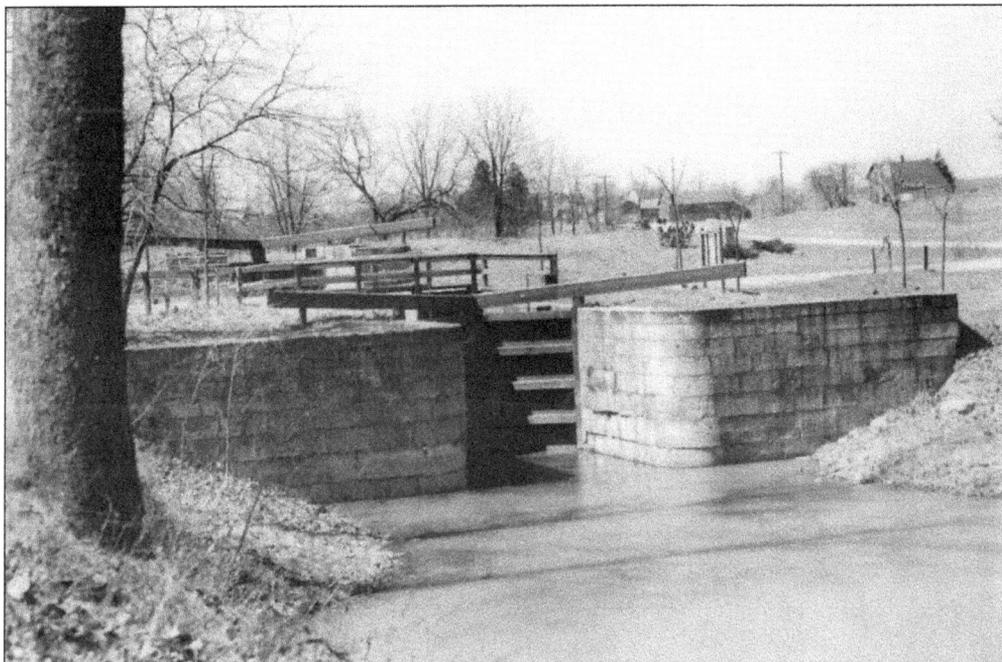

Lock 40n at Independence was also a beneficiary of labor supplied by a Depression-era works program. The Civilian Conservation Corp (CCC) fitted the lock with new gates and built a road bridge over it for access to the recently created Independence Dam State Park. This image shows the lock in 1939. (Courtesy of the Canal Society of Ohio.)

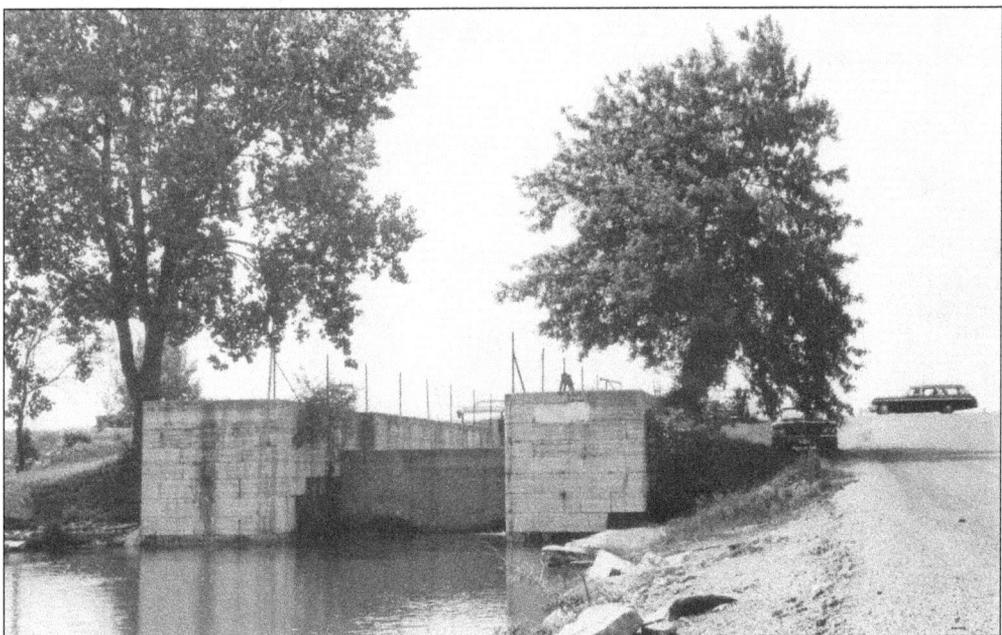

The bulkhead lock at present-day Grand Lake St. Marys State Park still feeds the reservoir's surplus waters to a short section of watered canal from St. Marys to Delphos. The Mercer County Reservoir, as it was originally named, became part of the state parks system in 1915. This photograph shows the bulkhead lock, with a road on top, in 1965. (Courtesy of the Canal Society of Ohio.)

This image shows several locks in Lockland prior to their removal in 1941. The locks were taken out by wrecking ball, and the canal's route was paved over for the Wright-Lockland Highway. This four-mile roadway served the Wright Aeronautical Plant, an important engine manufacturer during World War II. The highway later became the southbound lane for Interstate 75. (Courtesy of the Canal Society of Ohio.)

By 1957, Defiance Lock 37n served as an expensive retaining wall for a parking lot. Fortunately, the lock has since been partially excavated, refurbished, and fitted with lower gates, and is now the centerpiece of Canal Park. (Courtesy of the Canal Society of Ohio.)

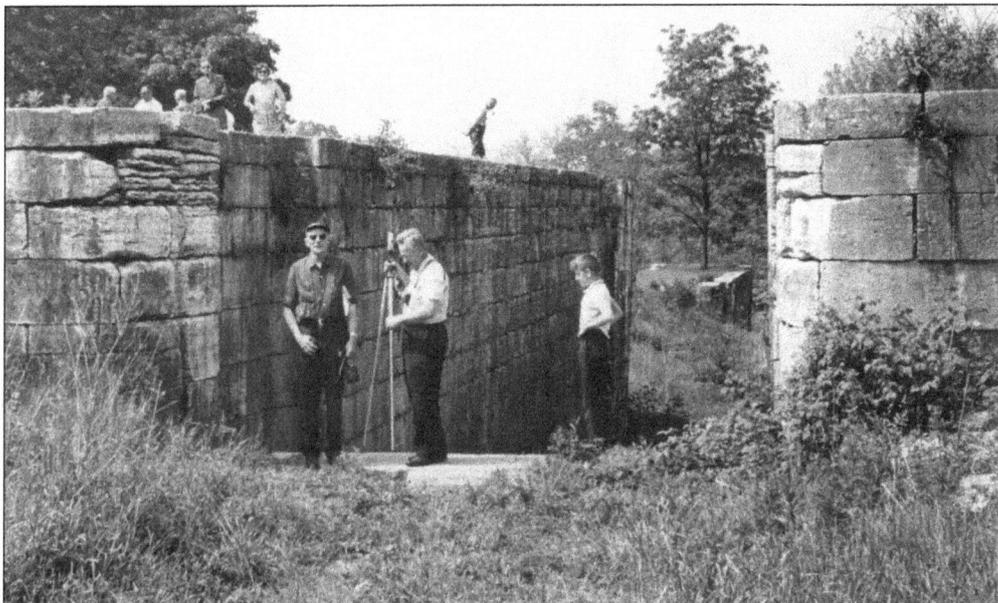

The staircase of locks at Lockington are now preserved within the Lockington Locks State Memorial, administered by the Ohio Historical Society. This image was taken at a Canal Society of Ohio tour of the site in 1965. Ted Findley, the society's first president, is to the left of the camera tripod, and founding member Harry Valley is to its right. (Courtesy of the Canal Society of Ohio.)

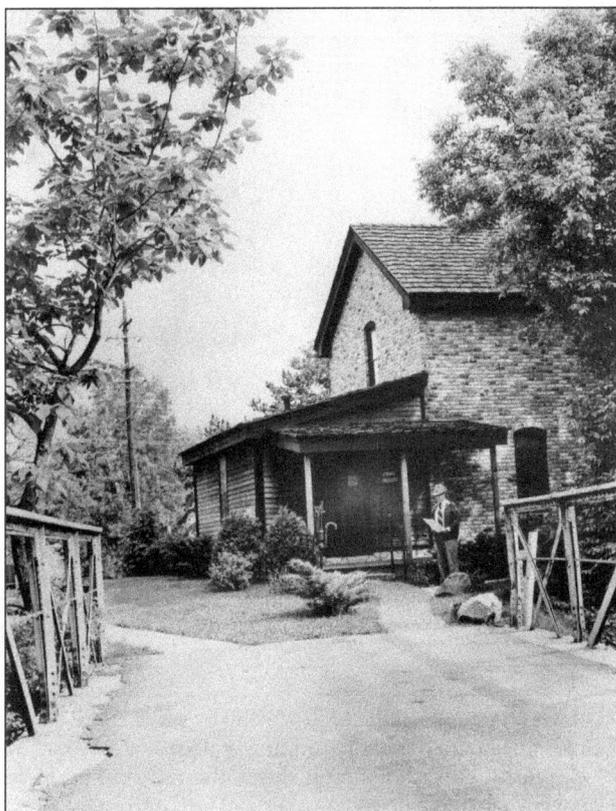

The Middletown Canal Museum was built by the Middletown Historical Society in 1982. The museum is located on the former route of the canal through Middletown and was modeled on the design of a lock keeper's house. This photograph shows the late local historian and writer George Crout in front of the museum in 1985. (Courtesy of the Midpointe Library of Middletown.)

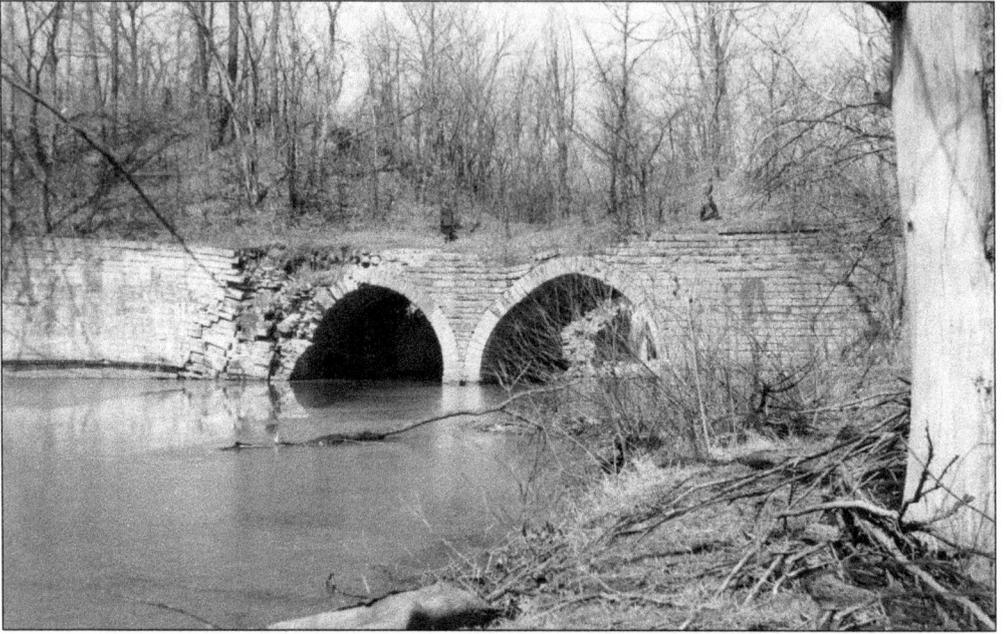

The Turtle Creek twin-arched culvert, on the Loramie summit, did not withstand the ravages of time very well. This photograph shows the precarious condition of the structure in 1965. Estimates for its repair were provided in the 1970s, but the county could not secure the necessary funds. The culvert was demolished in 1982. (Courtesy of the Canal Society of Ohio.)

Lock 27s was given to Miami Township by a local land developer in 1982. The lock was restored to its 1907 appearance through funding provided by a Montgomery County community development block grant. This photograph shows the refurbished lock being examined by members of the Canal Society of Ohio in October 1994. (Courtesy of Bob Mueller.)

New Bremen, located at the northern end of the Loramie summit, is proud of its canal heritage. Lock 1n had been much altered since its 1907 concrete rebuild and was showing signs of age. A lock tender's house that sat adjacent to the structure was burned down during a fire department exercise in 1968. A concerned group of historical organizations and civic-minded businesses secured funding for the lock's authentic restoration. The image above shows Lock 1 during its 2006 reconstruction. The photograph below shows the lock and the rebuilt lock keeper's dwelling in 2011. The lock keeper's home is now the headquarters for the New Bremen Historic Association. (Both, courtesy of Boone Triplett.)

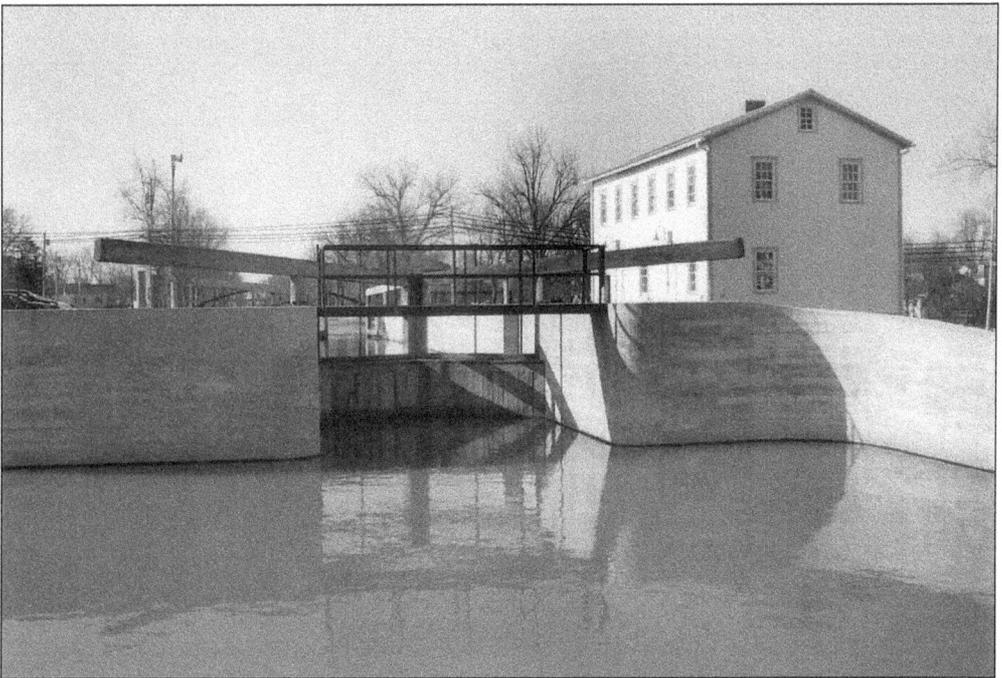

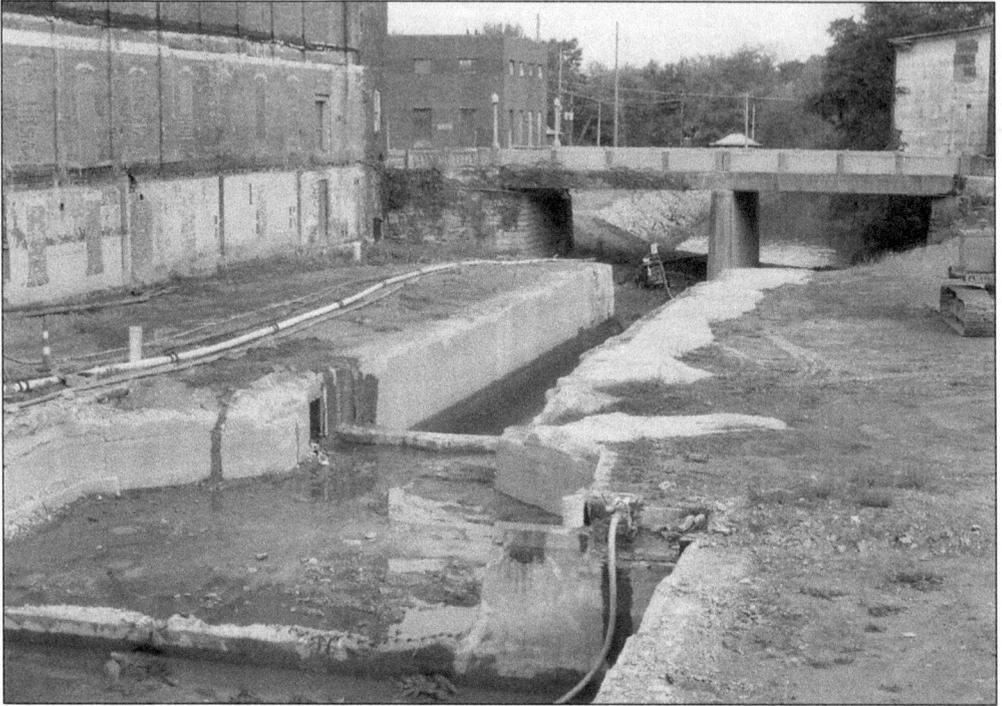

After navigation on the canal ceased in 1913, the adjacent woolen mill built a two-story addition to its building atop St. Marys Lock 13n. More than 70 years later, the city purchased and removed the defunct mill. The image above, taken in 2007, shows the long-concealed concrete lock to be in altered but good condition. The photograph below displays the lock after a three-year restoration that the city hopes will jumpstart a renaissance of the surrounding business district. The linear park created by the city includes a replica canal boat, the *Belle of St. Marys*, permanently moored in a watered section of the canal at Memorial Park. (Both, authors' collection.)

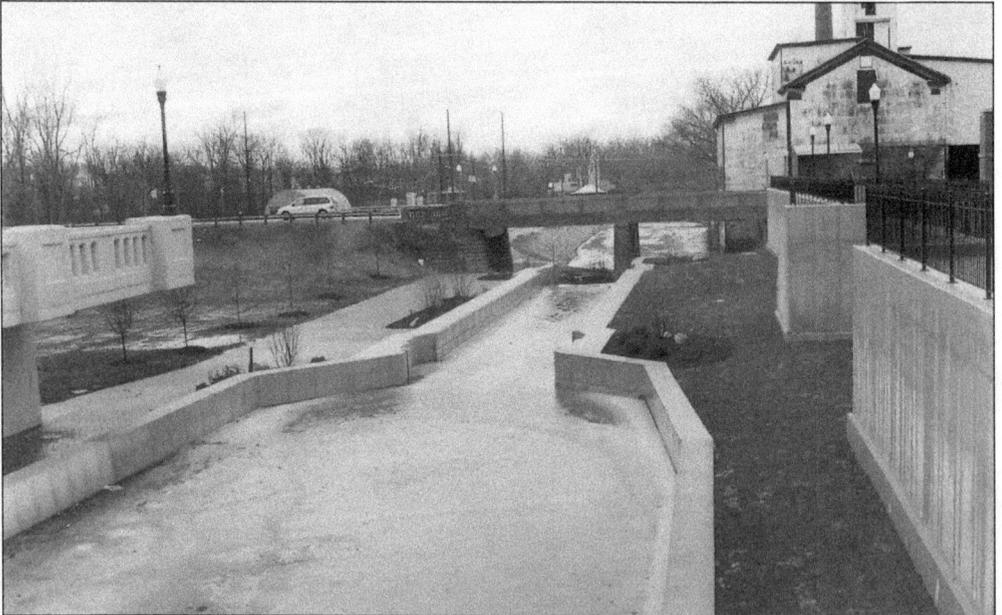

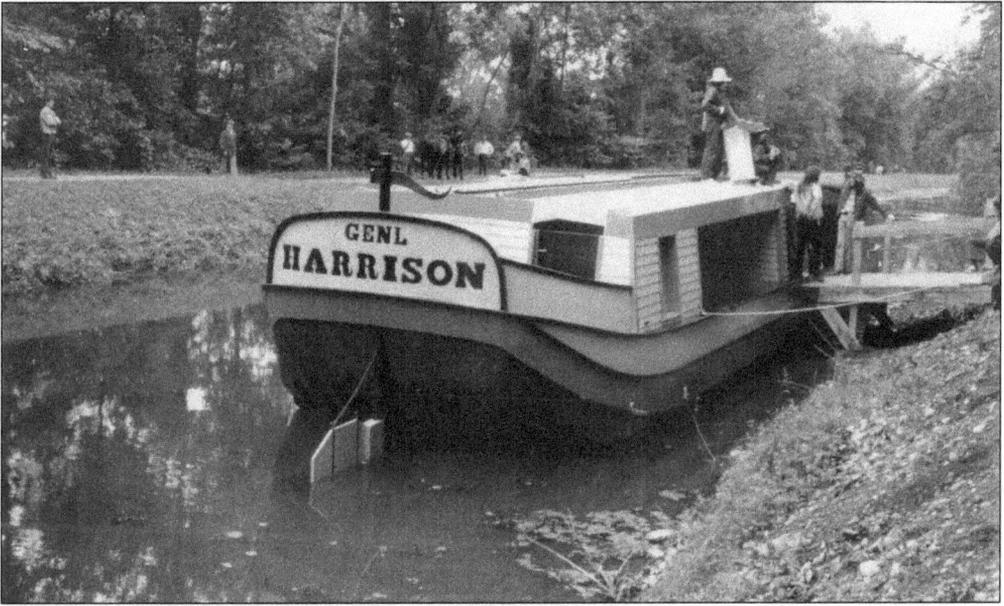

John Johnston was a member of the Ohio Canal Commission from 1825 to 1836 and influenced the routing of the canal through Piqua and his property. The Ohio Historical Society preserved the Johnston Homestead and a watered section of canal. Since 1972, they have offered rides on a replica canal boat, the *General Harrison*, at the 250-acre Johnston Farm and Indian Agency Park. (Courtesy of the Canal Society of Ohio.)

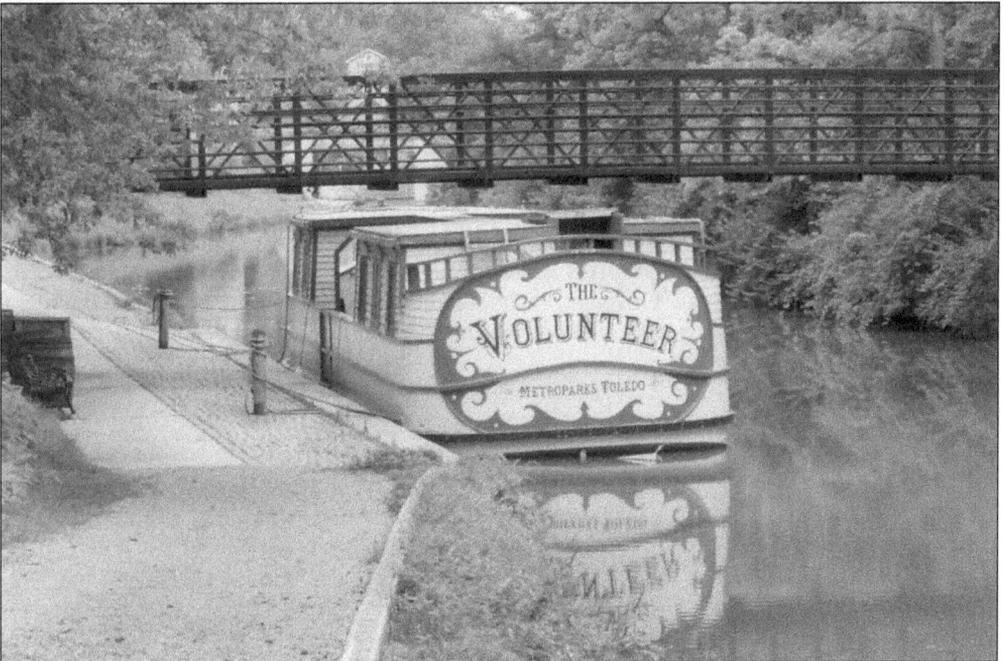

Cleo Ludwig purchased his ancestor's mill at Providence and donated it to the Toledo Metroparks in 1974. The park district restored the mill and the adjacent Lock 44n. The replica canal boat *The Volunteer* was completed in 1994 and allows its passengers the unique experience of locking through. (Courtesy of Boone Triplett.)

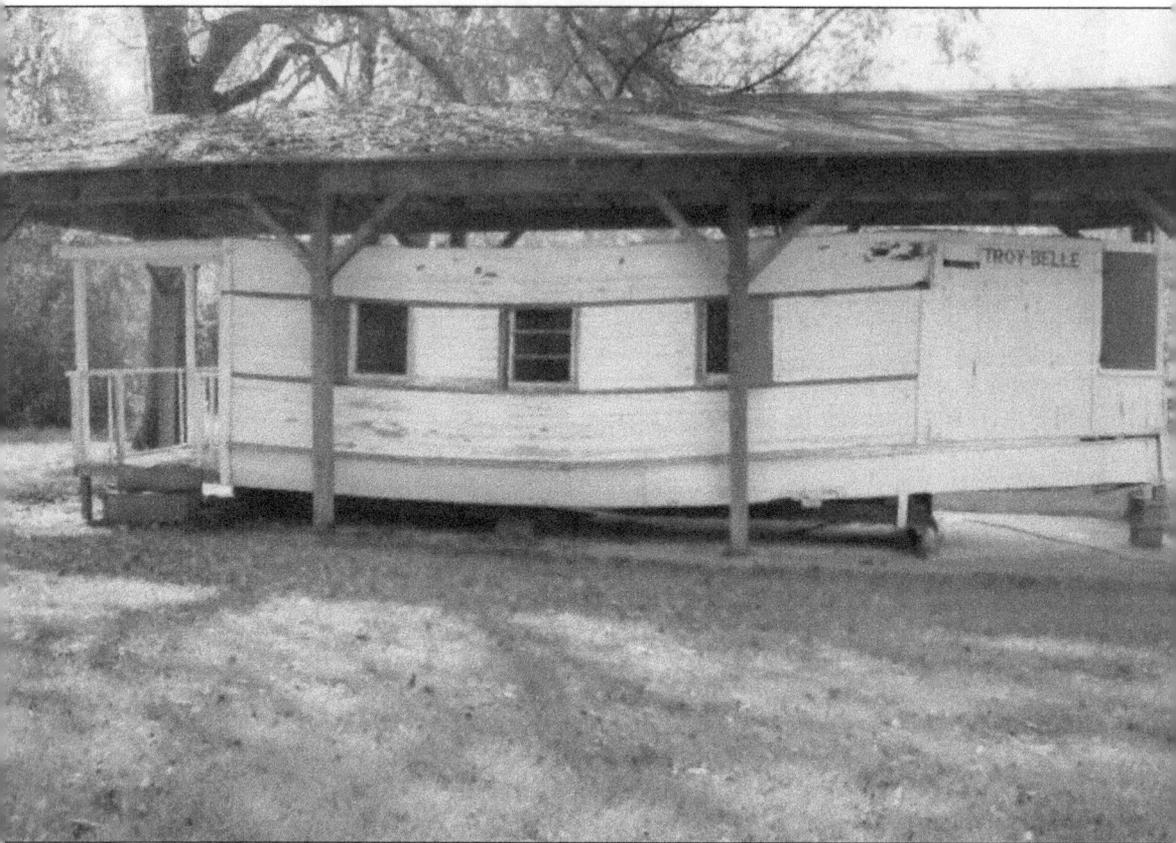

The saga of the *Troy Belle* did not end with the closing of the canal. After serving as a mobile photographer's studio, the *Belle* was towed to Dawson's Lake, a wide-water area on the Loramie summit. The small craft was home to a series of owners for the next 34 years. By the time Leo Brandewie leased the land where it rested, the boat had been moved to pilings on the lakefront. Brandewie utilized the boat as a fishing shack. Over the ensuing years, the *Troy Belle* was loaned out by Brandewie for the Delphos centennial pageant in 1951, and Fort Loramie's celebration of Ohio's sesquicentennial in 1953. The *Troy Belle* is thought to be the lone surviving example of an animal-towed Ohio canal boat. This photograph, taken in 2012, shows the boat docked under a shelter beside a pond on the campus of the Willowbrook Environmental Education Center, near Piqua. (Courtesy of Jim Metz.)

ABOUT THE
ORGANIZATIONS

In 1961, a group of citizens called the Canal Society of Ohio declared themselves to be interested in investigating the preservation of Ohio canal history. At first, their major activity was studying, locating, and measuring the dimensions of the remaining structures. Later, GPS was used to provide coordinates to mark locations. As time went on and deterioration of the canal system continued, the group saw that there was more to their mission. So, wherever they could, they contacted politicians, local citizenry, funding organizations, and newspapers to begin educating those who could provide help. The Canal Society of Ohio became active in supporting canal restoration projects throughout Ohio with expertise, funding, publicity, and even hands-on labor. The society members strive to demonstrate that the old canals, structures, and towpaths are still relevant to modern life. Today, the group conducts tours, twice a year, of Ohio's canal system all over the state. They publish a journal, *Towpaths*, as well as a quarterly newsletter. The society recently celebrated 50 years as an organization dedicated to the restoration, conservation, and interpretation of Ohio canals. Visit their website at www.canalsocietyohio.org.

Also active on the Miami and Erie Canal is the Miami-Erie Canal Corridor Association (MECCA), representing western Ohio. Founded in 1996, it is a coalition of citizens and corporate, community, and government agencies working to raise awareness of the historical, recreational, and natural value of the watered canal greenway. MECCA has worked to knit together various partnerships along the 40-mile watered canal corridor between Delphos and Piqua, restoring towpaths, rebuilding canal structures and related buildings, and developing tours, displays, signage, and guidebooks. Visit their website at www.meccainc.org.

Visit us at
arcadiapublishing.com